SpringerWienNewYork

Harald Gruendl, EOOS

The Death of Fashion.
The Passage Rite of Fashion in the Show Window.

SpringerWienNewYork

The Death of Fashion.
The Passage Rite of Fashion in the Show Window.

Harald Gruendl, EOOS
www.eoos.com

© 2007 Springer-Verlag/Wien
Printed in Austria
SpringerWienNewYork is a part of
Springer Science + Business Media
springer.com

Graphic Design
Günter Eder, Roman Breier
grafisches Büro

Copyediting, translation
Nita Tandon

Printing and binding: Holzhausen Druck & Medien GmbH, A-1140 Wien
Printed on acid-free and chlorine-free bleached paper

SPIN: 11941842
Library of Congress Control Number: 2006939202
With 44 mostly coloured figures

ISBN-13 978-3-211-49854-5
SpringerWienNewYork

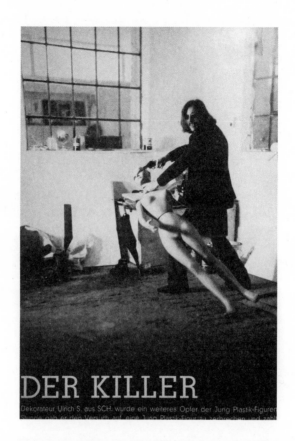

DER KILLER

Dekorateur Ulrich S. aus SCH. wurde ein weiteres Opfer der Jung Plastik-Figuren

Contents

Preface

This work is about the ugly. To be more precise, it is about the ugly show window that appears twice a year – during the seasonal sales of fashion when, strikingly enough, the visual economy of beauty is disrupted by the impact of the unsightly. We will call this Dionysian period the "death of fashion". Once the fashion collection of the past season is no longer in fashion, the period of the seasonal sales becomes the transitional phase between the old and the new collection. It seems to us as if documenting the ugly is a taboo today as merchandising literature is replete with images of the beautiful show windows. But what about the ugly window? The one scene never found on ancient Greek vases is the solemn moment in which the victim is sacrificed ceremonially. Is the "death of fashion" only a rational act of selling out leftovers, or is it something more meaningful? The fashion industry has perfected the ways of introducing new commodities, presenting a new generation of aesthetically different products twice a year. Catwalk shows in major fashion capitals stage these new collections in a ritualised way and the fashion industry organises and attends to the Apollonian festival during which the new collection is born. In contrast, the seasonal sale window is naked and instead of being clad in an expensive evening dress, the naked mannequin is merely clothed in packing paper. Rather than using a distinctive graphic design, window dressers write by hand.

How does fashion die in the show window? Is it a silent death, is it a murder, or is it a sacrifice? Whatever the case may be it is a high publicity event. The question lies somewhere between the production of fashion and its consumption. The "death of fashion", however, refers to the displayed garment and not to the garment worn, the seasonal sale being its last chapter and the end of a seasonal collection. We wanted to find out how this end is dramatised in the retail theatre. Do window dressers use any intuitive images? To what extent is the consumer involved in a ritualised "death of fashion"?

We decided to do a 'visual' research in four major European cities during the sales period in order to acquire basic material, which could subsequently be used to analyse the dramatisation and to discover its underlying patterns. We also wanted to know whether we could find instructions for dressing the seasonal sale window. Are there any illustrations in professional magazines? Do books on "the art of window dressing" deal with the seasonal sale window, or is this not an art form? We not only wanted to involve literature on the aesthetics of the show window, but also literature that helps understand the ritual and performative dimension of dramatisation. Alongside literature dealing with the ritual dimension of consumer behaviour, we also involved literature on ritualisation in design and marketing in order to understand whether marketing or merchandising deal consciously with the designing of rituals.

This book aims to base its discourse on the research of intuitive images and meaningful actions; it is a search for hidden mythologies and the reinterpretation of such ancient social practices as rituals. It is also a kind of "poetic analysis"[1] of our contemporary condition. Jean Baudrillard wrote that the presentation of commodities is not in itself convincing, but it is a necessary precondition for rationalising the act of buying.[2] Mary Douglas, on the other hand, pointed out that the general assumption that "shopping is a fully rational activity" has been rejected by consumer theory which discovered "utterly implausible limitations on that rationality"[3]. The "death of fashion" is a balance between the rationalisation of the act of buying and irrational basic emotions related to the system of fashion. Our interest in the following chapters lies in a careful excavation of stimulating dramatisations.

This book is written in English and has been copyedited. The footnotes of all translations from German into English are marked with an asterisk*.

1 This term was coined by EOOS to describe its approach to design research.
2 Baudrillard (1996:166).
3 Douglas (1992:115).

Ritual and
Image

"In this visual flood of images, there is still hope for reviving the
wild primal settings of the image. In a certain way, each image
has preserved something wild and incredible, but intuition is
capable of retrieving this "punctum", this secret of the image,
provided we take the image in its literal sense. And it is up
to us to want this literalness, this secret; it is up to us to let it
flow and put an end to this widespread aestheticisation, to this
intellectual technology of culture."[4]

4 Baudrillard (1999:36)*.

The Fashion System

Christmas was over when we opened the daily newspaper and found an advertisement for the winter sale in the boutique of an Italian fashion brand. Fashion brands do normally advertise in fashion magazines, but in a way, this advertisement was like a death announcement in daily papers. All it said was "Sale", and the address of the fashion boutique in the first district of Vienna, which was printed in bold white on a black background. So, we set out to take a look at the city's storefronts and their decoration, finding them all surprisingly ugly. The sales period was omnipresent, and all the shops in town were decorated in a strikingly ugly manner. Why did this period ask for ugliness and not beauty? The books we found on window decoration only showed the nice, the well-designed and "artistic" show window.[5] The large and glossy illustrations in our books showed the artistic side of the decoration business. Beautiful windows, like theatre stages presented the merchandise we were supposed to buy. It can be argued that the fashion business holds an exceptional place in the decoration business. The number of fashion show windows is generally over-emphasized in these lavishly illustrated books, which do not focus on fashion design alone. In reality, the show windows are not all like the ones we find in these expensive publications. But they are usually done up in a nice way, according to the store's budget. However, this changes dramatically during the sales period. All the stores compete in being uglier than the one next door. What is behind this period that recurs twice a year? The sales period lasts several weeks and takes place before the new spring/summer and autumn/winter fashion collections are launched.[6] Roland Barthes analysed

[5] Some good examples are Soto (2002) and Menchari (1999).
[6] The exact duration of the sales period is not easy to define. It also varies a lot depending on the city, the shopping area or even the individual shop. The studied sales period of the winter sale took place roughly within the first three weeks of 2004. Since law does not regulate the duration of this event today, it seems to be spreading like an epidemic. While in 1958, the fashion magazines introduced the new collection in April, in 2004 it was presented as early as in the January issue. The shift in the inauguration date will be not discussed in this paper because it does not change the general structure of the fashion year. It should also be noted that advanced methods of production allow the fashion industry to deliver more collections during the year. But the symbolic cycle of two collections parallel to the seasonal ones is still common, despite the existence of permanent sales (outlet centres) and mid-seasonal sales. These will not be discussed here.

the phenomenon of fashion in great depth[7] in the context of the "language of fashion" used by fashion editors in the fashion magazines of 1958/59. Exceptionally striking in this 'mathematical' discourse is a passage, which describes the change of fashion in spring. The advent of the new collection is compared with ancient Greek festivals like those of the god Dionysus. This text passage will not be highlighted initially[8], but we will later develop it in a new way.

> "[...] as a season, spring is both pure and mythical at once; mythical, by virtue of the awakening of nature; Fashion takes this awakening for its own, thus giving the readers, if not its buyers, the opportunity to participate annually in a myth that has come from the beginning of time; spring Fashion, for the modern woman, is like what the Great Dyonysia or the Anthesteria were for the ancient Greeks."[9]

This text fragment will be the starting point of our discussion on the phenomenon of sales. Barthes did not further develop his idea of the Dionysus myth and the intense experiences of such dramatisations in ancient Greece. In order to also remain metaphorical, this passage is the part left unprotected by the armour of his structural analysis. We will, however, take it as an inspiration to further investigate this trail. Friedrich Nietzsche placed the birth of tragedy in relation to the Greek Dionysian cult.[10]

> "In all corners of the ancient world – to leave the modern one to oneside here – from Rome to Babylon, we can prove the existence of Dionysian festivities, whose type is at best related to the Greek type as the bearded satyr to whom the goat lent its name and attributes, is to Dionysus himself."[11]

The striking parallel to Barthes' text lies in the fact that Nietzsche also addresses the likelihood of a continuing existence of the Dionysus cult. Nietzsche was also the one to place the nature of the cult in relation to Greek aesthetics. The desire for beauty in the form of celebrations, feasts and new cults contrasts with the desire for ugliness, an ugliness in the form of desire

7 Barthes (1990).
8 Miklautz (1996), for example. She points out this passage in relation to the renewal of her female informant's attire and the strong emotions that surface when new garments are consumed.
9 Barthes (1990:251).
10 Nietzsche (2000).
11 Ibid., p. 24.

for pain, pessimism, tragic myth, the image of the horrifying,
annihilating, ambiguous, and evil aspects of existence.[12] The
Dionysus cult stands for all these aspects of the ugly. The world
of Dionysus also represents the perception of reality in a fuddled
state in which the individual is annihilated in a mystic experience.[13]
The antagonist here is the god Apollo, whose world is one of
images, of fantasy and of creative force,[14] which indicates that we
may well be on the right path. If the ancient Greek gods Dionysus
and Apollo represent both ugliness and beauty, the show win-
dow would normally belong to the world of Apollo. Although the
two worlds are full of fantasy and colour, it seems that Dionysus
is the driving force behind the design during the sales.

◄ The show window is dressed with six mannequins. The man-
nequins are packed like corpses in plastic bags tied with a black
plastic rope. They are not lying on the ground waiting for burial
after the catastrophe but are in an upright position, maybe to be
better seen from the street. A shopping bag with the inscription
"3 DWAZE DAGEN" is mounted onto each of the six packaged
corpses. The number three is figuratively displayed as a packed
three-dimensional object, in the same way as the mannequins
are. The floor of the show window is 'undressed', its beige stone
visible through the transparent base. The backdrop is covered
with wallpaper, which displays a graphic element that could be
interpreted as a drop of water. This graphic element covers
the entire backdrop. Hundreds of drops outlined with yellow
form a regular pattern on the blue-green ground, creating the
impression of rainfall. A bold black arrow on a yellow ground
above the mannequins directs our gaze to the left side.[15]

This striking window is located in Rotterdam. The depart-
ment store's "crazy incredible bargains" are on offer for three
days.[16] A strange coincidence that the Dionysus cult held on the
Acropolis in Athens also lasted three days. Graf describes the
ancient Greek festival in the following words:

| "Dionysus was a god who came from outside and temporarily

12 Ibid., p 7.
13 Ibid., p.23.
14 Ibid., p. 21.
15 Descriptions of the show windows are by the author. The idea is to incorporate them into the text like recordings of
informants in ethnological field studies. We will continue with this form of representation throughout the text, but without
footnotes. The identity of the stores will be anonymous. In the sections without images, this will be the only form of
"visual" representation.
16 Tongeren (2003:78).

suspended the activities of everyday life. His festival created a space outside the day-to-day reality of the polis. The actors put aside their own identities, donning masks, high boots (kothornoi), and colourful costumes. Even the walk to the theatre of Dionysus, situated as it was on the slope between the homes of the Athenians and the citadel of their gods, removed them, for three days, from their familiar surroundings. This carnivalesque setting, this 'carnival time' gave them an opportunity to reflect critically on, and to call into question, all that was familiar to them: the polis, the people, the gods. At the same time, it fostered in them a sense of solidarity, which rendered such reflection and questioning tolerable. From this perspective, the festival of Dionysus seems the ideal occasion for the performance of tragedies."[17]

The creation of space where everyday behaviour can be reconsidered is an interesting point in the description of this ancient festival. Do we call into question the fact that we may have paid the double for a piece of garment had we bought it a day before the sales began? This, and the fact that with the upcoming collection the piece we buy during the sales will become a kind of taboo. The fashion of the past will not be further discussed after the arrival of the new one, after all, fashion does not speak about the not fashionable.[18] Rituals articulate conflicts and transform them into a symbolic practice. Barthes makes the verbal structures of the "written-garment" the object of his study. According to him, the study of fashion magazines is the study of the representation of fashion, for Barthes distinguished between the "real garment" and the "represented garment".[19] To follow this idea of the represented and the real we would also have to study the "real presentation" of fashion in the show window on the street. Barthes, on his part, discussed only the representational aspect of fashion in the fashion magazine. But purchase holds an equal position beside the fashion magazine, where the garments are displayed as "represented garments".[20] The attempt to present the garments in a fetishistic way is easily identifiable in the beautiful window. But what about the ugly window? What lies behind this visual attack?

17 Graf (1993:143-44).
18 Barthes (1990:79).
19 Carter (2003:146).
20 In this study, we will not take into account other possible areas (e.g. film) where fashion is in the state of the "represented garment".

"The more it should be common sense to an enlightened art scene that the categories "beautiful" and "ugly" have become irrelevant for the attempts at raising aesthetic questions and finding solutions to them, the more they keep sneaking into the discourse through the back door of the commonplace, of fashion, advertising and the ideologies of design – like spectres of themselves."[21]

The philosopher Konrad Paul Liessmann proposes that the category of the ugly has undergone considerable change, shifting from the arts into design, and so into our everyday life. If we follow this proposition, we could assume that the ugly has found its final abode in our seasonal sale window. It will, however, be worthwhile to look back at the arts and see what initial function the ugly had had. In Umberto Eco's historical analysis of beauty, we find that the aesthetic categories represented by the ancient Greek gods Apollo and Dionysus coexist side by side, although the incursion of chaos disrupts the permanent state of beauty and harmony from time to time.[22] In ancient Greek aesthetic economy, the cyclical appearance of the ugly was a stabilising factor. Will this be true of contemporary aesthetic economy of the high street as well?

The Dionysian rite is closely bound to myth; it is the myth of the dying god. James George Frazer draws a comparison between myth and rite in order to prove that ritual practice was the starting point for mythology.[23] The death of the god was, in a magical way, brought into relation to the awakening of flora. Here we find our way back to Barthes' argument in which he relates the advent of the new spring collection to the awakening of nature. The corn god is sacrificed and, with his resurrection, nature is reborn in spring.[24] Since Nietzsche, an archaic sacrifice is seen as the origins of the performing arts.[25] The orgiastic cult becomes the aesthetic opponent of beauty.

Today, the new collection is presented on the catwalk. The runway presentation is, in its aesthetic representation, more related to the beautiful world of Apollo. Nietzsche spoke about

21 Liessmann (2000:159)*.
22 Eco (2005:55).
23 Graf (1993:40). Today there are two hypotheses about the origin of tragedy. While the one uses a ritualistic approach, the other is founded on a literature-based approach. See Graf (1993:144-45).
24 René Girard dedicated one chapter in his book on the violent nature of sacrifice to the rite of Dionysus (1988:119-XX).
25 Brandstetter (2001:135)

the necessity of sacrificing to both gods.[26] The two sacrificial sites in the process of transformation from one trend to the next are perhaps the fashion show and the show window during the sales. In this way, we can detect the tension between beauty and ugliness in the show window throughout the fashion year, with the two incursions of ugliness during the sales periods. When we focus our attention on the sales period only, we find the ugly sales window on the one hand, and the presence of the catwalk presentations in the fashion magazines on the other.[27] We therefore see the balance of beauty and ugliness in different time scales. The dream of new garments on the catwalk stands in contrast to the reality of the tragic myth of the old fashion in the seasonal sale windows. The surprising fact that the ugly show window is not really documented can be explained by the claim that each epoch has its own forbidden zones of knowledge.[28] This forbidden zone, especially in the case of literature on show windows and fashion theory in general, will be the subject of our further research.

Consumer Beliefs

Before we analyse in detail the fashion show window and its ritualisation during the sales, we will briefly outline the cultural context of the phenomenon in the Western consumer society. According to Marshall Sahlins, the term culture denotes a meaningful order of persons and things.[29] The difference between culture and social structure is that social structure is the social system of interaction itself, while culture is a structured system of meanings and symbols where social interaction takes

26 Nietzsche (2000:131)
27 In the year of our research, fashion magazines presented the new trends simultaneously with the winter sale. Even if this was not always the case, it would not change the narrow (also economic) relation in fashion magazines of the symbolic representation of the new collection on the catwalk and the need to get rid of the existing stock in order to present the new garments. During Barthes' (1958/59) research phase, the new collection was not presented by using documentary-style photos of catwalk presentations of today but by traditional studio or outdoor fashion photography.
28 Liessmann (2000:13)
29 Sahlins (1976:X).

place.[30] Don Slater defines consumer culture as a culture of consumption:

> "The notion of 'consumer culture' implies that, in the modern world, core social practices and cultural values, ideas, aspirations and identities are defined and oriented in relation to consumption rather than to other social dimensions such as work or citizenship, religious cosmology or military role."[31]

One such core social practice connected to consumption today is the ritual. The ritual has the important social function of making relations stable and visible. A function that has not changed in consumer culture. Rituals not only stabilise our relation to consumption they stabilise social relationships as well. Cosmologies are the sum of those principles and terms that are holy to society.[32] Lévi-Strauss analysed many such cosmologies in tribal societies. When we look at his diagrams, we see, for example, heaven, earth and water as the axes of the cosmos.[33] The social structure is organised by these powerful elements and represents various rules of coexistence. Categories of life and death have their contemporary equivalents in the diagrams of consumer research – in terms of cheap and expensive. However, the order of things continues to be meaningful, even though the link to elementary experiences has been lost over time. A diagram for analysing soap, for example, is divided into four quadrants: price and design, ideology and premium quality, split by a vertical axis showing symbolic and functional values, and the horizontal axis represents materialistic and spiritual qualities.[34] The soaps are now positioned according to price and design. Above the horizontal line is the handmade soap, which smells of apple and the soap used by film stars. Below the line, we find the soap with real moisturising cream. In the lower left quadrant, we find the soap, which is sold in a double pack at a bargain price. Welcome to the commodity cosmos! The consumer society has learned to live within these quadrants. The choice of commodities defines our position in the universe of target groups. We are free to choose what we want: the smell of apples or none at all, a nice packaging or a cheap look: we

30 Geertz (1973:144).
31 Slater (2003:24).
32 Tambiah (1979:121).
33 For example, the diagram of the Winnebagos in Lévi-Strauss (1977:153).
34 Karmasin (1998:214).

can be film star today and feel the moisturising effect of our new soap tomorrow. The brand universe today can be compared to the number of stars visible in the firmament. Thousands of brands are glowing in it, some of them brighter than others.[35] The great number of stars calls for specialists to draw the maps of our commodity firmament. The main rituals of a society stand in close relationship to its cosmology.[36] Since the whole cosmos is bursting full of commodities, our main ritual is shopping. There is the everyday shopping, which we have already described as the act of selecting the appropriate soap for our personal grooming "rite".

"An even simpler example might contrast the routine activity of buying some regularly used article of clothing for spouse or child (such as gym socks) and the ritualised version of buying a similar but different article (argyle socks) and giving them as a gift."[37]

Ritualised shopping is not family shopping; it is a strategic version of it[38] and it is not only controlled by the consumer, but also by industry. Shopping rituals have been established as so-called calendar rites which is why there are fixed dates during the year, denoted with fixed meanings, when the consumers do their ritual shopping. The biggest (commodity) feast of all is Christmas. Starting at the beginning of the nineteenth century, the market for Christmas goods kept growing, reaching its apotheosis in the late nineteenth and early twentieth centuries in the department store of Christmas.[39] Consumer culture has transformed the religious festival into a festival of consumption. Santa Claus has been established as the secular version of Christ. While Christ is related to the realm of spirit, Santa Claus represents the realm of material abundance.[40] In this sense, Santa Claus (or his several alter egos in the different countries where Christmas is celebrated) is the god of consumption. He appears once a year, with his bag full of material goods, as the embodiment of satisfied consumer desires. That consumer culture – with its god drawn by graphic designers – has created a new successful material religion can be observed in its world-

35 The biggest food company today owns about 4000 Brands.
36 Tambiah (1979:121).
37 Bell (1992:91).
38 Ibid., p. 91
39 Schmidt (1995:108)
40 Belk (2001:83)

wide success. Christmas is now celebrated even in those parts of the world where Christianity's myth of the poor, newborn Christ in the stable was not very successful. Although in countries like Japan, local religious rituals cover the need for rituals dedicated to the family, its consumer society found a new reason for celebrating Christmas:

"In many respects the way in which Christmas is celebrated in Japan acts as a negation of the Taoist and Shinto celebrations. Christmas is located in the realm of mass culture, the city, and is thus placed beyond the reach of both local community and family. Young couples escape their social obligations for a night when they go out to celebrate themselves, romance, and consumerism."[41]

Thus, in Japan, the original purpose of the ritual to make the family stable has been adapted into a ritual that helps young couples to escape family and tradition. But the celebration of the consumer rite does not depend on its social function. The industry also has the liberty to take Santa's help so that it can do business during the sacral time. Every field of business is free to place its goods in the festively decorated Christmas show window. Christmas is a good opportunity to sell everything, from sex paraphernelia to soft drinks.[42] There seems to be no taboo on goods to be exchanged as gifts.[43] The strategy of consumer culture is to replace a festival thus far celebrated in order to start a parasitic life, which in the end kills the original festival. Several tribal festivals were overlaid by Christian rites to prevent heathen customs. We can thus assume that in a couple of years from now, only social scientists and anthropologists will know the true origin of the rites.[44] The successful transformation of Christmas owes to the fact that the sacral period does not last just one day or a few days, but extends over a couple of weeks. The coming of Christ is preceded by several ritual weeks before the holy day is celebrated. Therefore, the materialisation of the festival can begin weeks in advance, and will expand from year to year. Christmas music in the supermarket appears sooner than the year before. The problem of covering a single religious holiday

41 Moeran/Skov (2001:122).
42 See Belk (2001:76) on the softdrink-consuming Santa Claus.
43 I recently passed by a gun shop that had a Christmas animation!
44 Today, most people know nothing about the origins of the Christmas tree. One day we, too, may forget that Christmas shopping was invented by consumer culture only in the mid-nineteenth century.

by consumer rites arises from the simple fact that people are unable to shop because all shops close down so that they can perform their religious rites at their own holy places. Sometimes these holidays fall on weekends and sometimes on weekdays. Consequently, consumer culture has created its own rites, its blueprint being the social function of Christmas. In most cultures that celebrate Christmas, the rite is performed to stabilise the institution of the family. As there are other basic social functions not celebrated by religion, like the father, the mother and the beloved, consumer culture created new rites. These rites are in the calendars of all the marketing departments around the world: Father's Day, Mother's Day and Valentine's Day. And they are sacred to consumer culture. In fact, they are so important that industry even creates special products or product packaging for these events. A good example for this is the fragrance business. Secular products for everyday use are covered by the animation colour. Special altars are erected at the points of sales in order to present the oblations for fathers, mothers and the beloved. These altars have to be designed more innovatively and strikingly each year and a large proportion of the annual marketing budget is sacrificed for this religious service. The best designers are asked for their assistance, for it is not the duty of the salespeople to decorate the altar. Everything is designed in advance; nothing is left to chance. Companies go a long way to produce ever more attractive decorations for their events. Everyone wants to be more striking, more festive in order to enhance sales during the period before the rites are celebrated. The creation of special show windows dedicated to Father's Day, Mother's Day and Valentine's Day is yet another important marketing tool. As a result, everyone in the streets becomes aware weeks before the day arrives that they must do their ritual shopping. Owing to the significance of the occasion, no costs are spared for the artistic decoration of the window presenting the merchandise. Mary Douglas and Baron Isherwood describe the function of goods as follows:

"Consumption uses goods to make firm and visible a particular set of judgements in the fluid processes of classifying persons and events. We have now defined it as ritual activity." [45]

45 Douglas/Isherwood (2002:45).

Rituals are not only practiced on few fixed dates during the year, there are in fact rituals that are performed every day. People in Christian Europe had to pray to God on their knees everyday in acknowledgement of the final truth.[46] What kind of everyday ritual was it that created consumer culture? For example, there are rituals that are based on the preparation of daily food. "Food is a medium for discriminating values, and the more numerous the discriminated ranks, the more varieties of food will be needed."[47] Advertising plays an important role in introducing such consumer rites: The sun has risen and is shining through the window of a nice kitchen. Mother is preparing food for the rest of the family. The children are not in a good mood because they have had to wake up early for school. The ritual food is now brought in. Beams of sunlight fall on a package of cornflakes. Mother takes the package and pours a helping of it into the children's bowls. The children begin to smile and love their mother instantaneously. Music swells up in the background and the whole family is joyous. When we take a step back into reality, we will probably find that the child's mood does not improve by eating corn flakes. But the mother has learned to show that she is a good mother every day by buying a special brand of cereal.[48] The magic can only work when the ritual preparation of the food is performed everyday. The preparation of the ritual meal has to be distinguished from the consumption of food, which is not quite as burdened with symbolic value and only expresses a certain lifestyle. Another example for the shift of rituals from the social dimension to consumption are the rites of purification. Numerous rites are known from tribal societies. In this category of rites, our modern, developed Western society is less inventive when practicing the rite because the strength of these particular consumer rites seems to lie in the invention of myths. Since we produce a lot of filth in our commodity cosmos that renders us unclean, we must purify ourselves regularly. The attributes pure, fresh and clean are linked to the sacred in marketing literature:

"Our highly industrialised culture no longer has any notions preformed by religion, yet certain phenomena exist that can be compared to these concepts and they are also important for the market because it is the products/brands that bear certain

46 Langer, in: Geertz (1973:100).
47 Douglas/Isherwood (2002:44).
48 As advertising is very sensitive to social developments, things now exist that are ritually prepared by the father.

I attributes which allow us to classify them in these categories."[49]

Advertisements for products for "purification rites" are an interesting research field. For example, fictitious, fantasy figures that are embodiments of freshness. The funny lemon with eyes, a mouth, arms and legs, capable of performing acrobatic contortions, introduces itself as the priest of purity in our bathroom with the following magic formula: "Huiiiiiiii!" The yellow mystic figure shows how freshness can be brought into the toilet by jumping around and making stars fly out of the toilet bowl. More and more stars keep coming out and finally explode. The soundtrack is taken from fireworks. The product family appears from the explosion. Everything is now fresh and clean.[50] It is difficult to compare modern consumer culture with tribal societies, because it is difficult to find a vocabulary that is suitable for both worlds.[51] The description of dramatisation on the level of emotion conveys an idea of the power of such symbolic practices. Even today, the use of an intuitive, symbolic and poetic visual language can convey to us an idea of the feelings in former times when societies needed symbolic communication to deal with their fears and dreams.

Ritualisation

"Ritualisation is now frequently the preferred term particularly for studies focusing on ritual in technologically advanced societies."[52]

We will analyse the basic principles of ritualisation in the following subchapter. This is necessary to understand the performative dimension in the staging of the seasonal sales better. We will see that ritual theory provides fundamental insights into the

49 Karmasin (1998:290)*.
50 Example taken from Karmasin (1998:398-303). This commercial is presented like a storyboard with text, which normally serves as the basis for deciding whether it will be produced or not.
51 Douglas (2000:7).
52 Bell (1992:89).

complex dramatisation strategy of the seasonal sale window. The intuitive images, which will be described later, relate to ritualisation and play a vital role in it. Ronald L. Grimes edited a reader on ritual studies in 1982, which was a compendium of knowledge from various disciplines.[53] Marketing literature, for example, merely switched the terms, replacing ritual studies with trend research. It has explained the trend as ritual and projected properties assigned to rituals onto the phenomenon of the trend.[54] It has been argued that trends are the rituals of our civilisation based on the observation that cult, ritual and fetish emerge as fundamental to our social life.[55] Arguments claiming that trends are symbolically condensed, dramatised, definitive, and collective instead of individual inventions help in lending the term "trend" a more meaningful and deeply rooted connotation to better understand the way trends work. The same holds true of several other debates on everyday behaviour that desire to assert greater importance by using the term 'ritual' in the wrong context. However, there can only be an interdisciplinary approach to the ritual as a phenomenon.[56]

"In a very preliminary sense, ritualisation is a way of acting that is designed and orchestrated to distinguish and privilege what is being done in comparison to other, usually more quotidian, activities. As such, ritualisation is a matter of various culturally specific strategies for setting some activities off from others, for creating and privileging a quantitative distinction between the "sacred" and the "profane", and for ascribing such distinctions to realities thought to transcend the power of human actors."[57]

Rituals separate the profane from the sacred. Sacred does not mean religious, but as apart of the everyday. We now return to the seasonal sale, a period different to the one preceding or following it. During the sales period, merchandise is neither offered at its normal price nor is presented in its usual everyday dramatisation of beauty. The materialisation differs significantly in its aesthetic appearance as the ugly. Can this be the first sign indicating the ritual nature of the seasonal sales? Several categories have been extracted from the observation of ritual

[53] See also Grimes (1996) with a comprehensive collection of influential contributions to ritual studies from religious studies to marketing.
[54] Bolz/Bosshart (1995:47).
[55] Ibid., p. 50.
[56] Belliger/Krieger (1998:8).
[57] Bell (1992:74).

actions. Catherine Bell pointed out that these are not universal features, but rather help in differentiating and privileging particular activities.[58] Firstly, there are codes of communication which can be summarised as the formalities of movement and speech. The second feature is the involvement of distinct and specialised personnel. The third one is the periodical occurrence of ritualisation. The orchestration of activities is the fourth feature, which deals with the interaction of individuals. Some features, however, require materialisation in the form of space and objects. Ritualisation takes place in structured space, which usually entails restricted access. This necessitates preparations in both the physical and mental states. Ultimately, objects, texts or dresses used only in the ritualised context are brought into play. Axel Michaels has contributed a set of five categories to the contest between ritual theories. Only when all of them become certifiable does he speak of a ritual.[59] The first category is a causal transition. The second is the need for a formally articulated intention followed by the need for formal criteria of enactment, such as formality, publicity and finality. Fourthly, rituals are constituted through the subjective impression, transcendent (or what he calls "religio" here) experience and the creation of ritual fellowship. The last criterion is the change of identity, status, competence and role within society.[60] There are some correspondences in the argumentations, formal practice being among those shared by many others. The formality of movement and speech is a widely shared indicator for the classification of rituals. It results from the consensual interplay between two or more persons that is repeated in recurrent contexts, creating adaptive value for those who are involved.[61] Ritual practice is a kind of behaviour that is clearly separable from that of the everyday. Human beings have the ability to distinguish between and act of movement and action when the person adds intention to the movement.[62] Ritual is recognisable as well, but there is no personal intention in its enactment:

| "Action is ritualized if the acts of which it is composed are

58 Bell (1992:204-5).
59 Michaels (2001) is convinced about the existence of the autonomous ritual action, while Bell (1992) only acknowledges ritualised actions. Such divergent viewpoints lead to a different use of terms (ritual/ritualisation) and, in the case of Michaels, an emphasis on a "transcendental" purpose of the ritual, which can be either religious or sacral. We do not favour either of the two, but agree with Michaels that it does not make sense to call every routine action a ritual (like brushing teeth). See Michaels (2001:29).
60 Michaels (2001:29).
61 See Bell (1997:32) on this neo-functional approach, which is related to ritualisation also found in the social lives of animals.
62 Weber (1978:4). "Actions" are personally motivated, "social action" is motivated by the social relevance of the action.

constituted not by the intentions which the actor has in performing them, but by prior stipulation. We thus have a class of acts in which the intentions which normally serve to identify acts, that is to say, intentions in action, are discounted."[63]

Normally this can be directly applied to the interaction between people, but we will have to further develop this point in the case of the seasonal sale. The reason for this is that the show window, which is our primary subject, does not allow any direct interaction between the sales persons and the customers. Usually, the fashion show window has mannequins, which mediate between what has been selected by the shop and the passer-by. It is a kind of one-way communication with the passers-by, showing them the latest trend according to the personal taste of the window dresser. As we know, there are no limits today to being creative in the show window. Window dressing today is discussed as a kind of applied art.[64] We have already mentioned that the show window is different during the sales, but nothing within the shop indicates that the sales people interact differently during the sales. Nor is there any indication of the fact that the act of selecting items and buying them is significantly different during the sales period, although this is an important criterion in literature dealing with the ritual. Because of the reduction in prices, there are many, but by no means all, for whom the seasonal sale is a major factor in their general shopping strategy.[65] What then makes us conclude that the seasonal sale could be a kind of ritual although the interaction among the people is the same as usual? And how can categories applied to discuss human interaction be applied to this phenomenon as well, even though the direct interaction between salespeople and customers is still the same as during the year? Salespeople do not use a specific language or move in a special way. Customers come in and select an item, try it on, buy it, and leave. Nothing special. There are times when they argue because they cannot find their size or preferred colour, but they are used to it anyway. This is normal during the sales and customers are prepared for it. The last quoted argument concerns the intention of the persons involved. They do not act out of conviction, but in a given and predetermined way. In the case

63 Humphrey/Laidlaw (1994:97).
64 We are quoting a widespread belief here, without going into the problematic term "applied art".
65 Miller (1998a:55).

of the show window, the interaction takes place between the window dresser, as the person responsible for the materialisation of the seasonal sale animation, and the passer-by, who is the recipient of the message transmitted through the medium of the decorated window. This one-way communication is no hindrance in relating our case to ritual constructions in general. Maybe the attitudes of the shoppers change as well, and this would be an important argument for the indication of a ritual construction in studies more focused on the human interaction than on the aspect of materialisation.[66] If we transfer the argument of not doing what each of us would like to do to the design of the seasonal sale window, it would prompt the window designer to follow an aesthetic plan that is not in keeping with his individual ideas. The window dresser would no longer express his individual ideas but would merely pretend to design. We will take this argument as a hypothesis and make a note of it for our discussion. If we speak of the seasonal sale as a ritual, we will find that it does not provide any instructions for acting that are not motivated by the actors themselves. Ritual attitude accepts that we are not ourselves the authors of what we are doing,[67] a strange perspective of the creative people involved in the process of merchandising.[68] Another widely shared argument is that rituals have a transitional function.[69] This criterion also marks out the ceremony, which has some formal criteria in common with the ritual. While rituals transform, ceremonies have the function to indicate.[70] The fashion year is basically divided into two seasons. In terms of time, the seasonal sale is a transition between the seasons when shops stop selling the past fashion and want to get rid of their stock and the arrival of the new collection. As the event takes place at the same time every year, traditional ritual studies could call it a calendar rite.[71] Consumer culture has constructed a method of structuring time in a society less and less orientated to nature but to the consumption of consumer goods. It is no longer nature that structures our year, but the nature of the production of fashion items. Roland Barthes argued that when we look at special categories of fashion items we can see that they transform from one season to the next:

66 Humphrey/Laidlaw (1994:97) emphasise the importance of the ritual attitude of the persons involved in rituals.
67 Humphrey/Laidlaw (1994:98).
68 Especially in a creative world full of star authors.
69 Wiedenmann (1991:14).
70 Turner (1982:80).
71 Calendar rites have the important social function of structuring time, whereby they also stablise our perception of time. It is not our aim to categorise our case study in this way.

"There is, however, one point in the general system of fashion where the structure is penetrated by 'doing' which remains included in it (therein lies its importance); this point is what Fashion calls the transformation (the summer dustcoat which will become the autumn raincoat); a rather modest notion, but one to which we will attach an exemplary value insofar as it represents a certain solution to the conflict which constantly sets the order of transitive behaviour in opposition to that of signs."[72]

Transformation is described here as immanent to the structure of designing garments. We will not discuss this micro-level although, in the context of the show window, it could contain evidence for a larger scale materialisation of this argument.[73] Albert Bergesen provides a hierarchical model of ritual construction. According to him, we find on the smallest scale rituals that are based on language, rituals he calls micro-rites. The second level of rites is related to social interaction. These are rites with functions related to social roles and status. The largest among these are the macro-rites, which can be compared to formal ceremonies. Independent occasions are often the content of such rituals, occasions that can also be related to smaller social systems.[74] The smallest rite in this hierarchy is based on language. Also Barthes bases his analysis on the language of fashion. If we assume a connection between what Barthes found out by analysing the structure of fashion's language and the rules on which rites based on lingual patterns are constructed, we have the micro level of our seasonal sale ritual. According to Bergesen, there are deep relations between the different scales of rites:

"The Ritual Order is a hierarchical order. It is more than just separate kinds of ritual, for the three types of ritual nest within each other like smaller to larger kitchen pots. The Ritual Order, like any social order, has a structural integrity that is not visible unless all the rites are viewed in the interconnected totality."[75]

If we accept this, we can assume that the lingual level of transforming garments from one season to another on the basis

72 Barthes (2000:291).
73 The fashion item itself is not the subject of this analysis.
74 Bergesen (1999:163).
75 Bergesen (1999:182).

of regular "ritualisation" in the fashion magazines can be struc-
turally linked to larger-scale rituals as well. We will define the
shopping streets during the sales period as such a dramatisation
of a macro-ritual. The motif of transition, described by Barthes
as the inner structure of the fashion system, can be thus argued
as a motif of the macro ritual. In this sense, we fulfil the argu-
ment of transformation as an important category of rituals.
In the micro-rite, each item is transformed into the new trend
by describing its new features by means of language. In the
bigger, more abstract, macro-rite of the show window, the whole
collection of the previous season is in the process of being
transformed into the new collection. This transformation is inde-
pendent of the current trend and the individual characteristics of
each garment. Another aspect of the ritual hierarchy is the social
effect of the rites in relation to scale. While micro-rites have a
small audience, the audience of the macro rituals is large. This is
also true of the transition of fashion from one season to another.
Indeed, fashion magazines address fewer people with the lingual
transformation of the fashion items than the seasonal sale
windows do on the scale of the city.[76] Regardless of whether the
fashion victims or the people are totally disinterested in fashion
trends, the change of fashion is obvious for everyone. Rites that
fulfil the purpose of transformation have been called rites of
passage. These rites of passage transform one state into another,
in our case, one seasonal collection into the next. Arnold van
Gennep pointed out the original importance of such passages:

> "Because of the importance of these transitions, I think it
> legitimate to single out rites of passage as a special category,
> which under further analysis may be subdivided into rites of
> separation, transition rites, and rites of incorporation. These
> three sub-categories are not developed to the same extent by
> all peoples or in every ceremonial pattern."[77]

It is thus quite possible that these three stages could be
found in the show window as well if the seasonal sale were to
follow the structure of a rite of passage. Van Gennep pointed
out that such rites of passage are documented in relation to
the change of the seasons as well. The death of winter and the

[76] According to the statistics of the Viennese Chamber of Commerce, Department of City Planning (December 2002), about
35.000 people pass the windows in Vienna's shopping street Mariahilfer Straße on a normal weekday.
[77] Gennep (1960:10-11).

rebirth of spring are examples of such rites of passage.[78] These rites have been very important in agrarian societies, which depend on the rebirth of vegetation in spring. The physical inevitabilities have thus been transformed into cultural regularities.[79] The people whose lives were dependent on the rebirth of vegetation have handled their fear successfully by enacting the rites of passage every year. Has the fashion industry in our consumer culture taken on the function of performing the seasonal rites of passage? In our example of the show windows, we have already described the immanent potential of a crisis, which is caused when the past collection is declared as no longer fashionable through the inauguration of the new collection and the dramatic change of value caused by the drop in price from one day to the next. Ritualised action has often been used to deal with crisis.[80] We could assume that the dramatisation of the ritual of the sale prepares the path for dealing with this crisis. After the sales, the rites of passage stablise the new reality of what is new and what is old and outdated. The ancient fear of the periodical return of vegetation with renewed strenth has been replaced by the fear of the periodical return of the new fashion trend in our consumer society.[81] The way rituals communicate is essentially symbolic in nature. Umberto Eco described humans as symbolic beings and rituals as symbolic forms.[82] In ritual theory, we can find numerous definitions that refer to the symbolic nature of rituals:

"Rituals are the active forms of symbols. Although these are social actions, they are oriented to others, or beyond that even aimed at these: oriented to others that basically cannot be immediately experienced and belong to a different area of reality than the one inhabited by the everyday, by the agent."[83]

This means that a world outside our everyday world exists. Symbolic communication is directed into this other world, but it is not a communication between different realities. Both worlds unite during ritual practice. Clifford Geertz argued that during a ritual the world we live in and the world we imagine are one

78 Ibid., p. 172.
79 Bell (1997:94).
80 Turner (1982:92).
81 This does not mean that the trend is a ritual. This only means that there is the need for a ritual in dealing with the seasonal change of fashion trends.
82 Eco (1977:108).
83 Luckmann (1999:12)*.

and the same, melted into one system of symbolic forms.[84] If the seasonal sale window is such a symbolic system, then the imagined world of a regular change of fashion becomes, by symbolic means, part of our everyday reality at that point of time. Economic needs in our consumer culture become social reality by means of symbolic communication through secular rituals. An important aspect of such symbolic communication is the performative dimension.

> "[...] symbolic forms of expression simultaneously make as-
> sumptions about the way things really are, create the sense
> of reality, and act upon the real world as it is culturally
> experienced. The performative dimension of ritual action has
> become a central idea in most current theories of ritual."[85]

Performances are actions, and performance studies take these actions as their object of study.[86] The term performance, which was in the beginning a technical term in the theory of speech acts, has transformed into an umbrella term for cultural studies and the research of phenomenological conditions of embodiment.[87] Heuristic and contingent use of the term ritual has been criticised and rejected in the field of anthropology.[88] The seasonal sale window may not be appropriate for an exemplary discussion about these varying points of view. However, perfor- mative aspects restricted to the decoration of the window and the mannequins inside it are a special case and must be dealt with separately. For the time being incapable of moving, man- nequins are forced to represent the symbolic messages without movement.[89] The gestures of these mannequins can only be altered by changing their position within the show window. Most often, the figure's technical construction prevents its posture from being changed so that it usually remains fixed in one posture. The possibilities of changing the angle of the head, the arms and the orientation of the torso are thus limited. The performative aspect of the scenario can only be imagined and the physical representation can be interpreted as a frozen performance, like a photo of a ritual. But the symbolic aspect of the window

84 Geertz (1973:112).
85 Bell (1997:51).
86 Schechner (2003:1).
87 Wirth (2002:10).
88 Hughes-Freeland (1998:1).
89 Maybe this will change in the future. All we can do is wait and see how these sales robots will be programmed in a symbolic manner.

display can also be expressed very effectively without any real movement of the bodies because we are used to interpreting the symbolic meaning of the dressed body. Bell defined the dressed body as being one among the many possible features of ritualisation.[90] We will therefore take a look at the dress code in the seasonal sale window in order to find out what kind of symbolic communication is used to separate the dramatisation of the rite of passage from the everyday representation of up-to-date fashion items. This takes us to the orchestration of activities, which is yet another feature of ritualisation. As no law stipulates when the seasonal sale may start, the shops take their own decisions about the beginning and the end of the sales animation. We discovered that such orchestrations of sales animation can be found within a single shopping street in the observed cities. While some shops start their animations sooner than others, there are shops that stop the sales and introduce the new collection sooner than others, all of them usually dedicate their merchandising activities to the seasonal sale. This orchestration of activities, which, in another context, may be projected onto people taking part in a ritualised action, can be applied here to the orchestrated decoration of fashion shops. The orchestration of merchandising produces strong visual impressions, an orchestration that can also be studied in major consumer culture rituals like Father's Day, Mother's Day, Valentine's Day and Christmas. All of them employ strategies of symbolic communication. Especially Christmas has a strong impact on the appearance of the show windows. While during the year shops are decorated in a way that makes them look different from their neighbours, decorations during the big events seem more similar and orchestrated. In order to stage the Christmas animation, window dressers may not use their own specific theme. As discussed earlier, ritual activities do not allow individual expression. The orchestration of activities finds its visual equivalent in the dramatisation of ritualised shopping in the show window by using commonly shared signs. The Christmas tree, the use of decoration elements, snow scenes, the display of presents, are all examples of commonly shared associations with Christmas. Window dressers will not succeed in inventing an own and individual symbolism for a collective event; only the interpretation of signs can be individual and used in an artistic manner. Structured space may thus be an

90 Bell (1992:204).

interesting aspect for our investigation. It has been observed that during the sales the shop's layout is often changed temporarily to stage the off-sale items in a striking manner inside the store. But the most significant change is to the entrance to the shop, which is usually defined by the show window and can be interpreted as a kind of symbolic door. Arnold van Gennep argues that the architectural situation and especially doors are perceived as strong symbolic elements in passage rites. Doors symbolise transition, and rites of passage use doors to make changes visible.[91] Making things visible is an important function of rituals, which is why the materialisation of rituals plays an important role in making things visible as well as in making social changes traceable on the level of emotion and intuition. Materialisation strategies use such intuitive images like the door for this level of communication. When an initiate walks in through a door during the ritual dramatisation, the ritual audience can emotionally follow the change of social state. Although we go through doors everyday, the door assumes a symbolic function because of ritualisation. Decorating structured space is also a widespread practice because decoration indicates that a space is ritualised. The decoration privileges a space in relation to others and at times even restricts access. All this can happen, but does not necessarily have to happen. Bell explains it as follows:

"At best, ritualisation can be defined only as a 'way of acting' that makes distinctions like the foregoing ones by means of culturally and situationally relevant categories and nuances. When such culturally specific strategies are generalized into a universal phenomenon, much of the logic by which these ritual strategies do what they do is lost."[92]

For our analysis, this means that we should not to try to apply categories "blindly", but be aware of the nuances that separate the ritualised show window from the everyday and develop a discourse that emerges from a precise study of the phenomenon. Certain culturally specific strategies do what they do only because of the context, and we will not try to universalise them. But if we follow Roland Barthes' hypothesis, we would have to see whether the same universal phenomenon can be found in the advent of the new fashion collection and the

91 Gennep (1960:192).
92 Bell (1992:205).

Dionysian rite of the ancient Greeks. Rituals have been performed in magic societies, in religious societies and in our contemporary consumer culture as well. Ludwig Wittgenstein argued that the ritual cannot be disproved by the progress of science and since rituals do not express notions, they cannot be disproved by new scientific findings.[93] It seems that rituals have developed resistant antibodies in our contemporary consumer culture. Even the mystic would resist Wittgenstein's analytical philosophy.[94] Is it possible today to find anything that was performed under different cultural conditions in the past? According to Bell, the function of rituals is strongly linked to their cultural context. Seen in this light, if we assume a "return" of the Dionysus rite what would it look like under the changed cultural conditions and without the attached myth of the Greek god? Since the beginning of the twentieth century, dramatisations of the new seasonal collection in various media, like fashion magazines and show windows, can be taken for granted as a phenomenon of bigger cities.[95] Is the ritualisation of the fashion system a new invention or is it, as Barthes argues, a dramatisation, which has to be seen in relation to ancient rites of spring?

"The tendency to think of rituals as essentially unchanging has gone hand in hand with the equally common assumption that effective rituals can not be invented. Until very recently, most people's commonsense notion of ritual meant that someone could not simply dream up a rite that would work the way traditional ritual has worked."[96]

Both options are possible. Due to the dramatisation of the new seasonal collection, we can now encounter an old rite that has changed over the course of time and according to new cultural conditions, or we can encounter a newly invented rite of consumer culture. As we have illustrated above, the invention of consumer rites has also led to the successful invention of a lot of new rites. But all of them bear a strong link to the social dimension, to the family, to mother and father. Communist societies are a good example for the invention of several new socialist life-cycle rites, which are all attached to family life.

[93] Macho (2004:14).
[94] Wittgenstein (1963:115).
[95] Many magazines from beginning of the twentieth century show the presentation of garments. We are not speaking here of the phenomenon of the seasonal sale window and it is not the target of our analysis to delineate the historic developments of the phenomenon.
[96] Bell (1997:223).

Socialist institutions replaced the ritual service of the church with newly invented rites for births and weddings.[97] But the arrival of the new fashion collection is not an appropriate comparison in this context because its rites provide no link to such core necessities as the strengthening of family ties. The lack of knowledge about the ritual's origins has been discussed in ritual studies as well. Barbara Myerhoff argues that the invisibility of the ritual's origins and its inventors is intrinsic to ritual per se.[98] People do not want to acknowledge rituals as human inventions but rather see them as reflecting the underlying und unchanging nature of the world.[99] It appears that we do not want to know where our practices originated, for example, where celebrating Father's Day, Mother's Day, Valentine's Day or our celebration of new fashion collections come from. We perform rituals to make our social conditions stable; asking stupid questions is a violation of this system. The performance of rituals on a regular basis is an important aspect of the nature of rituals. This recurrent performance becomes self-explanatory. The effect, for example, of structuring the flux of time by calendar rites creates a sense of safety. The fashion year is one such system, bringing security into the life of the consumer society.

Fashion Cycle

The production of garments is linked to the seasons of nature. The change in seasons provide us with a natural explanation for the transition of special categories of clothing, which are adapted according to the weather conditions. Warmer or lighter fabrics are used for creating such garments. Even our language refers to the seasons, as we do not simply call a given piece of garment a jacket but mostly add the season for which the jacket has been designed. We say, for example, that we will

[97] Ibid., p. 228.
[98] Ibid., p. 224.
[99] Bell (1997:224).

wear our "winter jacket" instead of our "summer jacket" when the weather conditions change. The need to wear warmer or cooler garments is thus a good reason for linking the fashion year to the natural seasons. This natural order can also be reflected in that of our wardrobes at home. During the cold season, all the pieces for summer have a place in the rear. This order is then changed when the seasons change. As in former times, we still have a representation of nature as an ordering structure in our homes, although behind closed doors. Maybe this is a hidden ritual in our consumer society according to which we also restructure the order of garments in our wardrobe in spring and autumn. This is when we become aware of the seasons and begin to mentally prepare ourselves for the warm or the cold time of the year.[100] The awakening of nature in spring, summer, and its change in autumn and winter are natural references for the dramatisation of fashion collections. This why we pointed out that the fashion industry has a natural reference for creating collections according to the seasons. What is not clear for the moment is why garments become outdated, and why we face new fashions two times a year. Why do several consumer groups feel the need to discard the previous season's designs? What creates the social pressure to buy new clothes even though the old ones could still be used? What forces fashion shops to get rid of their stock of the past collection as fast as they can, and by any means? According to Thorstein Veblen, the reasons for it are manifold. In his *Theory of the Leisure Class*, Veblen argued that the change of fashion is motivated by the upper class's desire to display its social status through demonstrative wastefulness, a wastefulness that creates prestige. Fashion, in this context, is a good medium for such efforts. Another way to show wastefulness is the creation of new fashion trends.

"Having so explained the phenomenon of shifting fashions, the next thing is to make the explanation tally with everyday facts. Among these everyday facts is the well-known liking which all men have of the styles that are in vogue at any given time. A new style comes into vogue and remains in favour for a season, and, at least so long as it is a novelty, people generally find the style very attractive. The prevailing fashion is felt to be

[100] We are speaking from the middle European point of view, but fashion collections are introduced in the same way even in places such as Hong Kong where the seasons do not vary much. The show windows present pullovers and winter coats for the winter collection despite the hot weather conditions.

beautiful. This is partly due to the relief it affords in being different from what went before it, partly to its being reputable. "[101]

Although the above text was written at the end of the nineteenth century, there is still a lot of truth in it about our contemporary situation. Prestige is still an important motivation for the fashion cycle. Garments and furniture are, according to Veblen, categories of consumer goods in which the beautiful and the precious combine at their best. Prestige decides what forms, colours, and garments find approval at a certain time.[102] This may have been true of the times when the above words were written, but today we will have to take into account the balance between production and consumption, and the balance of power in claiming the necessities for a new trend and at least the approval of it. Veblen also pointed out the importance of novelty in showing prestige. For Boris Groys, novelty is an important force in the economy of our culture today:

"The new usually appears in history as fashion. Fashion must generally let itself be judged more radically rather than merely strive for the new. A new and widespread form of this judgement is the more often heard, contemptuous remark, 'Oh, this is just a new trend'. This means that the corresponding cultural phenomenon has no historical consistency, it is transient by nature and will soon be replaced by a new trend."[103]

Georg Simmel takes yet another approach, focusing instead on the conspicuous consumption of novelties and on the dynamics of class imitation. Class imitation is an internal mechanism of the fashion system:

"The vital conditions of fashion as a universal phenomenon in the history of our race are circumscribed by these conceptions. Fashion is the imitation of a given example and satisfies the demand for social adaptation; it leads the individual upon the road which all travel, it furnishes a general condition, which resolves the conduct of every individual into a mere example. At the same time it satisfies in less degree the need of differentiation, the tendency toward dissimilarity, the desire

101 Veblen (1934:177).
102 Veblen (1934:131).
103 Groys (1992:45)*.

for change and contrast, on the one hand by a constant change of contents, which gives to the fashion of today an individual example as opposed to that of yesterday and of tomorrow, on the other hand because fashions differ for different classes – the fashions of the upper stratum of society are never identical to those of the lower; in fact they are abandoned by the former as soon as the latter prepares to appropriate them. Thus fashion represents nothing more than one of the many forms of life by the aid of which we seek to combine in uniform spheres of activity the tendency towards social equalisation with the desire for individual differentiation and change."[104]

Marketing uses this class imitation model even today, but a more differentiated articulation of it. The classes today have been turned into consumer target groups: the upper class elite, the middle class and the lower class have been replaced according to the diffusion model by innovators, early adopters, early majority, late majority and laggards.[105] The trickle down theory has been revised since because with time it became clear that fashion not born in haute couture houses but influenced by street culture also had an impact:

"On the basis of these and other developments it seems perfectly reasonable to conclude that what we have now are multiple fashion systems in which fashion moves up, down and along from a variety of starting positions and in several directions, rather than a single system in which fashion only moves in one direction, "trickling down" from the elite to the majority. If this is so, we should be looking for new fashions in the street, from students in colleges of fashion, from "pop" designers, among ethnic minorities and so on, and not simply – or perhaps not at all – in haute couture."[106]

Of course, there is influence from the street today, but in comparison to the couture houses, the street has no strong economic backing for its contribution to culture. And the internal mechanism would not change the fashion trends year after year. Stanley Lieberson did an empirical study on first names in the United States.[107] The cycles in which names come into fashion

104 Simmel (1971:296-297).
105 Rogers (1976).
106 Du Gay (1997:145).
107 Lieberson (2000).

and vanish are longer than those in the fashion business, although the shifts in fashion are becoming more modest from year to year.[108] This leads to the assumption that there must be external factors, which, for example, do not exist in the non-commercialised context of first names.[109] External factors for it are:

"[...] the role of organisations on fashion; the impact of social, political, and economic changes; the influence of mass media and popular culture; the symbolic nature of fashion; the linkages of fashion to the stratification system; the different domains of fashion; imitation; long-term patterns change; and the role of such specific sources of fashion as France, California, Milan, New York, and London."[110]

And of course, we will not forget the role of the show window as an important communication medium in the dramatisation of the new fashion and in the change of fashion during the sales period. It is surprising that we have up to now found no evidence for how the transition from one fashion to another really works. Is it a rupture, or is there a kind of passage rite? Maybe it is a rupture because, as Roland Barthes claims, fashion magazines do not speak about the past trend, about the unfashionable.[111] It is a kind of taboo in our consumer culture, or as Emile Durkheim put it: a negative rite.[112] Negative rites do not prescribe actions, but impose restrictions on several actions (as in our case on the discussions about the unfashionable), the only exception being the seasonal sale window. It has to speak about the past collection, because it needs to sell it in order to get rid of the stock. It has to stage the things that are out of fashion; going by the date, they seem to be worth fifty percent less than they were the other day. Here, the retailers are an external force, and they crucially influence the production of the fashion cycle. Paul du Gay argues that the fashion retailers and the buyers for the store who act on their behalf play a more significant role than manufacturers, designers and the fashion public itself:

108 Lieberson (2000:93).
109 There are a lot of products on the market with human first names. Because of competition, bigger companies tend to register the names under specific product categories according to patent laws. Industry will gradually get rid of names that can be used for products. This is an interesting dynamic, where first names get commercialised and the right to use them is restricted to patent holders.
110 Lieberson (2000:20).
111 Barthes (1990:179).
112 Durkheim (1971:299).

"Many of the changes in the nature of and terrain of fashion can, nevertheless, be grasped by examining the power of leading clothing retailers and, in particular, the relationship that they have with fabric producers and garment manufacturers and their involvement with production and design issues."[113]

Thus, the retailer and the point of sale play an important role in determining the nature of fashion. But our investigation is more about the symbolic nature of the retailer's power within the fashion cycle, as we will not focus on economic or social science issues.

Ritual Mastery

Beside their main purpose to sell things, stores can fulfil symbolic social functions as well.[114] This insight does not come from sociology or social anthropology, but from marketing. It is especially important to mention that the function of brands is to gather group members. Rituals, too, have the function of stabilising groups. This makes the institution of the store a good place to perform rituals since it is a space for a special group with which it shares similarities, and therefore excludes others. Marketing literature calls the materialisation of the store – what we can see, experience, touch and smell – "retail branding".[115] The design of the stores has developed over many years and is a special discipline today that is far beyond what has long been called the shop-fitting business. The first impression we get of a retail brand is the storefront and the show windows as well as the logo with the retailer's name on it. The importance of show windows was recognised at the beginning of the twentieth century itself, when magazines in different countries started publishing for window dressers. The following quote is taken

113 Du Gay (1997:149).
114 Tongeren (2003:23).
115 Tongeren (2003:44).

from an article that emphasises the importance of changing the tiny show windows that were at the time common in Europe and take the example of developments in America to build huge storefronts:

"Americans have long been aware that light not only attracts moths but also humans. Regardless of whether [such] an American firm has jewellery or shoes on sale, its first priority is that the shop must look sleek and pompous."[116]

The reason for this counsel from the genesis of marketing studies was that an impressive appearance would attract customers passing by more effectively. The power of the show window has been a major concern from the beginning of the times when mass-produced items comprised the chief category of goods and the show window became the most important marketing instrument. It is, therefore, not surprising that the performative power of the show window has continually been the subject of critical discourse in the twentieth century. Design has become a powerful marketing tool, and this has led to protest. At the time when Roland Barthes conducted his studies on the fashion system, Vance Packard criticised marketing methods for using psychological and sociological findings to manipulate mass consumption.[117] He also attacked the inventions of consumer culture for creating rites of consumption as well as their dramatisation prompted by the new research field of motivational research. Packard called manipulators of symbols motivational researchers who had become experts in the symbolic communication with the consumer:

"The persuaders, by 1957, were also learning to improve their skill in conditioning the public to go on unrestrained buying splurges when such images as Mother and Father were held up. Mother was still the better image in relation to sales. Mother's Day was grossing $100,000,000 in sales, while Father's Day was grossing only $68,000,000."[118]

Show windows are an important advertising medium and, for small retailers, the only way of advertising in public

116 Austerlitz (1903:25)*.
117 Packard (1968).
118 Packard (1968:144). See also Boesch et.al. (2001) on the history of Mother's Day.

space. As consumer culture took the responsibility for a couple of functions of the social dimension, feasts and the dramatisation of the change of seasons became the responsibility of the stores in the cities. The basic human need to celebrate has been replaced by ritualised shopping, and window dressers did their share in making the feasts pleasant and appropriate. Consumer feasts are a big issue in all magazines for window dressing.[119] People need systems of orientation to feel stable. The reliability of such systems is important and rites of passage linked to the change of seasons have fulfilled such a function for a long time. In consumer society, we are dependent on the reliability of the stores whose function it is to dramatise the seasonal change of garments: It is summer when the store window says it is summer and winter when they say it is, even if it is not cold yet. Since this works quite well, we must first have proof for the power of the store window. The dramatisation only follows interests related to the production of fashion or when the link to the cosmos of nature has been weakened.[120] While Mary Douglas and Baron Isherwood scrupulously examine why people want goods[121], marketing literature ascribes this desire to the fact that merchandising is capable of "pure magic".[122] It is good to know that show windows are the laboratories for methods to bewitch the consumer. Marketing literature has even created a field of rules for decorating show windows. There is literature on show windows that asks whether beauty is calculable.[123] But rules sometimes go up in smoke, especially on luminous occasions. Our homes are a field of rules in which each thing has its place and is subject to handling regulations. But during Christmas, for example, rules are broken and things are shifted around to create a befitting place for the Christmas tree.[124] The magical rules for creating beauty go unheeded during the year, with the exception of the seasonal sale window. Is this a special form of magic? Is it something secret, known only to a few magicians?[125]

"Ritual mastery is the ability – not equally shared, desired or recognised – to (1) take and remake schemes from the shared

[119] Osterwold (1974:8).
[120] Today, the spring collection is inaugurated at the end of January, but it is usually still quite cold in the weeks thereafter. Spring does not begin when it is supposed to, but when the fashion industry likes to have it. This could well be during winter.
[121] Douglas/Isherwood (2002:3).
[122] Underhill (1999:200).
[123] Halbhuber (1994:38).
[124] Wood/Beck (1994:227).
[125] Magicians also work with symbols.

culture that can strategically nuance, privilege, or transform, (2) deploy them in the formulation of a privileged ritual experience, which in turn (3) impresses them in a new form upon agents able to deploy them in a variety of circumstances beyond the circumference of the rite itself."[126]

The blueprint for constructing ritual power cited above was created by Catherine Bell. We will try to apply this scheme to our consumer culture and to the seasonal sale's rite of passage. We could assume that the agents are the stores with the power to communicate the rite on their own. Although we have spoken about the enormous power of the stores and its buyers, we will also assume that the power comes from the fashion system. The stores thus have ritual power and we can be sure that they also use it, but to what purpose? Primitive agrarian societies anxiously awaited the return of vegetation in spring. Consumer societies, in contrast, worry about the periodical advent of the new trend. Like our ancestors we, too, create rites in order to exert control over nature. Rituals create power; they do not give form to power. Knowing this, we are aware of the power of the symbolic communication of rituals. Retailers are the agents of ritual mastery and the window dresser is their priest. But this seems to be a long-known fact. The window dresser has been described as the master of persuasion, especially during spring-time when flora reawakens:

"The season for the shopping mood is spring. When Nature re-news itself, the seeds of desire begin to germinate in human beings as well. The decorator's task is to give voice to such desires, to promote the growth of these seeds. He can do it, and he has the power to do it. He can do it through word, through colour, through image and finally, through the goods."[127]

The window dresser has the power and words, the colours and the images and his instruments are the material goods. Ancient shamans had no other materials and yet fulfilled their social responsibilities. And rituals are practices, which use materialisations. Although the symbolic effort is immense, rituals take the help of props.[128] Vilém Flusser described the different forms

126 Bell (1992:116).
127 Spectator (1929:3)*.
128 Macho (2004:16).

in which a bough can exist. One of these forms of existence becomes apparent when we transform a bough we have found or broken off a tree in the forest into a walking stick.[129] Thus, it can be used as a technical aid for going uphill in the forest. Elias Canetti's reflections on the broken bough do not address the mediation between nature and culture, they are much rather about the construction of power. In the hand of the leader, the bough becomes a lethal weapon. The gesture of raising it is the command for the mass to attack. Things can thus be categorised into those that bring death, and those that are only functional.[130] Ritual knowledge is attained by practice and not by contemplation. The use of objects creates ritual knowledge:

"This occurs in and through the handling of those objects (masks, sceptres, chalice, etc.) in which the cosmos is concentrated and represented in the ritual action. Ritual knowledge, then, is not so much descriptive as it is prescriptive and ascriptive in character. It prescribes and ascribes action." [131]

It will be interesting to find out what things contribute towards the materialisation of the commodity cosmos during the sales, creating ritual knowledge through practice. The ritual knowledge experienced by the presence of material things prescribes the practice of the people. In performance studies, preparing the space is important for the effect and success of the performance. This not only means the arrangement of media, materials, bodies, but also includes a wide range of cultural techniques capable of making things visible, which would not have been recognisable without dramatisation. Thus, dramatisation is a precondition for performance. Performance requires that a scene be put into practice, whereby everything that happens in the scene becomes a performative act.[132] Window dressing has been often described as a kind of street theatre and window dressers as stage designers. Such arguments seek to conceal the real nature of the business and its central function in the dramatisation of consumer rites. Performance is different from theatre because it involves the audience. Performance creates reality and confronts the audience with it, while theatre represents reality to a passive audience. The reality and the stage of the theatre

129 Flusser (1993:63)
130 Canetti (1973:218).
131 Jennings (1996:328).
132 Kolesch/Lehmann (2002:363).

are separated by what Goffman has defined as "frame". What is said on the stage is not part of our reality. In his example of an actor who wanted to warn the audience of an outbreak of fire but failed to do so because his warning was enacted on the stage, the action was not part of the real, burning world. The show window is not a theatre stage. What is performed there shapes our reality in the consumer world and proclaims truth.

> "Rituals are not merely in the service of power; they are themselves powerful because, as actions, they live from their power of assertion. Whoever wishes to ritualise actions must also be prepared to implement them. He or she must ensure that the actions are implemented and recognised despite resistance or lack of understanding. Ritual knowledge is knowledge that has asserted itself." [133]

Successful ritual knowledge is the reason why consumer rites like Father's Day or Mother's Day live so long; it is not a penetration into our personal thoughts by means of motivational research, as Packard argued, [134] but merely the transfer of basic human needs from the social dimension into the responsibility of consumer culture.

The Sales Window

Today, the show window is a place where many disciplines come together. Several specialists are involved in designing the appearance of contemporary show windows. The common denominator in architecture, art, design, graphic, marketing and advertisement is that their contributions jointly create an aesthetic experience in the show window. Commercialised aesthetics has the task of fulfilling a commercial function

[133] Belliger/Krieger (1998:28-9)*.
[134] Packard (1968:216).

beyond its artistic expression. In the case of the show window, this means a dramatisation of goods with the purpose of drawing customers into the shop. Architecture had to sacrifice the entrance areas of the houses in major streets in favour of the demand for huge and impressive storefronts. The storefront on account of its special use, divided the façades of houses in the commercial zone from the street up to the first floor, while the rest of the building was in keeping with the intentions of the building's architect. Commercial interests of house owners also helped in rebuilding our shopping streets as we know them today. Only the entrance level of residential houses was transformed into storefronts.[135] The impact of a storefront depends to a high degree on the architectural solution of the store, its entrance and the show window, and only in a second stage is its impact dependent on the window's decoration. At the beginning of the twentieth century, the design of the newer and bigger show windows had a major competitive edge. Older and smaller stores had problems competing with them in a time when customer expectations were growing at the same speed as the new field of merchandising was developing its new ideas. The storefront was and is until today an important aspect of the store's advertising function because mass production made new ways of merchandising necessary. Designed to make space for the increasing quantity of mass-produced items, the department store emerged as a new architectural typology in the 1950s. Shop design became an important means of expressing the architectural trends of the time. When it was not possible to rebuild the entire house, refurbishing the stores sufficed to change the appearance of the shopping streets at eye level. In the early stages of the new discipline of window decorating the well-designed artistic show window also became a major concern, especially from a commercial point of view:

"It seems to me that this is where a new field for art could be, a field that can bear rich fruit when treated properly. There are still a few firms whose beautifully decorated show windows catch our eye, otherwise tastelessness glares at us from everywhere, presenting to us a very lowly image of this field of art."[136]

135 Austerlitz (1903:25)
136 Friedmann (1903:1)*.

Not just those in the commercial field discovered the virtues of the beautiful show window, even architects and designers showed interest in applying the latest trends in art to this new discipline. Painting, sculpture and architecture have always been the sources for "applied" arts – and this was the new term in discussions around a field of creativity that lay somewhere between everyday life and fine arts.[137] This marks the birth of the need for an adequate discourse in the field of design. Nikolaus Pevsner was one of the art critics who examined applied arts in the context of art movements.[138] This may have certainly been true of the pieces that were being analysed, but the rest of the mass-produced objects remained in the dark recesses of the banality of everyday life. The artistic aspect of the design business was an important way of attracting more customers. Aesthetic research was undertaken in order to find out how windows could be dressed properly. Since then books and magazines on window-dressing have disseminated new ideas and trends for a contemporary design. It is important to be aware of this aesthetic history because artistic discourse is still vehemently critical when speaking about show windows. Discussing show windows in relation to the influence from current art movements is perhaps a possibility, but we think this would be the wrong path in our present case. We are not concerned with Apollonic aesthetics, which has been amply discussed in a huge body of literature, for the starting point of our analysis is the aesthetics of the ugly, which we found during the seasonal sales. We have related it to the aesthetics of Dionysus in contradiction to the aesthetics of beauty represented by Apollo. However, we will search for a more substantial definition of Dionysian aesthetics, which is not guided by what we like and dislike at a particular time. As rituals are symbolic practices, we can assume that it is possible to provide evidence for this symbolic communication. When Roland Barthes analysed the fashion system, he was convinced that it was irrelevant what year he chose for it.[139] He did not want to describe the fashion of any particular year, but Fashion itself.[140] We, however, do not wish to merely describe the fashion window during the sales period, but the conditions determining how fashion changes symbolically inside it. Our

[137] Kiesler (1929:14).
[138] Pevsner (2002).
[139] Barthes (1990:11).
[140] Carter (2003:145) said in his critique that the fashion system is a complex system of social relations, which cannot be described by isolating just one dimension that is subsequently declared as the source and the essence of fashion.

hypothesis is that fashion employs a rite of passage to dramatise the change of fashion. A crisis is triggered by the periodical change and the ritual articulates this crisis by making it visible. Since rituals communicate on an emotional and intuitive level, our approach will be significantly different to that of Barthes. It will not be a 'mathematical'-semiotic discourse, neither will it be a discourse about fine arts, nor are the garments on display the focus of our research. We do not want to explore the change in garments from one season to the next, or from one fashion year to the next. We are interested in focussing on a phenomenon, which is never documented at all[141]. It seems to us that the sales are a sort of taboo, which is why we want to find out what kind of role the dramatisation of the seasonal sale plays in the context of the fashion cycle. The relation between mythology and ritual will not be discussed.[142] We will only remember to take Barthes' metaphorical reference to a kind of relationship between the ancient Greek myths of Dionysus and the arrival of the spring collection as the starting point for our discussion. This does not mean that we believe that a ritual belonging to ancient times is still being celebrated today. At the same time, it should be noted that we do not consider the notion that female customers behave in the same manner as women did during the Dionysian rites on the arrival of the new collection as productive enough to develop. The female followers of Dionysus in myth and ritual performed ecstatic rituals. They would run across mountains in bloodthirsty ecstasy, moving like birds of prey, handling fire and snakes, attacking men, tearing animals and children asunder.[143] But why have we taken the Dionysian rite as a starting point when the rest of the story does not seem to be developable? As Nietzsche pointed out, the Dionysian rite is a paradigm of aesthetic production beyond its historical manifestation. And the ugliness of contemporary show windows is our clue for such a bridge to the Dionysian phenomenon. Since we will not be paying much attention to historic mythology, we can focus entirely on the symbolic communication of the ritual. We need to search for an embodiment of the dying god in the seasonal sale window, for he does not exist there.

141 What we have found in literature about the seasonal sale is significantly little and does not contain any clues for the direction we have developed the study.
142 Lévi-Strauss (1977:232) reflects on several problems in the discourse about the relation between ritual and myth. A more current discussion in the field of ancient Greek studies can be found in Graf (1993:50-51).
143 Bremmer (1999:78).

Peter Weibel described the show window as the epistemology of the twentieth century.[144] If he is right, we stand a good chance of finding answers to our questions. The restriction to analyse only the seasonal sale window stems from the notion that this phenomenon stands in relation to a lot of other external mechanisms of the fashion system and that it is the most seductive expression of seasonal change. We felt that design follows some primitive but unwritten laws.[145] Most strikingly impressive was the equivalence in ugliness. Objects do not have fixed meanings, and the manipulations by the window dresser are capable of changing the meaning of some of the things. Things that are mere decoration during the year can become signs for fashion's rite of passage. Beyond their function to tell a little story about fashion and represent the actual idea of beauty, they can be used to enact the drama of the death of the old and the resurrection of the new fashion collection. The objects used in the show window are freed of their commercial value as consumable goods and play a role in a much more symbolic process which has a privilege over everyday consumption. We will not take the opportunity of studying this phenomenon with a practice-centred or practice-oriented approach; there are enough show windows out there that can be studied for our purpose. Since rituals are an aesthetic phenomenon, we will focus on the study of that specific aesthetics. Csikszentmihalyi and Robinson did a research on the aesthetic experience of works of art in which they reminded us that aesthetic experience is historically grounded and inseparable from ideologies and social values.

"It would be impossible for an Australian aborigine and a New York art critic to have similar reactions to an abstract painting by Jackson Pollock. The objective visual stimuli would be processed in entirely different ways by the two viewers."[146]

In the case of the Jackson Pollock painting, we are willing to accept this conclusion. But what if both the Australian aborigine and the New York art critic are in front of a seasonal sale window? We all possess a certain ritual knowledge; when we travel to foreign countries we intuitively see the difference in behaviour that is indicative of ritual performance, and so we

144 Weibel (1980:11).
145 Durkheim (1971) took the most primitive religion in order to develop his analysis of religion.
146 Csikszentmihalyi/Robinson (1990:17).

are immediately able to understand that a ritualised action is in progress even though we may not understand the purpose behind the enactment. In the case of our two subjects, this could mean an advantage for the "primitive". Because he was used to the materialisations of symbols, and we assume that he had first had the opportunity to take in the beauty of the shopping streets, it was possible for him to intuitively understand that a rite that is expressed in a special decoration of our shopping streets is being performed. And this although he has a different cultural reference system than the art critic. Sigmund Freud presented to us both the savage and the neurotic. He argued that there are some similarities in the fears and dreams of both.[147] Beside the idea of universal images and myths related to the psychology of human beings,[148] it must be noted that a lot of our ritual symbols make no sense to other cultures.[149] This is of particular importance when fulfilling the purpose of the ritual symbol in order to separate, for example, different cultures. Clifford Geertz's example of an ethnological case study where a young boy could not be buried because there was no authorised person to perform the funeral rites shows the fragility of ritual constructions. The official asked to conduct the funeral service was from another religion said, "But I do not know your rituals."[150] Ritual knowledge is a prerequisite for the success of ritual actions. Arnold van Gennep discovered a three-step structure in passage rituals. This system can be applied to a wide range of rituals in different cultures and times. According to Gennep, the first phase disengages from the old system, the second phase describes the process of transition and the third phase unites with the new system.[151] The second phase in which transformation takes place has been further analysed by Victor Turner, who coined the expression "betwixed and between" to describe the state of "anti-structure":

"As such, their ambiguous and indeterminate attributes are expressed by a rich variety of symbols in the many societies that ritualise social and cultural transitions. Thus, liminality is frequently likened to death, to being in the womb, to invisibility, to darkness, to bisexuality, to wilderness, and to an eclipse of the sun or moon. Liminal entities, such as neophytes

[147] Freud (1995).
[148] Jung (1992) and his theory of the archetypes. See also Lévi-Strauss (1977:208).
[149] Douglas (2000:40) mentioned as example the taboo of pork in Jewish culture.
[150] Geertz (1973:154).
[151] Gennep (1960:10-11).

in initiation or puberty rites, may be represented as possessing nothing. They may be disguised as monsters, wear only a strip of clothing, or even go naked, to demonstrate that as liminal beings they have no status, property, insignia, secular clothing indicating rank or role, position in a kingship system – in short, nothing that may distinguish them from their fellow neophytes or initiands." [152]

Although this is extracted from ethnological descriptions of foreign cultures, there are striking similarities to what we found in our seasonal sale windows. There are naked mannequins, which at times are dressed in cheap paper, and there are windows where a poster is hung to block the view. But van Gennep, too, tells us that rites of separation use veils whereby the view is blocked, which symbolises the segregation during the ritual. [153] Darkness, nakedness, opacity, a minimum of clothing, poverty, all these seem to describe the aesthetic dramatisation of the seasonal sale window perfectly. During the year, the mannequins that represent the role of the well-dressed fashion leader are often staged as naked, and without cultural identity. But at least the presence of the body remains. [154] Victor Turner describes this temporary social condition as follows:

"The second, which emerges recognizably in the liminal period, is of society as an unstructured or rudimentarily structured relatively undifferentiated comitatus, community, or even communion of equal individuals who submit together to the general authority of the ritual elders. I prefer the Latin term "communitas" to "community", to distinguish this modality of social relationship from an "area of common living". [155]

"Communitas" is a phenomenon, which can be observed in our consumer culture as well. There are several secular and religious rituals, which dramatise passage rituals with a symbolic anti-structure phase. Here, the people involved are made equal for the duration of the ritual. [156] The visual language of the store seems to use such intuitive anti-structural images as well. But when they are not attached to our cultural experiences, as we

152 Turner (1997:95).
153 Gennep (1960:168).
154 Fischer-Lichte (2004:255).
155 Turner (1997:96).
156 Bell (1997:95).

might feel when we read Turner, how could we interpret them in the right way? Do they represent a more abstract and culturally independent symbolic language? Turner used the term "liminal" for obligatory symbolic actions, and "liminoid" for symbolic actions in our contemporary consumer culture, but these are voluntary. Although the seasonal sale is not in the first moment an obligatory ritual, the following description fits it well:

"Liminal phenomena tend to confront investigators rather after the manner of Durkheim's 'collective representations', symbols having a common intellectual and emotional meaning for all the members of the group. They reflect, on probing, the history of the group, i.e., its collective experience, over time. They differ from preliminal or postliminal collective representation in that they are often reversals, inversions, disguises, negations, antitheses of quotidian, 'positive' or 'profane' collective representations. But they share their mass, collective character."[157]

When we interpret the seasonal sale as an inverse collective representation, which has the same value in indicating the change of fashion for all consumer groups, then we could define the term "liminal design" for a design approach capable of inversing the collective assumptions of aesthetics. "Liminal design" is the design of the ugly, the Dionysian design. The domain of this anti-structure is a sacred one. According to Bergesen, various dichotomies can be considered as being equal to sacred/profane, because they are part of the same ritual practice.[158] We can therefore see in the beautiful/ugly a possibility to express the sacred/profane dichotomy as well. We have found an example from the beginning of the twentieth century to demonstrate the striking visual presence of clearance sales:

"We have all often put the rule to the test. Not because the poorly decorated shops were bad or unimportant. No, it was the average variety. And this was probably why nobody noticed the firm. It is quite possible that one only takes note of such a firm once it has stopped to exist, when it puts up the notice for a 'total liquidation sale'."[159]

157 Turner (1982:54).
158 Bergesen (1999:180).
159 Austerlitz (1904:105)*.

The occasion for the death of a store is related to its decoration strategy, which intuitively has a bigger visual impact than all kinds of decorations attempted during the life of a store. This phenomenon still holds true today. Dying shops stand out of the mass, which is why the strategies of beauty are not longer used. Instead of an adequately restrained design, liminal design strategies are used to make the shop stand out, which, according to what we have heard, is often for the first time in its life. The dramatisation of death is a strategy of passage rites as well: making visible someone's departure from an old life so that they can become part of a new social reality after symbolic rebirth. The aesthetic practices during the seasonal sale bear a striking resemblance to similar dramatisations performed on the death of a store. Another evidence for this is the fact that even the economic target is the same: away with everything. Thus, staging the death of the store can be one option for theorising the aesthetic appearance of seasonal sale windows. Parallel to this we will also try to see how an aesthetic practice can be developed along the concept of liminal design. Liminal design articulates the ugly; it is antithetical to the beautiful design of show windows. So what should stores look like today?

"A store must stand out, attract and seduce and then carry out its promise with true personality."[160]

The distinct personality of the store is a key value. But during the sales, this rule seems to go up in smoke. There is a strange uniformity in the way the stores of shopping streets dramatise their sales. We can almost compare this dramatisation to a state of communitas, where all shops are temporarily in a state of equality and anti-structure. The nice individual window dressings are stopped for the time being and replaced by the aesthetics of commercial death. Profane is related to beautiful, and sacred to ugly. The store attains its truly sacred state during the sales. Other celebrations of consumer rites, like Christmas, employ condensed symbols to indicate their sacredness. These elaborate codes are used to indicate the hallowed time within the aesthetic economy of beauty. In contrast, the seasonal sales use a mixture of condensed and diffuse symbols.[161] Condensed symbols are conscious and recognising them is an acquired

160 Tongeren (2003:30).
161 See Wiedenmann (1991:129) for the relation of symbols and ritual.

ability, whilst diffuse symbols work on a more unconscious level and can be recognised intuitively. An example for a condensed symbol is the percentage sign. When we see it in the show window, we become instantaneously aware that we are encountering a sale. What Turner described as the threshold state can be categorised as diffuse symbols. Darkness, nakedness, disorder are more universal and intuitive images, and cannot be attributed to the seasonal sale alone. But especially these diffuse symbols are important for achieving impact. This takes us back to the early stage of window dressing. Here we find evidence of considerations for using disorder as an impressive element of design in the show window:

> "A kind of confusion of inanimate goods; it seems as if a box or suitcase full of goods has been turned upside down. Compared to the fact that the showcase always presents its goods in symmetrical order, this, too, seems to create an impact."[162]

This merchandising advice shows that the effect of disorder relies on the interruption of everyday beauty. Although we have found no examples for it here, we can point out that the strategy of ugliness has long been known as a way of creating an impact on the consumer.[163] While all other counsel, such as using the mass effect of equal merchandise or staging a single piece on a pedestal, amounts to dramatising the commodity fetish, randomness and ugliness stand out depending on the way merchandise is treated under normal circumstances. The accidental character of overturned merchandise on the floor of the show window stands in contradiction to the everyday practice of showing goods as fetishes.[164] In this context, the compulsive beauty of the show window finds its rival in the domain of ugliness, both used to attract attention and business. There is, of course, a difference between the reception of ugliness at the beginning of the twentieth century and today. Especially modernist movements of art like Dada, Surrealism and Nouveau Realisme were responsible for a much wider aesthetic experience in the field of art. Thus, the beauty of ugliness also found its way into the archives of art. Well-dressed show windows today can therefore use strategies of ugliness as well. But the ugly was never a mass phenomenon

162 Austerlitz (1904:89)*.
163 Randomness as strategy in art was to become important in Surrealism.
164 Randomness, uncertainty and suddenness are the three categories of evil according to Nietzsche (Liessmann (2000:327)).

in art, nor was it in the field of window dressing,[165] and it is certainly not the aesthetic of the masses. From this point of view, we will exclude the ugly as an everyday means of attracting people. It is much rather a strategy for provoking attention. This is the reason why we have quoted the case of the disorderly store, which remained invisible for the duration of its life. It was so inconspicuously decorated that it went entirely unnoticed, which by no means implies that it was not well-dressed. Only when the store died and the sale was announced did the people notice it at all. The dramatisation of the sale is staged with inexpensive means. The visual aesthetics that emerge from showing the stock in the show window rather than staging single pieces only, or merely covering the show window with normal white paper rather than the backdrop with colourful wallpaper, stands out against the normative beauty of show windows. Ultimately this is what made the shop visible at the end of its life. Although there are neither rules nor counsel for window dressers on decorating the "death window" and that such windows are strikingly similar, we are led to assume that certain unwritten rules must exist. If ugliness is so successful in attracting attention, why is it not employed more often? Most shops probably fear that they would disappoint the general expectations of customers during the year. It seems that the seasonal sales mark the only time in the year when such a provocative aesthetic practice is tolerated in show windows. Since mass marketing strategies normally avoid conflicts with the customer, the seasonal sale must be an exceptional occasion for inverting our aesthetic preferences. The inversion of social structures and the play with other roles are important motives during carnival. This is also when offensive things can be said which would lead to prosecution during the rest of the year. The carnival is a ritual that inverts the social structure, allaying the crisis created by social order during the year. The slave becomes the king and the king the slave for this period of time. This temporary inversion forms a legal frame for a critique not permitted during the year. Thus, the ritual ultimately affirms the power of the powerful, affirming at the same time the social position of the slaves, a position that must be sustained after the carnival. But in aesthetic terms, the carnival is dramatised in show windows using the everyday aesthetic of beauty.

[165] We are dealing with the conscious artistic use of ugliness and not with the reality of the unskilled show window.

"Prince Carnival has come of age! In addition to the original carnival decoration that we featured in our previous issue, we now present you the complete guide to showcase decoration, which will make ball-dress fabrics and silks, ribbons, laces, flowers and larvae, as well as cotillion insignia and firecrackers create the greatest impact. It is especially effective because the entire arrangement creates an unforgettably cheerful atmosphere so that everyone will remember where and when he or she had laughed."[166]

Carnival decorations are festive in character and use decorative elements commonly used during the feast. They show costumes or, as in our example, the fabric in order for them to be tailored. Using masks and disguising mannequins are widely used decoration techniques. The anti-aesthetic attitude of the seasonal sale window is absent during the period of social inversion, which has no equivalent in aesthetic inversion. Like Christmas, the carnival is also a festive occasion. Comic aspects are largely responsible for unusual decoration ideas. What goes on behind the glass pane is a reflection of what is going on in the street; carnival celebrations on the street are the reference for the show window decoration. According to Turner, the carnival is a voluntary ritual; the show window therefore only invites us to take part in it. The disorderly behaviour of some individuals during carnival is not imposed by ritual; it is much rather a personal choice made from a selection of roles possible during that time. Herein lies a significant difference to disorderedly behaviour in obligatory tribal rites.[167] Although the seasonal sale is not obligatory for consumers, its aesthetic appearance follows a visual scheme of obligatory rituals and their use of widely shared intuitive images. Rites of passage probably deploy the aestheics of darkness, nakedness and disorder for the same reason as why disorderly dramatisations of goods were presented in merchandising literature: Anti-structure has a striking attention-generating visual power. While this suffices for merchandising, ritual construction also needs symbolic inversion to show the transformation from one state into another. It is our hypothesis that the seasonal sale window follows the rules of passage rites as well. Firstly, because fashion changes after the sales period, and secondly because the visual language bears striking

166 Austerlitz (1904:68)*.
167 Turner (1982:170).

parallels to archaic passage ritual dramatisations. It will be interesting to find out how these intuitive images of the past resonate in the visual economy of today. The use of ugliness today can have the same deep roots as in the past when it was the opponent of beauty. But guidelines for deploying ugliness are hard to find in literature. Unwritten rules often make themselves apparent in an indirect way: when decoration books are not aware of them and do not wish their arguments in favour of beauty to be disrupted:

"A sale is not an excuse to leave windows unstyled and merchandise shabby and shoddy."[168]

It is our hypothesis that there must be a reason to do so. And the reason is not known publicly, otherwise we would have found it in the books we had browsed through on show windows. The slovenly and the ugly, naked mannequins that lose their function as representatives of styles and roles, the veiled window that blocks our view like the materialisations in the separation phases of passage rituals, all these are indications for a phenomenon we will be exploring here. Decorating the show window with a narrative scene is a common strategy for selling goods. But what scene is it that we face during the sales? In merchandising literature, the creation of a show window is described as a summary of the product, product association and its materialisation to create a seductive world.[169] When stores want to sell, the summer collection, for instance, which, according to Barthes, is associated with the holidays,[170] then the window dresser might take the theme of the seaside as product association. The backdrop painted sky blue, sand-covered show window floor together with a few deck chairs easily create the sense of being at the seaside. The mannequins don appropriate dresses, and the illusion is perfect. Advertising works with this simple, seductive logic, which creates wishes that are symbolically fulfilled by the purchase of goods. On seeing the show window we would dream of being at the seaside and therefore buy something which represents this wish. But how do rituals work? The materialisation of the winter sale is not born of associations related to the winter collection. Scenarios related

168 Portas (1999:118).
169 Bauer (1997:156).
170 Barthes (1990:251).

to the winter collection are significantly different to what goes on during the winter sales. There is practically nothing about this phenomenon of the sales in literature on show windows, which is why we decided to do our research on the street.

For Roland Barthes, the launching of the spring collection is that exceptional moment in the year which creates a mythical experience for the consumers because of its link to the awakening of nature. In former times, the renewal of nature was linked to rituals that dramatised the death of the corn god and his resurrection by using myths such as those of Dionysus. Belief in magic suggested that when the corn god is resurrected, nature would wake up as well. Similarly, the renewal of fashion is also immortal for its followers:

"The spring collections are here! There is much excitement in Paris. Journalists and buyers are pouring in from all corners of the world to stimulate their fantasies in the fashion laboratories with the thousands of new ideas floating around like opalescent soap bubbles. They are here to be inspired by the extravagant new trends that Paris invents twice a year for those who believe in its immortal gift of renewing itself." [171]

This was written in 1958, at the time when Barthes did his research on the language of fashion in fashion magazines. But fashion's renewal is a phenomenon that is not based on language. Fashion is immortal because its followers perform a ritual twice a year in order to perpetuate the fashion system. The importance of nature's rebirth in spring in agrarian societies has been replaced by the renewal of fashion in consumer societies. Rituals serve the purpose of eternalising social structures and beliefs, which they do by means of symbolic communication. We believe that analysis of the seasonal sale windows can help in proving symbolic communication based on Dionysian aesthetics, which, according to Victor Turner, is the basis for rituals of passage. Furthermore, it will furnish evidence for Barthes' assumption that the arrival of the new spring collection still has roots in the past, for the construction of rituals in our consumer society is still founded in archaic intuitive images.

[171] Charles-Roux (1958:I)*.

Intuitive Images

"I believe that magical attitudes towards images are just as powerful in the modern world as they were in so-called ages of faith."[172]

With this statement, Mitchell concluded that in today's visual culture we have to deal with the paradoxical double-life of images: they are alive, but they are also dead.[173] The vital life of images in the religious context has often been compared to the use of images in consumer culture. In a text fragment from 1921, Benjamin compared capitalism with religion. He illustrated this by contrasting holy images from different religions to the images on the banknotes of different countries.[174] Today, this comparison seems less powerful when regarded in the light of money's progressively vanishing physicality.[175] But the direction of the critique is still readable: Capitalism uses the power of images in the same way as religion does. Bolz, who addresses marketing strategies in the consumer society, frequents this bridge built by Benjamin equally often:

"Not the churches but the consumer temples are the places of modern religiosity. [...] The ideal of marketing is religious icon worship."[176]

The religious image represents the exterritorial power of god. It is often a tangible principle like the power to heal or to protect from evil.[177] It is doubtful that consumers today consciously approach the images in consumer cathedrals with equally high expectations. For Mitchell, commodity fetishism is

[172] Mitchell (2005:8).
[173] Ibid., p. 10.
[174] Benjamin (2000:290).
[175] See Zizek (1997:103) for the transcendence of capital to its effect.
[176] Bolz (2002:115)*.
[177] Belting (1996:44).

an iconoclastic monotheism, which destroys all other gods.[178] During the seasonal sales, the show window becomes a sacred space in the commodity cosmos. For example, through the disappearance of the price tag or the disappearance of the commodity itself! But even the disappearance of normative beauty is a significant sign of the holy time represented in the show windows of the high streets. This fact, that continues to be a blind spot in the Marxist critique of commodity fetishism, has been expressed by Bolz in more modern words:

"The enthroning of commodities, their adoration as fetish, in keeping with rituals of fashion, is the only content of the capitalist cult."[179]

The gaze into the seasonal sale windows shows that worshipping beautifully presented commodities is not the only capitalistic cult. While Christian celebrations of Easter dramatise the death of the Son of God and his subsequent resurrection, the seasonal sale dramatises the death of the seasonal fashion collection. By the same token, while the Christian festival is consciously dramatised with a set of striking images, the seasonal sale depends on the instinctive skills of the window dresser. A similarity between the two "monotheistic" dramatisations lies in their use of "mannequins". Sculptures were used to dramatise the death of Jesus on Good Friday. Freedberg describes models of such sculptures in his study on the power of images. One of them is a sculpture of Jesus holding a cross with moveable arms,[180] another one even has moveable arms so that Christ taken from the cross can be wrapped in a shroud and placed on the altar. On Easter Sunday, the crucifix thus vanishes to dramatise the resurrection.[181] The expressions of the mannequins in the fashion show window are comparable to those of their religious ancestors. Dramatising the death of the fashion collection requires that the mannequins are removed from the window, dressed in special ritual garments or undressed altogether. The performative action with the crucifix follows the canon of religious paintings of the time and dramatises the images documenting the death of Christ. While these images are well-known and present for the idolaters, the images behind the dramatisa-

178 Mitchell (1987:200).
179 Bolz (2002:65)*.
180 Freedberg (1991:244).
181 Ibid., p. 286.

tion of the death of fashion are in the dark. The beautiful statues of consumer culture enact a strange rite of ugliness for several weeks in the year.[182] Are they like idols with an irrational and unwarranted power over somebody (the shoppers)?[183] For those who have doubts, a few more from Freedberg:

> "It is obvious that paintings and sculptures do not and cannot do as much for us now. Or can they? Perhaps we repress such things. But did they ever?"[184]

Advertising and propaganda are the image-makers of today, and there is little doubt that they want us to believe in their seductive images. And the show window is the best way for a shop to advertise. During the year, the beautiful and fashionable mannequins wear what we should be wearing. But what do they want us to do when they are naked or dressed in paper? During the year, they wear different clothes, signalising that we can achieve individuality by shopping. But in the state of anti-structure, they are dressed identically and have lost all their individuality. The window dresser is the ritual master and image-maker behind the scenes, who transforms the show window into a ritual space during the seasonal sales, treating the mannequins symbolically, divorced from their representational function. These beautiful statues are now together with the evil snake, but the representations of men need images beyond those of the body,[185] and these images are created by fashion. During the sales, however, they are replaced by images beyond the fashion canon of the high street. The process of making a fetish out of the garment requires that the mannequin in the show window is dressed. While the clothes rack represents the state of the commodity before it becomes a fetish, dressing breathes life into the mannequin. This is analogous to dressing holy statues for religious services. The life-like image is suspended by the seasonal sale when the mannequins are undressed. This state becomes ambiguous because the periods of symbolic death are part of the dramatisation of passage rites, at which point the mannequins really come to life. They cannot move, but they are also not "allowed" to move in this liminal state. Thus, their very inability to move becomes the real strength of the dramatisation.

182 See Mitchell (1987:109) for a discussion on the beautiful Greek statues in combination with the servant.
183 Ibid., p. 113.
184 Freedberg (1991:10).
185 Belting (2005:357).

The image of communitas is based on lost individuality. Bodies are dressed in a ritual garment and lined up. Likewise, the show window and its actors are unable to perform a ritual and are as inanimate as a photograph on which it is only possible to identify what Goffman called "small behaviours" in his study on gender commercials.[186] Pictures, too, only show us the gestures and arrangements of things, but never the actions; we only project these onto the picture.[187] This is why the immobility of the mannequins in a passage rite is only imagined, as is their lifelike appearance during the year. In the days when mannequins were made of wax, the surrealist Louis Aragon depicted his experiences with the representational state of the show window:

"I shall say no more of these waxworks that fashion has stripped of their clothes, digging cruel thumbprints into their flesh in the process."[188]

Pictures can be both curatives and poisons. Modern iconoclasts of the advertising industry prefer the poisonous effect of images. The call to replace the beautiful faces of fashion models by sculls is a good example of counter strategies within the modern visual economy of advertising and brand cult.[189] No report exists claiming that abused pictures were the focus of new cults that developed after ancient religious paintings were attacked.[190] But "death is back in Arcadia",[191] at least with the aggrandisement of the seasonal sale windows. And iconoclasm comes as a counterforce to the idolatry of commodity fetishism. It is an up and down within the same system, but it is "creative destruction" that perpetuates the symmetry of idolatry and iconoclasm.[192] And iconoclasm comes in a sublimated form. Pictures are not attacked by acid,[193] but it can happen that a seasonal sale window has a pink splash on its panes with the words "final days".[194] It looks like an attack by a psychopath on a painting in a museum. Interestingly enough, while we were conducting our field research during seasonal

186 Goffman (1979:24).
187 Bohnsack (2003a:91).
188 Aragon (1994:41).
189 Lasn (1999:131).
190 Belting (1996:197).
191 See Panovsky (1955:295-302).
192 See Mitchell (2005:21).
193 Freedberg (1991:187) refers to the 1977 attack on the painting of the *Seated Old Man (or Thomas Apostle)* by Nicolaes Maes in the Staatliche Kunstsammlung in Kassel, which Freedberg erroneously believed to be by the Rembrandt School.
194 This window was found during the summer sales 2005 in Vienna.

sales on Avenue Champs Elysées in Paris, many show windows were attacked with stones. A true iconoclastic act?[195]

The seasonal sale triggers a crisis because the prices are brought down from one day to the next, for example, by 50%. And this is when the show window, interpreted as a picture, gains social importance. Mitchell relates the importance of images to social crisis:

"The value and life of images becomes most interesting, then, when they appear as the center of a social crisis."[196]

Images and their ability to create magical effects are historically related to their origin. Icons were precious at the time when they originated in Byzantium. Today, the origin of catwalk images from places like Paris, Milan or New York impart magical powers to the fashion collections presented there during the fashion weeks. Fashion introduced elsewhere possesses fewer magical powers within the system of glamour fashion journalism. The places of origin are related to cult legends, which guarantee power and awaken expectations of healing.[197] While Byzantium was the capital of icons, Paris is the capital of fashion. And fashion that comes from this mythical place is charged with the mythical power of the legends of couture. In medieval Venice, religious images were dramatised in a certain way by being shown only on special days. Belting describes this rite in the following:

"As cult image, the original was concealed from the view of others by a curtain in order to make a stronger impression on the weekly feast day."[198]

This example bears a striking parallel to the introduction of the new fashion collection because the windows are often covered over during the sales. Removing the cover and presenting the new collection to the public aims at the same effect as in the mediaeval religious practice in which ritual was linked to the art object. But today, "we do not bend our knees anymore".[199]

195 See Weibel/Latour (2002) for a broad discussion of iconoclasm in the fields of art, science and religion.
196 Mitchell (2005:94).
197 Belting (1996:196).
198 Ibid., p 186.
199 See Liessmann (1999:38 and 99) on the end of the relation between art and ritual as described by Hegel and Benjamin.

And if we do, it is only metaphorically, although the seasonal sale window can be interpreted as a devotional image. Panovsky described this type of image as having an intention to communicate rather than being consumed as aesthetic pleasure.[200] According to Postrel, aesthetics are the substance of today: "Fashion exists because novelty is itself an aesthetic pleasure."[201] But this pleasure exists only in relation to the Dionysian period of sale, which is the duplicity of the Apollonian and the Dionysian as Nietzsche called it. While beauty and aesthetic pleasure are appealing, the ugly is repelling.[202] And repel is what the fashion industry wants to do to the leftovers of its past collection: a magical act based on the power of images. Therefore, the show window is transformed into a "stage" for the Dionysian festival, which banishes the Apollonian and voluptuousness and barbarism take over charge. Sloterdijk coined the term "erotrop" for this condition.[203] And the window dresser is the perpetrator of the crime, for it is he who creates the images of violence.[204] A striking example is a show window in which dismembered mannequins lie around on the floor during the sales. Mitchell explains the mechanism behind the way values are changed by images:

"Images are active players in the game of establishing and changing values. They are capable of introducing new values into the world and thus threatening old ones."[205]

And this is exactly what the seasonal sale window does. The image of the old fashion collection is threatened, preparing the ground for the introduction and establishment of the new fashion collection. Or, expressed in Turner's terms: The representation of fashion undergoes a phase of anti-structure during its passage rite. Mitchell describes how intuitive images resurrect from the past in picture theory:

"The life of images is not a private or individual matter. It is a social life. Images live in genealogical or genetic series, reproducing themselves over time, migrating from one culture to another. They also have a simultaneous collective existence

200 Panovsky (1955:12).
201 Postrel (2004:80).
202 Liessmann (1999:70).
203 Sloterdijk (2004:407).
204 See Sloterdijk (2005:339) for the relation of image and violence.
205 Mitchell (2005:105).

in more or less distinct generations or periods, dominated by those very large image formations we call 'world pictures'."[206]

The following chapter is based on a visual analysis of the images created to express the rite of passage exemplified in the sale window. We conducted our field study of the upper and middle classes during the winter sales in major shopping streets in January 2004. Four Central European cities, Paris, London, Vienna and Hamburg, were chosen for this research in order to avoid local peculiarities in the final conclusions on the nature of sales. Photos where taken in the manner described in marketing as "trend shopping". Therefore, major shopping cities were visited only briefly;[207] the pictures taken were intuitive and without prior preparation. The only parameter was to find striking images representative of the dramatisation in the high streets. The pictures were taken in view of the cornerstones of the discussion thus far. The nature of the working images thus gathered for the visual research are best described in Pink's words:

"Interdisciplinary exchanges should be carefully situated. Anthropologists' photographs, designed to participate in anthropological discourses, might fare badly under the scathing gaze of art critics. Similarly, photographers do not become anthropologists by virtue of informing their photography with anthropological methods and concepts; their work will not necessarily participate in anthropological debates."[208]

Although the above quote refers to the collaboration between ethnographer and artist, the described methodological risk is evident. But in the future, the artist as "ethnographer" has a potential that has not been sufficiently examined.[209] In the interest of the present discussion, it must be stated that there is neither an artistic endeavour behind the documentation nor is any anthropological discourse intended. The analysis is

206 Mitchell (2005:93).
207 In the case of this study, it was a full shopping day per city. An exception was made in the study in Vienna because another day was assigned for the visit to lower income shopping streets.
208 Pink/da Silva (2004:159-60).
209 Stafford (2005:114) cites the example of the artist Thomas Struth, who documents how museum visitors react unconsciously to the composition of paintings with their position in the museum space. The *Orgien Mysterien Theater* of the artist Hermann Nitsch is a vital contribution to the understanding of the nature of blood sacrifice. The intuitive images produced by the artist (see Rychlik, 2003) can help us understand sacrifice as a visual and physical phenomenon in addition to textual based analyses such as those by Hubert and Mauss (1981). Taking the artistic gaze as an equivalent to the methodology of scientific research for creating knowledge for cross-disciplinary research is a challenge for visual studies. Foster is sceptical "about the effects of the pseudo-ethnographic role set up for the artist or assumed by him or her" (1995:306). This role attribution usually comes from outside. How should the artist Nitsch set up his artistic research on sacrifice without ethnographic knowledge? This example shows that the discussion on roles (or role attributions) needs to be rethought in order to create new knowledge beyond disciplinary thinking.

situated in the cross-disciplinary field of "visual studies" alone. For Bredekamp this field is "everything that the narrowest definition art history is not".[210] This research field covers disciplines from anthropology, sociology, cultural studies, media studies, visual culture and symbolic interaction to documentary photography.[211]

One person who is often cited in visual culture studies[212] is the photographer Eugene Atget, among the first to portray urban life in Paris with his camera at the beginning of the twentieth century. His "direct and frank"[213] gaze fell not only on the streets, but also on storefronts. Beaumont-Maillet describes Atget's gaze as follows:

"Even though Atget's work is photography reduced to its essential self, without contrivance, without pretensions, his images have the tragic quality of ordinary things. They create "that salutary movement whereby man and the world around him become strangers to one another."[214]

These "documents", not acknowledged as art in his times,[215] have found their way into the archives of museums today as well as into research on visual culture. This shows that Pink's arguments might not apply today, or, that they should be discussed by later generations of scholars. The research photos that the following chapters are based on are also "documents" or "working images". The selection has been undertaken with the intention of exemplifying each shopping street with one view. The examples are presented in chronological order as if a shopper had walked down each of the shopping streets. The visual tension created by a few examples thus conveys the overall atmosphere of the seasonal sale in each of the shopping streets. It is assumed that it is possible to reconstruct the nature of the seasonal sale by observing one single event.[216] In addition to the four cities Paris, Vienna, London and Hamburg, there is yet another fashion capital: New York. The chapter on New York is an excursion into the field of art and performance studies but it does not include any images of a field research. The assumption

210 Bredekamp (2003:428).
211 Ibid.
212 See Mirzoeff (1999:76).
213 Beaumont-Maillet (1992:28).
214 Ibid., p 27.
215 Except by the surrealists.
216 Smaller investigations conducted before and after confirmed this assumption.

that the seasonal sale is a visual phenomenon with roots in the past is examined only by means of text and not a historiography of images. Since this book deals with the nature of the seasonal sale and not with its visual history, historical examples of seasonal sale windows were only taken into account as long as they were textual.[217] It is further assumed that the images seen today are related to older generations of images dating back to ancient times. Panovsky termed the transformation of ancient prototypes "pseudomorphosis".[218] He explains this term through the example of the ancient mythological figure "Chronos", who figures as logo for the Bowery Savings Bank.[219] Warburg provides yet another example of mythical figures "resurrected" in consumer culture through an advertisement for soaps.[220] He uses a collection of images of art works to develop his arguments on the conscious and unconscious use of ancient themes in art.[221] While the above two examples illustrate the idea of the resurrection of images, a different discourse will replace the arguments based on art history. Mitchell describes the "rethoric of images" with what is said about images as well as what these pictures say.[222] This rethoric of images will be developed in the following chapters with reference to a methodology introduced by Panovsky, who called this methodology "iconographic-iconological interpretation". The method social sciences use for discussing images is built on this model and its expansion by Imdahl,[223] who also extended the discussion to compositional aspects of the image. Social sciences today use a model called the documentary method based on the arguments by Mannheim, who transferred the model from the arts to the social sciences.[224] While the interpretation of images according to this qualitative method is based on a multi-layered eight-step model,[225] the discursive interpretation of the working images draws on Panovsky's simpler original model,[226] and the analysis is based on a three-step model.[227] The first step is the pre-iconographic description. This is a description of what can be seen on the photo, but without any social or mythological inter-

[217] Sturken/Cartwright (2001) draw the timeline of visual phenomena by using historic images. But the argument referring to ancient rites goes far beyond the area of documentary photographic images. All questions concerning the nature of the seasonal sale should be examined by what is seen today.
[218] Panovsky (1962:70).
[219] Ibid., p 69-94.
[220] See, for example, board number 77 in Warnke (2003:128).
[221] Warburg started his scientific project on the "MNEMOSYNE atlas" in 1924.
[222] Mitchell (1987:1). See as well the different categories of images, ibid. p 10.
[223] Imdahl (1996) termed this expansion of the discourse "Ikonik".
[224] See Bohnsack (2003a:87).
[225] See Bohnsack (2003b:237).
[226] Because it is sufficient to work out relations to ancient motifs.
[227] See Panovsky (1955:40)

pretation. The second step is the iconographic analysis where the picture is interpreted through the knowledge about the themes and images. The last step is termed iconological interpretation, an analytical step for which synthetic intuition and personal psychology are the tools. Mitchell shares Panovsky's main interest in investigating how the motifs from classical antiquity can be interpreted:

"Turning now from the problems of iconography and iconology in general to the problems of Renaissance iconography and iconology in particular, we shall naturally be most interested in that phenomenon from which the very name of the Renaissance is derived: the birth of classical antiquity."[228]

But the Dionysian motif is not the only concern of this discussion, which is why we have employed Panovsky's model differently. After the pre-iconographic description, visual interpretation has become much more open to themes found in the literature other than antique iconography, such as ethnography, philosophy, sociology, material culture studies or design theory. This experimental approach left open whether both steps of interpretation or only one can be used. The texts were linked to the images by what can be called a similitude key,[229] which is how many narratives are connected to their visual representation. Hörisch's example of the unicorn, on the other hand, is related to the son of the monotheistic god because it only has one horn, and alone the fact that the horse has "one horn" links it with the concept of "one god".[230] The narrative and the image are thus connected by likeness, resemblance and similitude.[231] Precisely this likeness of image and "scientific" text (instead of mythological text) is the criterion for the following discussions on each selected working image from the dramatisation of the seasonal sale. In order to guarantee a better reading, the scientific texts were selected according to the place of the authors' origin whenever possible, and thus related to the respective city.[232] This structure was not chosen because the aim was to develop categories of images, but to try "visual keys" as often as possible in order to find likenesses. The

228 ibid., p 51.
229 See Hörisch (2005:88).
230 Ibid., p 88-89.
231 See also Mitchell (1987:10).
232 No scientific reason exists for this decision. Readability was the only reason for it.

door will be opened in the final chapter in which the micro-analysis of each single window will be summarised and connected with the beginning of this discourse.

This discourse can be termed "Bilddenken",[233] which is an analytical reflection on images by means of images. It is a proposal for opening the boundaries between disciplines in order to create cross-disciplinary knowledge.

[233] See Bredekamp (2003:418) on a similar difficulty in translating "Bildwissenschaft" into English.

Visual Lexicon

Rites of Passage: "The attributes of liminality or of liminal personae ("threshold people") are necessarily ambigious, since this condition and these persons elude or slip through the network of classifications that normally locate states and positions in cultural space. [...] They may be disguised as monsters, wear only a strip of clothing, or even go naked, to demonstrate that as liminal beings they have no status, property, insignia, secular clothing indicating rank or role, position in a kingship system – in short, nothing that may distinguish them from their fellow neophytes or initiands."

Turner (1997:95).

nakedness

darkness

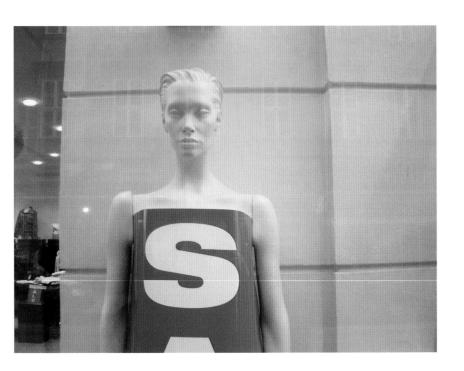

ritual clothing

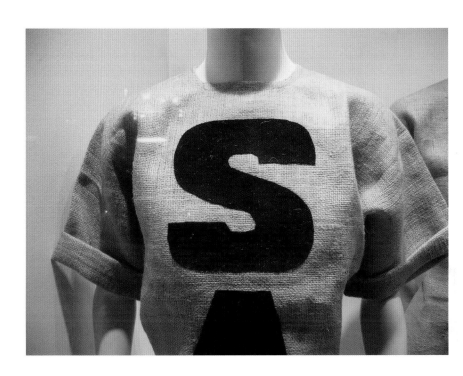

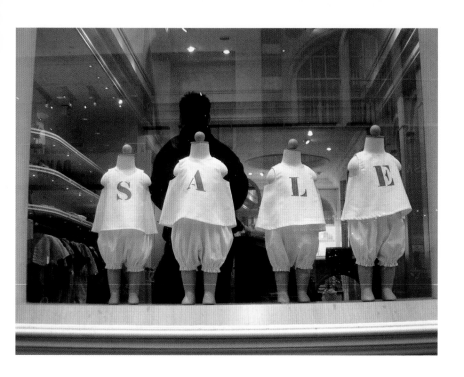

communitas

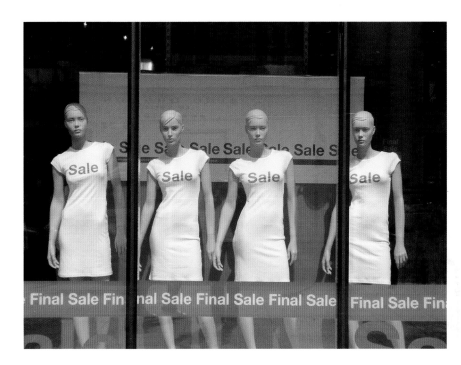

antistructure

festival

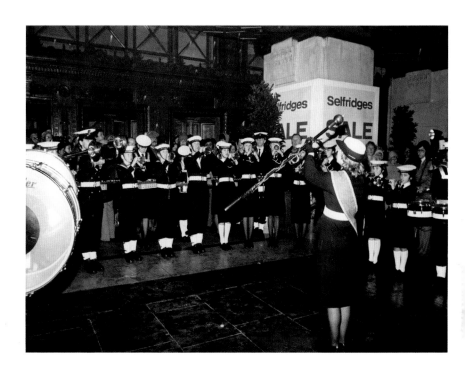

opening ritual

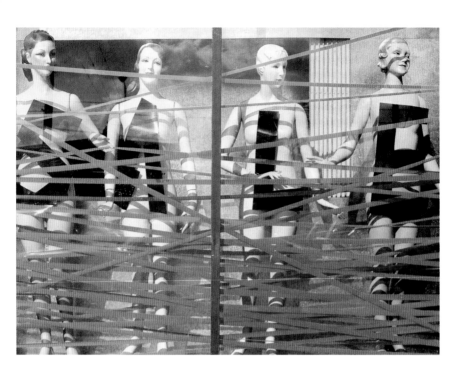

Passage Rite
Simon Doonan for Maxfield
Los Angeles, 1981

City
Walks

Avenue des
Champs Elysées

Avenue
Montaigne

Rue du
Faubourg
Saint
Honoré

Boulevard
Hausmann

PARIS

"For fashion was never anything other than the parody
of the motley cadaver, provocation of death through the
woman, and bitter colloquy with decay whispered between
shrill bursts of mechanical laughter. That is fashion. And
that is why she changes so quickly; she titillates death
and is already something different, something new, as he
casts about to crush her." [234]

234 Benjamin (2004:63).

AVENUE DES CHAMPS ELYSÉES

We start our walk down Avenue des Champs Elysées from Place Charles De Gaulle, and cross over to the left side of the road because this is where more fashion boutiques are located. The very first fashion shop we pass by proves to be a prototype of what we have heard about the dramatisation of the state of transition according to Victor Turner:

◁ All three female mannequins have the same long black hair, but slightly different postures. The one in the front looks to the right, the other two who are a step behind it gaze directly at the shoppers standing in front of the window. The mannequins are wearing black trousers and red T-shirts with the word "soldes" written on them in glitter. The back of the window is dressed with a black plastic curtain, highlighting the red T-shirt and the naked arms. Above the heads of the mannequins is the word "sale" written on the curtain in white so that it is possible to read it from afar. Warm light is coming from behind the black backdrop. The garments have no price labels.

Turner describes the state of transition as a state in which the people attending the ritual are made equal. They either wear the same clothes or are naked in order to signify their state of communitas. The three mannequins in the show window are wearing a T-shirt, which is not for sale. It is a special garment produced to denote the transition of fashion in the sales period. The daily business of the mannequins is to show the latest trends; they are the models for the fashion on the street. Their function of wearing the latest trend changes during the sales, when they indicate the death of the past fashion. Michel Foucault described the symbolic dramatisation of executions by saying that the criminal is presented to the mass with a number of symbolic actions. At the threshold to death, the victim is treated in a special way in order to make his social status clear.

What we have here is a political ritual for demonstrating the power of the ruling system.[235]

"The public execution, then, has a juridico-political function. It is a ceremonial by which a momentarily injured sovereignty is reconstituted. It restores that sovereignty by manifesting it as its most spectacular. The public execution, however hasty and everyday, belongs to a whole series of great rituals in which power is eclipsed and restored (coronation, entry of the king into a conquered city, the submission of rebellious subjects); over and above the crime that has placed the sovereign in contempt, it deploys before all eyes an invincible force. Its aim is not so much to re-establish a balance as to bring into play, as its extreme point, the dissymmetry between the subject who has dared to violate the law and vice versa."[236]

The change of fashion is a ritual of asymmetry and its audience has to extol the coronation of the new fashion trend. The power of the system is made stable by means of symbolic actions and their frequent repetition. Foucault describes the presentation of a delinquent with the words of a witness of ancient practices:

"The prisoner condemned to death will be taken to the scaffold in a cart 'hung or painted in black or red'; if he is a traitor, he will wear a red coat on which will be inscribed, in front and behind, the word 'traitor'; if he is a parricide, his head will be covered with a black veil and on his shirt will be embroidered daggers or whatever instruments of death he used; if he is a poisoner, his red shirt will be decorated with snakes and other venomous animals."[237]

The proposals to dress the aberrant in a red shirt with the words or symbolic signs describing the crime bear a striking resemblance to the decoration of our observed seasonal sale window. Such rites of punishment used a strong visual language whereby each element of the rite had to speak about the crime. Therefore, written descriptions of the crimes were used on big boards and on the clothes of the delinquents. The crime had

235 Foucault (1995:47).
236 Ibid., pp. 48-49.
237 Foucault (1995:111).

to be made apparent to all citizens as a fresh reminder of the system's power. "Soldes" written on the red T-shirts of the three mannequins and in large letters on the backdrop of the show window makes all three figures equal and expresses what Turner called communitas. At the same time, however, the lettering on the commodities makes them inconsumable.

Parading the criminal as in the above case used to be a major public event with highly symbolic content. Such cases of precedence played an even greater role in the demonstration of power in which the death of the offender at the hands of the executioner was also a symbolic act. In our case, the fashion system, the fashion retailers are the executioners. Twice a year they execute the old fashion in a symbolic ritual in their show windows. "Outdated" could well be the crime that is emblazoned on the T-shirts. Thousands of people walking down Champs Elysées thus become witnesses to a crime, which is elaborately demonstrated twice a year. The fashion system presents to us the old fashion as a criminal, who is denied the right to be seen on the street. Since the fashion system is capable of lending power to a new collection, it can also do away with it in the same manner. As the historic example of Foucault shows us, this is done by way of symbolic actions. The T-shirt, normally part of the summer collection, is used here to make the seasonal sale of the winter collection visible. It will be difficult to find out the reason for this because it seems as though the old collection can be executed in its absence even. The mannequins representing the well-dressed consumer are symbolically put into a phase of transition in which the figures represent a liminal state. All of them are identical and must live without being fashionable during the sales. They now wear clothes that are no longer up to date. The body is a political entity that carries out tasks, emits signals and performs ceremonies.[238] The mannequin symbolically suffers in our place due to the transformation of fashion. The fashionable community of mannequins is in a state of transition from the day the sales begin to the day the new collection is introduced. Pain is an important factor in the rites of punishment and money a major value in modern economy therefore it also hurts when the price for a piece of clothing bought a few weeks before the sale

[238] Bell (1992:202).

starts is reduced by fifty percent during the sales. Price manipulation is thus an instrument of power and the punishment for buying garments during the sales is to possess outdated garments. Another sign of power is the timing of the sales period and lies in the hands of the fashion retailers who decide the point of time when the old fashion may be executed. We continue our walk down the shopping street and reach yet another strange show window:

⊲ Four white textile banners block the view into this store's interior. The banners are opaque and hang over each other directly behind the glass. The curtain does not fall all the way to the floor so that it is possible to make out the legs of a dummy. The word "soldes" is written in large letters across the white curtain and the letters are attached to the four overlapping banners; the first and the last letters are on one banner each, while the two middle banners have two letters each. The white curtain, the black letters, the black lines of the window frame and the white fabric of the sun protection produce a strong graphic effect. It is impossible to imagine what is behind the door. The window dressing is done with simple materials; the general look, though rather improvised, is elegant.

According to van Gennep, rites of passage follow a three-stage pattern. The steps are, however, not always dramatised with the same intensity. The first step is the stage of separation. Veils have been used for a long time to block the view and to make the separation visible. Both the black veil worn by widows during funeral rites and the white veil worn by brides on their wedding have the same symbolic purpose: it is impossible to see the person from outside. In the case of the wedding, the bride is separated from her social group, and in the case of the funeral, the widow is separated from the dead body. When the fashion retailer obstructs the view into the show window, we are also denied the view of the fashion. We can no longer see what is en vogue. By blocking our view we are separated from the past fashion trend, which means that the show window will not show what is in fashion until the new collection is introduced. The precondition for this symbolic articulation of the separation phase is that the participants of the consumer rite have a common consciousness. Pierre Bourdieu describes this shared pattern as follows:

"All the agents in a given social formation share a set of basic perceptual schemes, which receive the beginnings of objecti-fication in the pairs of antagonistic adjectives commonly used to classify and qualify persons or objects in the most varied areas of practice."[239]

Human beings and things are interpreted on the basis of pairs of oppositions. The show window is also oriented along this basic pattern. The everyday window in which the new fashion is presented becomes inverted during the sales so that shopping produces a different ideological pattern during this period, dividing the shoppers into those who save money to buy the old fashion, and the fashion elite, who wait for the new collection. Since they already possess the past collection, the trickle down effect commences at very the beginning of the sale. Fashion is a system of signs undergoing continual change. But the fashion retailer on the street is responsible for the dramatisation of the change:

◁ A central entrance divides the storefront into two show windows. A poster mounted on two rods goes all the way up from the floor to the ceiling in each of these windows. The construction looks temporary, like scaffolding. The poster has a black ground with white dots, which are reminiscent of falling snow. The word "soldes" is emblazoned in red capital letters across the middle of the poster. The rest of the window is left empty. The spot-lights that normally highlight the fashion are now directed onto the poster.

Emptiness prevails here. The poster is presented in the centre of the show window so that the impression of the view being blocked is not so strong. The poster is displayed rather than the garments or the mannequins presenting them. In fact, there are no visible signs of fashion. The falling snow could be a metaphor for the falling prices inside the shop. Since we normally associate snow with winter, the winter collection is on sale now.[240] The poster is produced professionally and indicates the centralised merchandising strategy of a global retailer.

239 Bourdieu (2005:468).
240 We found this poster again during the summer sales, so our association with winter and snow might be wrong for the summer, or the relation to the seasons not as important as in the case of the summer T-shirt in the first window during the winter sale.

In the following description, the strategy used is once again of blocking the view:

> ⊲ Its frame divides the huge main window into three parts. Three white posters are attached directly to the glass and cover most of the window's surface. All one can see through the gap are two red walls, they are slightly higher than the posters and block our view to a second level. The white posters in the front are lettered with the word "soldes". A sub text says "sur certains articles". However, no articles are displayed in the show window.

Although only certain articles have been reduced in price, none are displayed in the show window. What is on sale and what is not, remains a riddle; the window simply indicates the sacred period of the consumer ritual: Cheap decorations for a cheap shopping experience. We walk further down the street and find a window, which is different to all the previous ones we have seen:

> ⊲ The show window is totally covered by a nontransparent red film. A small horizontal line interrupts the cover on eye-level, making it possible to peep into the show window. A second, smaller horizontal window has been created for shorter people. The red film on it bears the word "soldes" in huge white letters below and above the slit. Small white, blue and green squares below the smaller horizontal window form the background for the information that items have been reduced by 50%, 30% and 20%. Two slits permit a view of the decoration inside the window, but on coming closer we see four mannequins dressed in some items of the winter collection.

Turner described the isolation of the people in the phase of transition.[241] This window's decoration, too, symbolically isolates the mannequins representing the old fashion. They are separated from the public sphere as if in a prison cell and the word "soldes" explains the reason for their punishment. As illustrated by Michel Foucault with the historical example of a delinquent, the crowd should be allowed to visit the convict at regular intervals. The name of the delinquent, the crime and

241 Turner (1997:95).

the judgement had to be written on the door of the prison cell in large and legible letters.[242] When we peer into the cell, we see mannequins on a pedestal; they are no longer on street level. The prisoner in this case is the winter collection, and its only crime is that the winter collection is no longer in fashion. The verdict: The winter collection must die!

AVENUE MONTAIGNE

Traditional fashion labels have their boutiques in this street. There are not many shoppers walking around because most potential clients are either driven over by their chauffeurs or come by taxi. A famous hairdresser in this street employs an attendant who parks the cars for his clients. It is the peak of the retail pyramid, but even high fashion boutiques need as much traffic as the shopping streets. This is why some traditional couture houses changed their location to such streets. It will be interesting to see if boutiques for the upper strata dramatise their seasonal sale equally well. Since the people who shop in these boutiques are the leaders in fashion, why should they buy clothes that are no longer in fashion? The first conspicuous show window belongs to one of the traditional Parisian fashion boutiques:

◁ The storefront is split into three parts. The middle one is the entrance with a double door with a tall show window on either side. The two show windows are totally covered with a white nontransparent film and even the doors are completely covered with white film so that there is absolutely no view into the store. The white covering has been pulled away slightly at the height of the door handles, but all we can see is a plank. The appearance of this high-end fashion boutique is even more radical than the seasonal sale decorations found on the middle-class shopping street.

242 Foucault (1995:111).

But when we came closer, we found the explanation for this on one of the show windows. The boutique had moved, and what we had seen was the abandoned show window. Curiously enough, the dead shop was dressed in quite the same way as the alive ones on the Avenue des Champs Elysée, where totally covering the show window was a frequently used decoration technique for dramatising the seasonal sale. Passage rites also employ symbols of death in the transition phase to represent the transition from one state to the other. Initiates in tribal societies are put to death symbolically and have to stay in this state for some time. Covering the show windows completely clearly indicates that the store is abandoned, dead, during the year and it also protects the empty shop from the eyes of the passers-by. The shop is thus separated from life. Were someone to die on the street, the corpse would also be covered immediately. It seems to be a deep-seated intuitive gesture, which also means separating it from the rest. Like the veil of the widow, the show window's covering also separates us from the death and emptiness of the former boutique. We walk down the street and pass by the next couture house:

◁ Behind a black, painted cast iron fence with golden spearheads we see the show window, which is cut precisely into the façade of an old, traditional Parisian house. The rectangular show window is almost totally covered by a white film, which is pasted directly onto the pane of the show window. Only a small gap has been left between the slender, stainless steel frame. Then, cut out right in the middle of the cover is the word "soldes". It is impossible to look into the store. Only the warm light from its interior escapes through the gap between the frame around the covering and through the cut out letters.

The window dressers here have used the same cheap material for the still alive shop that they had used for the abandoned shop. The diffuse symbol of covering the show window entirely is the same here: the intuitive image of the hidden face or façade conjures up associations with someone who is dead or has been separated in a symbolic manner. In the context of the fashion boutique, this means abandonment, or dramatising the seasonal sale. When a shop is closing down, it wants to get rid of its stock as well. So, we are in fact very close to the death of the shop, also in a realistic sense of the term. Having tested

the theory of the execution of the winter collection against the dramatisation rites of punishment, we also discovered visual aspects of the death of the shop itself during the sale. Both these concepts are linked with death caused by someone else. Do fashion retailers execute the winter collection, or do they dramatise the death of their own shops? Does all this symbolic activity only serve to show the customers that they can save money if they shop during the sales, or is a deeper symbolic purpose concealed behind the covered show windows? We continue our walk and come to a small couture boutique on the same side of the street:

< On the left side of the storefront is a double door with a slender wooden frame. On its right is a nearly square show window going all the way down to the pavement. The entire glass surface is covered with an opaque, red film. From a distance, some cut-out forms in the middle of the show window can be identified as a capital "E", the first letter in the name of the couture house.[243] There must be a lot of light inside the store, but not much of it escapes through the opaque, red film. We can discern three mannequins in the show window. The mannequins are abstracted white figures in black dresses. Neither of them is looking onto the street. The one in the middle is facing the store, so we can only see it from behind. Each of the other two is looking to the left or to the right, which is quite an unusual positioning. The white dummies are decorated with black ribbons. One of them has a ribbon around its head, the second one around the wrist, and the one on the left has a long black ribbon around its neck. All of them are so long that a length of ribbon lies unrolled on the floor. The dummies seem as if they were frozen in dance poses. One is holding its hand in a horizontal position, while the other's hand is raised. One roll of ribbon is left on the floor. One small transparent sign on the floor says "soldes" and "a l´interieur" in smaller letters. We would have not seen the little sign had we not explicitly looked for it. Impossible to see it from afar, it is difficult to find it when in front of the show window.

We ask ourselves whether the black ribbons are accessories for the black dresses, or decoration elements. On first

[243] We have changed the letter in order to conceal the store's identity.

glance, the ribbons do not look neat, and the fact that they are lying on the floor could well mean that they are not part of the winter collection. We begin to wonder what symbolic meaning the black ribbons have in this particular dramatisation of the seasonal sale window. In certain religious ceremonies ribbons are used to make the sacred nature of the victims during sacrificial rites visible.[244] We have already pointed out that the dichotomy of ugliness and beauty is equally capable of creating a sphere of religiousness of this kind. Here, the dramatisation does not use ugliness as a means to signify the religious character, but the decorative aspect of the ribbon. Ribbons are used for separating spaces, persons or animals from the everyday. In our case, the mannequins are decorated with precisely this symbolic sign. The scene seems to be set for symbolic use, also because the dresses have no price tags and the show window has transformed from a space for advertising into a symbolic space. Although the range of the mannequins' movements is limited, the unnatural position of their arms creates postures that are rather unusual and in a way even grotesque. The classic text by Henri Hubert and Marcel Mauss on the nature of the sacrifice could be of help in analysing this symbolic dramatisation.[245] Hubert and Mauss were the first to introduce the term "sacrifier" in this context:

"We give the name 'sacrifier' to the subject to whom the benefits of sacrifice thus accrue, or who undergoes its effect. This subject is sometimes an individual, sometimes a collectivity – a family, a clan, a tribe, a nation, a secret society."[246]

The question of benefit can only be answered symbolically. Rituals are symbolic actions, and the clearance of stock or buying things at a lower price during the sales are rational actions on first glance. But even inanimate objects can be befitting subjects of a sacrifice:

"There are, however, cases where the effects of the sacrificial consecration are exerted not directly on the sacrifier himself, but on certain things which appertain more or less directly to his person. In the sacrifice that takes place at the building of a

244 Hubert/Mauss (1981:29).
245 Hubert/Mauss (1981).
246 Ibid., p 10.

house, it is the house that is affected by it, and the quality that it acquires by this means can survive longer than its owner for the time being. In other cases, it is the sacrifier´s field, the river he has to cross, the oath he takes, the treaty he makes, etc. We shall call those kind of things for whose sake the sacrifice takes place objects of sacrifice."[247]

By this token, the cornfield can also be an object of sacrifice, and there are a lot of sacrificial rites toward this purpose in all cultures and through all times. Spring was a favoured season to perform them because Nature had to be awakened to guarantee a successful harvest. The more important the sacrifice, the more important must be the victim. Thus, the sacrifice of the god developed into one of the most perfected forms of the sacrificial system.[248] The sacrifice of Dionysus belongs to this category. But how can we relate Nature, the corn god and the cornfield to culture, to the production of fashion, to the seasonal collections and to the followers of the new trend, who, according to Barthes, are in a similar mental state as the followers of the Dionysian cult? How can we build this bridge to the past? Going by Barthes' claim, we must firstly assume that the arrival of the spring collection can be related to an ancient experience of ritual sacrifice. We will now follow the analysis proposed by Hubert and Mauss and try to find out who plays the role of the victim, and who the role of the sacrifier. In the Dionysian rite, the sacrifier is Nature, particularly the cornfield. The spiritual life of the fields is externalised by Dionysus' bull and his goat. The death of the god and his resurrection is magically linked to the life of the cornfield. The death and the resurrection of the god, acted out in the ritual in order to awaken Nature for sacrifice, have a vitalising power. The treatment of the victim is an important aspect in the construction of sacrificial rituals. It is necessary to relinquish the links to the profane world so that the death of the victim is not a crime, but a sacrifice. There are numerous rituals for relinquishing links to the profane world. Victims used to be dressed up, painted, made drunk, adorned with a crown or bedecked with ribbons.[249] In agrarian sacrifices, the victim is a symbol of the fields and their products.[250] In the case of the Dionysian rite, the links that

247 Hubert/Mauss (1981:10).
248 Ibid., p 77.
249 Ibid., p 29.
250 Hubert/Mauss (1981:69).

bind the corn to the fields must be weakened. This is done by the transition into an animal, like the bull or a goat of Dionysus, who represents the fields. We will attempt a leap from the life of the cornfields into the life of fashion. The lifetime of a collection is half-a-year. Every half-year a collection symbolically dies so that it can be replaced by the subsequent one. The winter collection is followed by the spring collection. When we apply the logic of the sacrificial system to fashion, then the winter collection has to be sacrificed in order to give new life and power to the spring collection. Thus, the victim is the collection, which is followed by the new one. We have pointed out that the victim has to be sublimated into a sacred state. We will assume that in our case this is done by blocking the view with the opaque red film and by decorating the black dresses with ribbons. We define this decoration as a sacred stage, the next step being the sacrifice of the victim. In the case of the bull or the goat, this involves rites of slaughter. In the solemn moment, the knife cuts into the carotid of the animal making the consecration final and irrevocable. In consumer culture, slashing the carotid can be compared to the slashing of price. The prices related to goods are the lifeblood of commodities. When we cut the prices, the blood runs out, and the fashion collection loses its value and dies. After the bull was sacrificed, the participants of the rite would eat its meat. This can be compared to the consumption of the sacrificed winter collection during the sales period. What follows thereafter is the resurrection of the victim that, in our case, is the spring collection. The seasonal sale window is the altar at which fashion is sacrificed twice a year, the sacrifier being the fashion system. The power of the new collection is symbolically generated by the sacrifice of the previous one. It is ultimately Dionysus' resurrection that brings new life to the cornfield. This finds its equivalent in the life of the new seasonal collection, which, in turn, is renewed by the sacrifice of the previous collection. We are standing here in front of a Parisian couture house, which is performing a sacrificial rite from the past. We will now leave this show window and the theory of Mauss and Hubert behind us and visit a livelier shopping street.

RUE DU FAUBOURG SAINT HONORÉ

All the big names in fashion have their shops on this street. It is narrow, the shops are considerably smaller than the ones in the big shopping streets, and it has no mega stores. Some big brands have opened several smaller branches here so that they can present their entire collection. We find our first striking example of a seasonal sale decoration in the shop of a fashion designer, who not only presents his own collection but also designs for a big fashion brand. Because the shop is on a street corner, its window decoration can be seen through enormous show windows both from the shopping street as well as from the side street.

A major section of the shop is dedicated to the seasonal sale decoration. Its triangular space has one big show window facing the main street and one facing the side street. Inside the shop, colourful garments on a structure made of chromed tubing form the third border. Everything is white beyond this border of colour. The chrome tubes extend into the sacred white space because garments are also presented in this area during the rest of the year. We count six mannequins, one dog and five electric fans within the sacred stretch of space. The dog, totally chrome-plated, with a white crown of feathers is seated on a white upholstered chair, with head turned up to the sky. The upholstered chair faces the corner of the shop. Chromed fans mounted at varying heights on tripods surround the dog. The six mannequins, who also have chrome skins and a white feather crown, are all dressed in white lingerie and have a transparent white shawl wrapped around their shoulders. The shawls, each approximately six meters long, move in the wind generated by the fans and invisible wires hold their ends, making it appear as if trainbearers were holding them. The scene looks dynamic. One of the women dressed in white is kneeling before the dog, while the others seem to follow the procession led by the dog sitting on the white throne with its head raised.

We get the same feeling as when accidentally drawn into a procession in a foreign culture. It is clear to us that we are witnessing a symbolic action, but we are not sure at first about what is being dramatised. We are reminded of the ballet *Le Sacre du printemps*, which was premiered in 1913 at the Théâtre des Champs-Elysées in Paris, a theatrical performance of a sacrificial ritual. Images of Russian rituals served Vaslav Nijinsky as the basis for his choreography set to the music of Igor Stravinsky. As the story goes, a young girl is selected by a ritual process and then sacrificed. She has to dance until she dies. Nicholas Roerich, who used early ethnographic material for the scenery and the dresses, also designed the stage.[251] We do not know whether the window dresser of this show window is well-versed in ethnography. We remember a scene in the ballet in which young women are dancing and the one who falls down is chosen as victim. Has the mannequin next to the dog perhaps fallen down and then become the victim of the sacrificial rite? Nietzsche referred to the Dionysus cult in his *Birth of Tragedy*, but the text can also be read in order to understand the new constellation of science and art at the beginning of modernity:

> "In the constellation of art and science, in the context of ritual as a cultural pattern – both as discourse and scene – a concept that seems important to me for locating the choreography of *Le Sacre du printemps* becomes discernible. Not the ritual is the concern of the respective reconstruction – scientific or artistic – but rather the ritualising processes, or the 'representations of the ritual'. It is when the performative representations of a pattern of relations between body, space and time are organised in rituals, as Catherine Bell defines them, that the 'representations of the ritual' are designed and communicated, both in ethnographic descriptions as well as in the fictions of art."[252]

The stage designer Roerich was both scientist and artist. He not only studied ethnology and archaeology, but also painted and designed sets.[253] What we see in the show window of the couture shop is not a reconstruction of a ritual but an artistic

[251] See Brandstetter (2001) for an in-depth analysis of the ballet from the viewpoint of ritual studies.
[252] Brandstetter (2001:135)*.
[253] The parallel artistic and scientific research in the Russian avant-garde is an interesting phenomenon. While scientists built machines for analysing the visual capacities of architects and painters, the artists used the machines in order to analyse their artwork.

representation of a ritual. Ritual is represented through rituali-
sation; in our case, however, it is in the liminal representation of
the mannequins that the ritual process is shown as a frozen im-
age. We previously pointed out that, according to van Gennep,
the seasonal sale can be interpreted as a rite of passage.
The liminal state of the shop that sells garments at a lower price
is indicated only by diffuse symbols, no word is written here.
The retailer as agent of ritual mastery has applied an artistic
method for executing the seasonal sale. The myth related
to the fashion system claims that a new collection is born twice
a year in the fashion capitals. According to Barthes, a myth is
merely a declaration and everything can become a myth. Only
formal borders exist, but there are none where meaning is con-
cerned.[254] Barthes' analysis of everyday myths helped us
to throw light on the disturbing fact that the mannequins are
wearing lingerie even though the shop does not sell lingerie:

> "Striptease – at least Parisian striptease – is based on a contra-
> diction: Woman is desexualized at the very moment when she
> is stripped naked. We may therefore say that we are dealing
> in a sense with a spectacle based on fear, or rather on the pre-
> tence of fear, as if eroticism here went no further than a sort of
> delicious terror, whose ritual signs have only to be announced
> to evoke at once the idea of sex and its conjugation."[255]

Voyeurism as a form of consumerism can also be ascer-
tained in the case of the show window. This is why on viewing
this seasonal sale window for a second time we are confronted
with the delicious fear of another type of ritual: the Parisian
striptease. Obscenity is yet another of the Dionysian categories
alongside the naked body. According to Turner, it is an intuitive
sign of ritual, especially in the second phase of the rites of
passage. In high culture, dramatisation does not directly deploy
the sign of nakedness, but only an indication of it so that the
voyeur has to envisage the desexualised ritual body. Myths are
in a constant state of flux. Claude Lévi-Strauss describes this
readjustment of rituals to new social realities in tribal socie-
ties.[256] According to him, myths are altered in order to create a
difference to the neighbouring tribe. We, too, adjust our myths

254 Barthes (2000:109).
255 Barthes: (2000:84)
256 Lévi-Strauss (1977:277).

from time to time in our contemporary consumer culture, but only for commercial reasons. Nietzsche describes the central function of the myth within a culture as follows:

> "But without myth every culture forfeits its healthy, natural creative force: only a horizon defined by myths completes the unity of a whole cultural movement. Only myth can rescue all forces of imagination and of the Apollonian dream from their aimless roamings."[257]

The myth of fashion based on its renewal twice a year is one such myth that appears on the horizon of our consumer culture. The ritual of the seasonal sale and its symbolic dramatisation in the seasonal sale window makes the belief in this myth stable. But as Lévi-Strauss noted, this myth can change. And this changing myth could lead to a change in the related ritual as well.[258] A show window on the other side of the street shows another way of dramatising the ritual, but using Dionysian aesthetics:

⊲ The storefront of the boutique is quite small. In the middle is an entrance, and small show windows on either side of it. This boutique belongs to one of the most renowned Parisian fashion houses. This couture house is famous for its colourful, playful and rich garments. But the two black, headless velvet mannequins are dressed with paper. The dress is sleeveless and down to the floor. The following message is written on it in black handwritten letters: "SOLDES 40% SUR TOUT LE MAGASIN".

Pierre Bourdieu described lifestyle as a systematic product of "habitus".[259] Habitus is a system of internalised patterns capable of producing all the typical thoughts, perceptions and actions of a culture – but only these.[260] Bourdieu describes in his *Distinction* the different ways in which people create their lifestyles, for example, by using music to show their status.[261] In this sense, decorating shops is also a way of addressing different lifestyles and creating distinction. Contrary to our conviction that expensive boutiques dramatise the seasonal sale more

257 Nietzsche (2000:122).
258 See Lévi-Strauss (1977:232) for the relationship between ritual and myth.
259 Bourdieu (2005:172-73).
260 Bourdieu (1974:143).
261 Bourdieu (2005).

artistically, we have now discovered an example that would also apply to consumers of the lower strata of society. The brand name is the only symbol of distinction left in the show window during the sales. Here, the sacrificial dress is simply made of cheap paper. The liminal phase of inversion is also very intense, because during the rest of the year the garments are its very opposite. The difference becomes stark when the new collection arrives. The winter collection is now represented by the paper dress, the sacrificial dress. Once the winter collection is sacrificed, the new collection can resurrect from its ashes and from the visual poverty of the seasonal sale window. Barthes pointed out that speaking about outdated fashion is a taboo in magazines. Perhaps the show window follows a kind of unwritten "negative rite" which says that the old garments have to be concealed, or replaced by representations like the paper dress in our case.[262] In a discussion with Jean Baudrillard, Jean Nouvel spoke about how architecture, and especially design, works in a sphere of "aesthetic of sacrifice".[263] What Nouvel addressed here is the "sacrifice of the visual", whereby all that remains is the interaction with the dematerialised commodity.[264] According to him, this aesthetics of visual sacrifice are interesting in relation to rituals as well. It is the symbolic use, the gesture, which creates the result, regardless whether the dress is made of gold or paper. The ritual action makes it possible for design to work within the sphere of visual sacrifice. A shop for children's clothes shows on a smaller scale what we saw earlier:

< There are two child mannequin torsos in the show window. Both of them are dressed in white, sleeveless cotton dresses with the word "SOLDES" in big red characters written vertically on them. There is no backdrop, so we can see the baskets inside the shop with the goods on sale. Behind the window are teddy bears, and at the rear of the shop are the reduced garments.

Here again the mannequins are wearing their ceremonial dresses. But the ceremonial dresses look used. It seems that the window dressers use them every time the seasonal sale has to be staged. It is not the store's glorious mise-en-scène that invites us to an economic exchange inside it, nor is it a sacralising

262 "Negative rites" do not demand several actions, they in fact forbid them. See Durkheim (1971:299).
263 Engelmann (2004:55).
264 For example, the miniaturisation of electronic products.

ostentation as described by Baudrillard. It is yet another symbolic giving which is presented in the show window during the sales. Baudrillard says the following about the show window:

> "The shop-window – all shop-windows – which are, with advertising, the foci of our urban consumer practices, are also the site par excellence of that "consensus operation", that communication and exchange of values through which an entire society is homogenized by incessant daily acculturation to the silent and spectacular logic of fashion. That specific space which is the shop-window neither inside nor outside, neither private or wholly public, and which is already the street while maintaining, behind the transparency of its glass, the distance, the opaque status of the commodity – is also the site of a specific social relation. [...] Shop-windows thus beat out the rhythm of the social process of value: they are a continual adaptability test for everyone, a test of managed projection and integration." [265]

This is Baudrillard's claim for the everyday show window that showcases the commodities with their fetish character in a spectacular atmosphere. But this is also true of our seasonal sale window. Social status can be achieved by purchasing the latest trends. The seasonal sale beats out the rhythm in which the collections change and symbolically performs the transformation from one trend into the next. This is done by performing a passage rite, another form of which is shown to us by the next show window:

◁ White T-shirts, displayed on white hangers. Attached to bamboo sticks and suspended from the ceiling, they seem to be floating in the air. Blue dotted lines criss-cross each other on the window-pane, and a few percentage signs also float around.

The window does not look sophisticated. It certainly does not meet the usual standard reigning in this stylish shopping street. The T-shirts are not typical winter garments, but are placed in such a way that they become the background for the percentage signs. The random arrangement of signs and clothes along with the slanted dotted lines creates a special atmosphere

265 Baudrillard (2003:166).

in the façade. We may have found the type of places that Michel Foucault called "heterotopias", places where the crisis occurs, namely, in the nowhere. Heterotopias have no fixed geographic position.[266] Although the show window belongs to the street, it also belongs to the store. It is private and public at once. The production of signs is for everyone, but the consumption for just a few.

≪ A big white paper poster conceals the window of the little fashion boutique. On a smaller page, we can read "Soldes", and a colour code related to the logic of the reduction system is listed below it. A green dot means 30%, a blue dot 40% and a red dot 50% reduction.

Baudrillard's seduction through signs[267] is reduced here to a mathematical symbol, a black percentage sign on white paper. Coloured dots represent off sale goods. No indication of the spectacle: mathematical signs and numbers instead of a glorious mise-en-scène. An article published in 1959 in *Vogue* magazine illustrated the fashion code with traffic signs where the models are presented like cut out figures in an abstract white space.[268] Thus, the percentage sign is the symbol of the seasonal sale, a sacrifice of the visual instead of excessive display. Guy Debord reflected on the spectacular nature of the consumer society in the following:

"As the indispensable packaging for things produced as they are now produced, as a general gloss on the rationality of the system, and as the advanced economic sector directly responsible for the manufacture of an ever-growing mass of image-objects, the spectacle is the chief product of present-day society."[269]

266 Foucault (2004:375).
267 For a profound discussion on Baudrillard's theory of signs, see Reck (1986:237).
268 Maybe this was Roland Barthes' inspiration for his work on the fashion system. The August issue of *Vogue* was published in the same year in which Barthes did his research on fashion magazines (from June 1958 until June 1959). The article is called "Le code de la mode" and describes in short the characteristics of fashion details. See Charles-Roux (1959:26-33).
269 Debord (2004:16).

BOULEVARD HAUSSMANN

In his analysis of the fashion system, Roland Barthes did not take into account the visual representation of fashion – neither in the fashion magazine, nor in its spectacular represen- tation in the show windows of fashion stores. The main body of his analysis only addresses fashion.[270] But this is exactly the reason why the transition from one fashion to another and the transitional phase is not within his field of vision. The seasonal sale stages the not fashionable, in fact it confronts us with items of fashion that represent the old fashion. Barthes pointed out that fashion magazines never speak about what is not fash- ionable.[271] This could be interpreted as a negative rite.[272] While fashion magazines are only concerned with the new fashion, the show windows have to deal with the no longer fashionable. The spectacular fashion window's promise to stage the fashion- able during the year is disrupted by the seasonal sale windows, which display the old fashion. We have already pointed out that the seasonal sale window is a passage between the old and the new fashion collection, and it is this transition from one collection to the next that Barthes describes:

> "But in Fashion this transformation, it seems, is justified in a particular and even more imperious manner. If Fashion's tyranny is identified with its being, this being is ultimately no more than a certain passion of tenses. As soon as the signified Fashion encounters a signifier (such and such a garment), the sign be- comes the year's Fashion, but thereby this Fashion dogmatically rejects the Fashion which preceded it, i.e., its own past; every new Fashion is a refusal to inherit, a subversion against the oppression of the preceding Fashion; Fashion experiences itself as a Right, the natural right of the present over the past [...]."[273]

270 Barthes (1990:12).
271 Ibid., p 184.
272 According to Durkheim (1971:299), negative rites are taboos. The believer is not allowed to perform certain practices, while positive rites prescribe such practices.
273 Barthes (1990:272-273).

We encounter two important aspects in this quote. The first is fashion's "natural right" to change, to create the present and the past in the same moment. Fashions change like the seasons of nature. The strong link of fashion to natural seasons seems to empower the fashion system to change the fashion regularly. But this would not explain how the fashion system succeeds in creating new fashions every year. The transformation of the winter dress into the spring dress is a change, which is not related to the general system of fashion. This transformation is immanent to the system,[274] which is why the change of fashion is synchronised with the natural seasons, although the mechanism of change is not related to this natural phenomenon. Secondly, the change has to be analysed in a more abstract world, in the world of signs. Culture can be described as a system of sign systems.[275] A piece of garment (signifier) becomes fashion (signified) when it follows the fashion rules of the season. The codes (of fashion) define the relation between the signified and the signifier.[276] The code of fashion can be a colour, a texture, a style or the skirt length, which the fashion magazine has declared as the new look. In a classical study, Richardson and Kroeber analysed the lengths of women's dresses in an objective and quantitative attempt to define stylistic changes over a long period of three centuries (1787 – 1936). They summarize their findings as follows:

"The evidence until today shows that when a proportion has swung on the way to its extreme and gone halfway the other, it may oscillate for a decade or two part way back to the first extreme, but normally it resumes its swing toward the opposite. [...] No generic significance can be claimed for the value of a century found for the average periodicity or wave length of dress proportions."[277]

While traffic signs have a fixed meaning, the signs of fashion are constantly changing. According to Richardson and Kroeber's study, the skirt length changes from year to year. The code of fashion defines the length each year. And it seems as if there is a rule behind this, one we have not discovered yet.[278] In the

274 Barthes (1990:291).
275 Eco (1977:185).
276 We use these terms according to the semiotic triangle (e.g. Eco 1977:28).
277 Richardson/Kroeber (1940:149).
278 This might become even more difficult after the cited study, especially for the subsequent development of the fashion history.

meantime, we have reached one of the big department stores on Boulevard Haussmann:

⊲ The large show windows are totally covered with an opaque, red foil. On a white background in the middle of the show windows is the word "soldissimes". The typeface looks handwritten and has the appearance of a logo. There is no way of looking into the store or its showcases because we only see ourselves and the people on the busy street mirrored in the window. We now enter the store and pass by the accessories section where handbags with couture logos and watches are on sale as well. Again, we find the sale logo: "soldissimes". While the showcases are full of seasonal sale logos as well as signboards announcing reductions, the signboards pursue the following structure: the sales logo on red background, the name of a couture brand in bold, black typeface, the percentage of reduction in bold red typeface. The goods on sale still bear their discreet price tag. Several handbags are displayed on a table, and they are shielded from the sale-storm by a signboard saying that the displayed goods are not on sale. It is like a tiny island on which several couture handbags have survived from being drowned. We get to the area where the garments are on sale. The institutional furniture has been partly removed to make place for the big rummage boxes on legs. The boxes are orange in colour and do not correspond to the department store's sale graphics. Inside the boxes are disorderly piles of goods. The box with the belts looks like a basket full of snakes. When customers searching for bargains dig into the box, the belts seem to come alive. But also pullovers, skirts, shawls, shirts, socks are piled up in disorder, one group next to the other. One box is full of couture shirts for men in a variety of textures, colours, styles and brands. Holding them together is an orange box with a handwritten piece of paper announcing the size of the piled-up pieces inside it: size 38.

The box with the couture shirts is a wonderful example from the world of brands, illustrating what Victor Turner called "communitas". Turner often observed that initiates passing from one state into the other had to go through a transitory phase during rites of passage. In this phase, they are treated as equal, and their nakedness or poor clothing makes their status visible to us. In our case, the orange box is the place where the couture

goods become equal. While during the year the shirts are nicely presented and separated by brand names, during the sales all brands are mixed, ordered only by size. The shirts lose their status in the world of branded goods; they are no longer in fashion. The arrangement of goods in boxes (rummaging boxes) is a common strategy in retail. When goods are "arranged" in boxes, the customer automatically takes for granted that they are cheap. But to guarantee the success of the sale it is of utmost importance to provide indications of the items' former value.[279] This is usually done by crossing out the original price (the items' value) and by writing the new price on the signboard. Another way of guaranteeing the original value is by retaining the original price tags and indicating the reduction in percentage. Thus, the percentage of reduction is laid over the items like a ritual dress, making the world of brands equal for the time of the seasonal sales. The next big department store on Boulevard Haussmann welcomes the customers with a very festive decoration:

‹ Hundreds of yellow flags hang from the porch of the store. They are about 3 meters long and 50 cm wide. Every second flag has "SOLDES" written on it. It looks like the decoration for a big festival. The show windows are empty and big, and yellow posters indicate the sales period: "SOLDES. DU 7 JANVIER AU 7 FÉVRIER". The spotlights on the ceiling of the show windows are turned on. But nothing in them is spotlighted. A few weeks ago, the spotlights highlighted the mannequins presenting the winter collection. Now the beams are directed to the wall or the floor. And this is what dramatises the absence of fashion. We enter the department store and find ourselves in the midst of hundreds of yellow boxes with goods on sale piled up in them, one box for a special group of items. We see a box full of ties, another one full of gloves, one with belts, and so on. The boxes are all yellow and each of them is equipped with a board indicating the reduction. All pieces in the box have the same price. The original price is marked as 28, the first sales offer was 18, and today the items can be bought for 5. The figure five is big and bold, the original price and the first reduction smaller, the latter two amounts are crossed out. Loud music is playing, the

279 Karmasin (1998:229).

song, a hit single from the charts, is being played at an unusually loud volume:

> "[…] Music stations always play the same songs / I'm bored with the concept of right and wrong / Everybody comes to Hollywood / They wanna make it in the neighbourhood / They like the smell of it in Hollywood / How could it hurt you when it looks so good / Cause you're in Hollywood / Cause you're in Hollywood / In Hollywood / In Hollywood / In Hollywood / Check it out, this bird has flown".[280]

The song is still playing when we walk out. The volume is unusually loud, as in a bar. Normally, music in sales environments stays in the background.[281] "Elevator music" is silent, in the background, anonymous. No vocal music, no text, no hard drums. But in our case, it is a popular hit single and you could sing along at the top of your lungs in the elevator. This music is not calming; in fact, it even animates us to dance among all these yellow boxes with all the mess inside them. Elevator music is meant to calm us down while imprisoned in the constricting space of the elevator, but the supermarket itself is like an elevator in whose constricting space between the shelves we are trapped. The quantity of goods is so overpowering that it can cause claustrophobia the way an elevator full of people can. In a full elevator, we can feel the presence of the people, their breath, their smell and their bodies. In the sales environment, however, we feel the presence of goods, but they cannot be as loud as they are outside. Outside on the streets, they cover huge walls, talk to us about their advantages through different media. But in the supermarket, arranged next to each other as tightly as possible, they have to be quiet, gently whispering their commercial messages through their packaging. Marketing literature uses the term "commodity pressure" as a metaphor for a wall full of merchandise.[282] A legal limit prescribes the number of people allowed in an elevator, but will there be a law stipulating how much "commodity pressure" we can take? We would probably go crazy without the insipid elevator music. Back on the street we pass by the next store:

280 Song text by Madonna and Mirwais Ahmadzai 2004.
281 This is true of most shopping malls, supermarkets, and big department stores. A specialised branch of business produces elevator music. It is fairly common practice in boutiques, especially those for younger customers, to play loud popular songs.
282 The German term for it is "Warendruck."

⊰ The entire surface of the huge square show windows is covered
up to the entire height of six meters. It is impossible to look
inside. The word "SOLDES" is written in bold white letters on
the lower part of the windows. The background is red; a play of
graphics with three-meter high orange letters saying "S-A-L-E"
tries to make the huge surface more appealing.

No "window shopping" is possible at this time because
most of the windows are closed-off by the sales posters. We see
"nothing", but this nothing itself is the message. The blocked
view is an intuitive strategy for creating meaning. When we
block the view, we also separate the spectator from the sphere
behind the veil. Here it is not the bride or the widow who
is being separated from her familiar social environment by the
veil, but the fashion of the previous season being separated
from the consumer society. Rites of passage deploy such
intuitive images in order to dramatise the separation or
transition phase: "archaic" images meet "advanced" marketing
techniques. In this sense, we have never been modern.[283] We
simply mix cultural techniques from different times, no mat-
ter if very old, like the intuitive image of the blocked view, or
only recently introduced, like the seasonal sale. The origins of
such intuitive images are never apparent, although we can still
feel them taking root in our unconscious. Gaston Bachelard
expresses the impact of intuitive images in poetry as follows:

"For the rationalist, this constitutes a minor daily crisis, a sort
of split in one's thinking which, even though its object be
partial – a mere image – has none the less great psychic reper-
cussions. However, this minor cultural crisis, this crisis on the
simple level of a new image, contains the entire paradox of
a phenomenology of the imagination, which is: how can
an image, at times very unusual, appear to be a concentration
of the entire psyche? How – with no preparation – can this
singular, short-lived event constituted by the appearance
of an unusual poetic image, react on other minds and in other
hearts, despite all the barriers of common sense, all the disci-
plined schools of thought, content in their immobility?"[284]

283 Latour (2002b:75).
284 Bachelard (1964:XIV-XV).

Intuitive images can even overcome the barriers of time. There is no need to tell the customers about the roots of the blocked view; they comprehend their meaning intuitively. The inalterability of such images would be a precondition for the possible return of rites from ancient times, like the Dionysian rites Barthes relates to the enthusiasm of the fashion followers upon the launching of the spring collection. The continuity of these images can be adapted to changing contexts. Such images are free and have no material determination.[285] In this sense, the seasonal sale window of a global fashion retailer can be a materialisation of such intuitive images. Our next window does not block the view. We can look through its glass pane:

⋖ Two mannequins are placed next to each other in a rather empty show window. The background is white. All the mannequins are wearing the same flowery skirt and blue jeans. On the show window is written: "40% Soldes".

Not a very spectacular dramatisation of the seasonal sale. But again, we find the principle of comunitas here. The mannequins are not dressed in a ritual dress, but in an identical manner. The window is a ritual place, because it is nowhere. There is no colour and no scenario, just emptiness. Nothing reminds us of, or relates to the old or the forthcoming trend. It is the in-between. We pass by a show window, and stop:

⋖ "SOLDES –50%" says a poster attached to the pane of the show window, covering the upper third of the total glass surface. When our gaze travels downwards, we see the inside of the small store. In the middle of the room and in front of the walls are piles of shoeboxes, up to ten boxes of each model. The boxes are different in colour, and each of them bears a price tag with both the old price and the reduced one on it. One single shoe is presented on the top of each pile that is like a pedestal. The show window has no back wall and as many shoes as possible lie exposed on its floor, making it look like the entrance to a mosque or a Japanese house that people may not enter with their shoes on. The shoes are placed in five rows, one next to each other. A jagged, hand written, neon yellow price tag is attached to each of the shoes. The boots are placed in one corner of

285 Eco (1977:111).

the window. A little sticker on the show window beckons the customer with: "ENTRE LIBRE".

It is hard to imagine what this shoe boutique looks like when the shoes are not on sale since no shop fittings are in view. The commodity fetish on its pedestal has been transformed into the seasonal sale item and presented on top of a pile of its own boxes. The more pieces of a shoe model are leftover, the higher the pedestal of boxes. The piles of boxes are of different heights, and as they are placed next to each other, they look like a diagram. Columns in diagrams are often in different colours, the way the piles of shoes are here. The pile of shoeboxes in the middle of the room looks like a mountain and we are immediately reminded of the term "totemistic geography".[286] Primitive societies sometimes use the topography of a mountain to describe each step of a ritual. The structures of myths and the programme of their rites are illustrated in the image of the mountain. And since everything is a potential totem,[287] why not also the piles of shoeboxes during the sales that illustrate our economic myths and turn our sales diagrams into totems? Our next shop is also a shoe shop:

◁ The show window is very wide. There is a wall in the middle of the window, which leaves the view into the store open on both sides. The back wall is rectangular with space in the middle for its merchandising visuals. A frame and two shelves are symmetrically aligned on both sides. Instead of a visual related to the seasonal collection hangs a poster with violet and blue vertical stripes. The small stripes are interrupted by three horizontal red stripes with "SOLDESOLDES" written on them in white lettering. Three words, "SALDI (horizontal), SALE (vertical) and SOLDES (horizontal), form a crossword puzzle between the red stripes. "SALDI" and "SALE" use the same "S" and "SOLDES" intersects with the "L" of "SALE". But the altar is empty; there is no merchandise on the shelves. Instead, piles of shoes lie scattered all the way up to the altar, as if literally flung on the floor. There is a mess inside the store as well. The shoes are on the shelves, but in a state of great disorder.

286 Lévi-Strauss (1966:165).
287 Lévi-Strauss (1966:155).

Merchandising uses such walls to feature several selected items and relate them to a bigger theme. This theme is represented by an advertising image. But in this case, the merchandise has been toppled from its throne. The shelves are empty; the shoes are on the floor. No image could better illustrate what goes on during the seasonal sale. The commodity fetish, which is on a pedestal during the year, is now thrown onto the floor. This is a symbolic act of desacralisation. Hubert and Mauss describe desacralisation as essential to sacrificial rituals:

"Of all the procedures of sacrifice, the most general, the least rich in specific elements, that we have been able to distinguish, are those of sacralization and desacralization. Now actually in any sacrifice of desacralization, however pure it may be, we always find a sacralization of the victim. Conversely, in any sacrifice of sacralization, even the most clearly marked, a desacralization is necessarily implied, for otherwise the remains of the victim could not be used. The two elements are thus so closely interdependent that the one cannot exist without the other. Moreover, these two kinds of sacrifice are still only abstract types. Every sacrifice takes place in certain given circumstances and with a view to a certain determined ends."[288]

The determined end of the seasonal sale is the advent of the new collection. It is the new seasonal collection, which has to be reinstated on the merchandising throne. The throne, however, is empty for the duration of the seasonal sale; nothing may be placed on it. The fetish character of the commodities is disrupted by the sales period. Is the sacred character of the commodity then sacrificed? One last look at the empty altar, and we proceed to the next strange window:

⊲ This is a medium sized show window, more or less square. Two headless mannequins are placed in it. They stand like guards posted before a door. The white skinned mannequins are dressed with a robe made of white plastic. The plastic robe is comprised of a 50 cm wide and 3 m long stripe, on which the word "SOLDES" in red typeface with a frame around it is repeated as a pattern. There is a hole in the middle for the neck. This ritual dress is the only cover for the naked mannequins.

[288] Hubert/Mauss (1981:95).

In the back is a white backdrop on which bold letters twice repeat: "-50%".

The two figures with their ritual dress look frightening, like initiates in a primitive ritual. As Turner described them, these initiates wear humble clothes to be distinguished from the rest of society during the passage rite. In our case, the figures are even separated from the normal life of the fashion mannequin. There is nothing in the show window, which could be bought. Sheer nakedness – nakedness in the graphic design and the actual nudity of the mannequins. Veblen points out that while other societies created longer lasting costumes our demonstrative wastefulness has led to the accelerated change in garment fashions today.[289] Ritual dresses also last longer, and they signify with great emphasis that a ritual is being performed. Similarly, the change in clothing from the regular garments of seasonal collections to the humble plastic ritual dress indicates that something is going on. Turner used the term "collective representations" for symbols which have the same emotional value for a group of people.[290] The humble attire of mannequins in the show window indicates the death of a fashion collection in our consumer culture. In this case, the added fact that the mannequins have no head makes the scene even more bizarre. Fortunately, we have not yet found a fashion window in which the mannequins were publicly beheaded to dramatise the seasonal sale. If they happen to be headless, it is because mannequins without a head are also en vogue from time to time in the decoration business.[291] Outside on the street, a vendor is presenting some cheap garments on low tables, like at a flea market. The garments are presented in disordered piles and most of the pieces have the same price. The same style and atmosphere that we found in the elegant and expensive department stores reigns here, the only difference is that it is not a seasonal sale and our vendor does not use any of the seasonal sale signs. On the low wooden table: no couture brand item is being sacrificed. Marketing literature tells us that the storefront window must stand out and seduce. Product, price, look and feel are important factors that influence the consumer's choice and make the stores distinguishable from one another.[292] During

289 Veblen (1934:175).
290 This term is originally from Durkheim, see Turner (1982:54).
291 For the history of mannequins and the changing fashions, see for example Parrot (1982).
292 Tongeren (2003:28).

the sales, however, these distinguishing factors are not applied. Both look and feel are the same as at the flea market, no matter whether it is a high-fashion boutique, a department store or a mass-market outlet. The merchandise is always subject to the same ritual rules. No one stands out; they are like initiates during the passage rite. They are all identical, dressed in humble clothes or forced into nakedness. Once again, we stop in front of the peculiar window of a fashion boutique:

‹ Two white male mannequins are placed in front of a white back-drop. They are dressed in just a skirt and a sash. These two pieces of clothing are made of blue paper on which "SOLDES" is written in bold white letters. One of them holds a pair of black shoes in its hands and the other one a paper cone, which looks like a sceptre. On the other side of the entrance is yet another pair. Both of them are holding a paper sceptre. No other decoration, no other merchandise, nothing written on the show window.

The mannequins appear like archaic figures to us. It is as if a deep-seated image in our unconscious is being awakened here. Is it a mythical figure we see here? Csikszentmihalyi and Rochberg-Halton refer to Jung when speaking of the return of mythological figures in our consumer culture:

"The archetypes of the collective unconscious are forms that shape the content of history, and the archetype dominating modern society and consciousness is the trickster, the Faustian devil figure, the bringer of chaos."[293]

The trickster, the bringer of chaos could really be a nice explanation for the chaos of merchandising during the sales. He could be the patron of the fashion sales, for it is he who brings Dionysian chaos into the shopping streets. The hearts were given to Faust, he has replaced them with a stone. Bataille also comes to mind. In his *Accursed Share*, he described the Aztec myth about how the sun was created by a sacrifice of the gods. Two gods where selected to sacrifice themselves in fire. Tecuciztecatl was the first. He was rich and healthy, so he could make generous offerings before he had to sacrifice himself.

293 Csikszentmihalyi/Rochberg-Halton (2002:42).

Nanauatzin was scabby and poor. He sacrificed pus instead of incense.

"The following night, a little before midnight, when they were to do their office, Tecuciztecatl was given his adornments. These consisted of a headdress of aztacomitel feathers and sleeveless jacket. As for Nanauatzin, the buboso, they tied a paper headdress, called amazontli, on his hair and gave him a paper stole and a paper rag for pants to wear."[294]

And it is Nanauatzin who is the first to jump into the fire, because he has nothing to lose. The wealthy god refused to sacrifice himself first, so he sprang into the fire after the god dressed in paper. For us it is like standing in front of Nanauatzin, with his sash and skirt made of paper. His sacrifice will make it happen that it becomes day, and the new seasonal collection will shine for the next half year. Paris was the city in which the surrealist movement was born. The surrealists were in search of poetry, but with a new form of aesthetics. They were in search of the "marvellous" in the chaos of the everyday, the ugly and the desperate. Benjamin linked Surrealism with fashion in his incomplete work on the Parisian arcades:

"Fashion is the predecessor – no, the eternal deputy – of Surrealism."[295]

The search for the marvellous did not stop even after Surrealism was long past. Lefebvre took up the marvellous again in his *Critique of the Everyday Life*. The marvellous, according to him, has been transformed into the bizarre, the evil into the nasty, the myth into the anecdote. He describes the law for the transformation of the irrational as follows:

"The mysterious, the sacred and the diabolical, magic, ritual, the mystical – at first all of these were lived with intensity. They were part of the real lives of human beings – thoroughly authentic, affective and passionate forces. Then, with the appearance and development of rationality, they were doubly modified, along with their relationship to everyday life."[296]

294 Sahaguin in: Bataille (1991:47-48).
295 Benjamin (2004:64).
296 Lefebvre (1991:117).

Does this transformation addressed by Lefebvre make the reception of what we see so ambiguous? Do we encounter the marvellous or the bizarre in the show windows during the sale? While Lefebvre claims that the rite has been transformed into gesture, Lévi-Strauss says that the ritual is a game in which the end is prescribed. The effect of this game is that winners and losers are segregated. The ritual has the opposite effect; it is connective. An asymmetry at the beginning is so transformed that everybody wins in the end.[297] But this has changed in consumer culture:

"Like science (though here again on both the theoretical and the practical plane), the game produces events by means of a structure, and we can therefore understand why competitive games should flourish in our industrial societies. Rites and myths, on the other hand, like 'bricolage' (which these same societies only tolerate as hobby or pastime), take to piece and reconstruct sets of events (on a psychical, socio-historical or technical plane) and use them as so many indestructible pieces for structural patterns in which they serve alternatively as ends or means."[298]

Flusser also addressed this transformation:

"The new human being is not a man of action anymore but a player: homo ludens as opposed to homo faber. Life is no longer a drama for him but a performance. It is no longer a question of action but of sensation. The new human being does not wish to do or to have but to experience. He wishes to experience, to know and, above all, to enjoy."[299]

297 Lévi-Strauss (1966:32).
298 Lévi-Strauss (1966:32-33).
299 Flusser (1999:89).

Mariahilfer Straße

Favoriten Straße

Meidlinger Hauptstraße

Innere Stadt

VIENNA

Lutz in Act one, *They are Dying Out*:
"Have you ever watched the faces of housewives, during a sale? A mass of
mindless, dehumanised, panicstricken grimaces that don´t even perceive each
other any more, staring hypnotically at objects. No logic, no brains, nothing but
the seething stinking subconscious."[300]

300 Handke (1997:248).

MARIAHILFER STRASSE

This is a very busy shopping street, especially during the sales period. People are rushing up and down, hunting for bargains. We start our walk in a shopping centre:

◁ A young woman is staring at us. She has her arms behind her head. Her blonde hair is cut to the length of her chin and is slightly dishevelled. She is naked and is standing close to the show window, inside a boutique for young fashion. Her breasts are covered with a yellow poster saying "-50% SALE". Two white bird's wings cover her pudendum. On her left are two female mannequins without heads. One of them has the same yellow poster saying "-30%", while the breasts of the other are covered with "-50%". Both of them don the white bird's wings.

It is not 1937 and we are not in the surrealist exhibition of mannequins, although these mannequins would have fitted into it quite perfectly.[301] It is not Man Ray, Max Ernst or Salvador Dali who created these exhibits. The surrealist movement is long past, and we are not in a museum that has recreated these exhibits for a retrospective show of the surrealists' work. This is real. Man Ray documented in photographs what the surrealists did with the nineteen mannequins that were abducted from the show windows of department stores.[302] We stand in front of a show window and wonder how the mannequins had managed to escape from an orgy in an art gallery. Placing the white bird's wings on their pudenda is a surprisingly creative act of dressing the mannequins for the seasonal sale. The wings, like those of a baroque angel, are not attached to the back but to the genitals. Or are they not attached to anything and can fly away whenever they want, like birds startled by something that has escaped our notice? One bird leads while the others follow.[303] We will be left with the unprotected nakedness of the mannequins, caught in a Dionysian orgy of obscenity. Nakedness is the prerogative of the innocent, of children and the primitive. In our culture, we may only play a frivolous game with it.[304] And that's what we do during the seasonal sale, but surprisingly not very consciously. All these aspects are located in

[301] Parrot (1982:153-157).
[302] Ibid.
[303] The seasonal sale is not regulated by laws today. A few shops in a shopping street start their sales, and then the others simply follow suit. So, at least all the birds are in the sky.
[304] Liessmann (2000:277).

the subconscious of marketing activities.[305] Deeper instincts are involved in many expressions of ritual activities as well:

> "Like when the expressive dimension of the ritual finds a purposive instrumental use, as often in marketing but also in artistic representations, or even an occurrence in political events. Of great importance for the effectiveness (social or cultural) of some rituals, as e.g. practices of magicians, is the extent to which such control functions can be taken over from the intentional level of the partici- pants and – once 'exposed' – made available to them, or used purposively."[306]

Marketing and art are mentioned here in the same breath as areas that use the power of ritual for their purposes. It would be truly interesting to find out the extent to which customers and "masters of ceremony", window dressers, are conscious of such practices during the sales. Do customers see through the practices of the seasonal sale? Are they able to "read" the signs consciously? We now walk further down the street and stop in front of a huge store with huge show windows:

⊲ The show window is partly covered with a nontransparent red film; its three stripes form a kind of flag. The top stripe is red, the middle one transparent and the bottom one is also red. On the bottom stripe is written: "WIR reduzieren ALLES".[307] "ALLES" is underlined. As the middle stripe is transparent, we can see a white wall at the back.[308] A clothes rack made of scaffolding elements is placed in the front and goes all the way from one side to the other. The garments are all on hangers. So many items have been presented that it is impossible to see the individual piece of attire. On the shoulder of each piece is a huge price tag, but the price is written in such a small typeface that it is not easy to read. The following show window also has the same long scaffolding rack for the garments. The difference, however, lies in the window's covering. Here, the show window is separated vertically and two thirds of it are covered in red, the rest is transparent.

Hanging garments on a rack is the usual way of stocking them. It is per- haps alright to hang the garments on a scaffold rack in the backroom of a store, but what about the show window? Frederic Kiesler was among the first to reflect on the importance of art and its application in the store window. He gives us the following advice in his book on window dressing:

305 We leave the psychoanalytical questions of the seasonal sale to scholars, who are more familiar with it.
306 Wiedenmann (1991:24-25)*.
307 "WE are reducing EVERYTHING"
308 It looks like the Austrian flag.

> "Make the store interior a show room instead of a stock room. Repeat the
> window inside, but without glass!" [309]

Kiesler would have been shocked to see his advice so brutally ignored.
Here even the show window is a stock room! What is normally hidden from
the customer's view is extensively exposed here. Everything looks provisional.
The rack, the backwall in paper and the presentation of the fashion pieces on
miserable hangers in the show window. In a boutique like this, the garments are
normally presented on mannequins in the show window. A clothes hanger can
be interpreted as a bone. In a manner of speaking, clothes hangers are the
skeletons of the fashion mannequins. Mircea Eliade describes the transformation
of shamans during their initiation process. The shamans are torn into pieces; all that
remains are their bones. They are then reborn from their bones. The belief that
animals and men can be reborn from their bones is not only restricted to shamanism.

> "The same mythico-ritual complex, in addition, has been preserved in more developed
> cultures, whether in the religious tradition itself or in the form of fairytales." [310]

The bones stand for death. In a way, this show window also seems to echo
such myths. During the winter, the collection is presented on mannequins, and
then comes the seasonal sale when the mannequins are dismembered and
stocked in the backroom of the store. The remaining bones (hangers) are used to
show the collection, which is no longer in fashion. Once the seasonal sale is over,
the mannequins seem to be reborn from the clothes hangers, wearing the new
collection. It is hard to imagine that a window dresser has consciously concocted
a story like this. But who did, and how did it come to be that it is dramatised in
the show window? The belief that life can be recreated out of bones can be found
in the bible as well, [311] for as long as the bones remain, life can be reborn out of
them. We now walk further and are astonished to see pieces from the new spring
collection so soon:

⊲ Its central entrance divides this boutique's façade into two show windows. On the
right side are two mannequins dressed in casual street clothes. The prices of
their clothing are on a small price tag standing on the floor. On the floor in front
of the mannequins is a small photograph showing a fashion model wearing the
exhibited pieces. The backdrop for this side is a narrow banner hanging down
from the ceiling with the image of a prestigious chandelier on it. The show win-
dow to the left is a little bit smaller. There are two mannequins here as well.

309 Kiesler (1929:85).
310 Eliade (1970:161).
311 Eliade gives the example of the book Ezechiel (37, 1-8), see Eliade (1970:162).

Both of them are dressed in a white T-shirt and long white trousers. A red fabric is wrapped around their pelvis. "SALE %" is written on the white T-shirts. Here, too, there is a red backdrop and bears the following inscription: "BIS MINUS 50%".

The shop is already in the phase that van Gennep called the incorporation phase. This is the last phase of the transition process of passage rites. While the new life of the fashion collection is shown on the right side of the window, the transition phase is shown on its left. Nothing from the last seasonal collection is used in the windows. The ritual dressing of the mannequins on the left side refers merely to the pieces on sale inside the shop. They indicate that the shop still has leftovers from the past collection even though the new collection has already arrived. The decoration makes two kinds of spaces clearly emerge: a sacred and a secular place. The new collection represents the normal state during the year; they are pieces that people will wear in the coming season. The very decoration for the seasonal sale is now for sale. Nobody will ever think of wearing it, for its sole purpose is to indicate the seasonal sale. The mannequins wearing the season's fashion for us are also wearing the dresses of the rite of passage for us. The symbolic act of transforming the fashion from the past collection into the new collection is carried out in the show window only. Here the sacred is not the prestigious, but the poor. The sacred cannot be bought; the sacred is abstract and monochrome here. This is not the way marketing literature introduces the new places of pilgrimage:

> "Brandscaping transforms the brand itself into a location – an attraction. Behind all the brand-building efforts there lies the conviction, that the glamour and power of the brand are the key weapons in the battle for the target groups and customers. By staging the brand experience in flagship stores, shop designs or entire theme parks, companies communicate the image of the brand and imprint a characteristic atmosphere on the consumer consciousness." [312]

Brands try to build sacred places. They build them very consciously with a lot of money so that the customer is impressed. But they also do it unconsciously, without money, during the seasonal sale because they do not bring out their own brand during this period. This is because the windows are kept anonymous, and their decoration poor. The following text on retail marketing also maintains that building churches is not necessarily what makes places sacred:

> "I enter a flagship store anywhere and sense – due to the artefacts of sacred archi-tecture – a feeling of grandeur, of magnitude and meditation which reflects on the range, the image of the company and, last but not least, on my state of mind." [313]

312 Riewoldt (2002:8).
313 Mikunda (2004:125).

Nobody has yet thought about how our soul responds to the seasonal sale and its dramatisation of the ugly. The ugly, or Dionysian aesthetics interrupts our profane consumer life in the retail churches. The sacred appears within the context of the everyday. It is created by means of desacralisation, by using what is poor und ugly. Sacred places are not created with money, but with ritual, or ritual-like action and the use of key symbols:

"If we were to try to pin down the exact nature of the sacrality evoked in such symbols, we would find a type of circularity by which sacredness, when not explicitly a religious claim to divinity, is a quality of specialness, not the same as other things, standing for something important and possessing an extra meaningfulness and the ability to evoke emotion-filled images and experiences."[314]

We find this specialness in the decoration of the seasonal sale window in comparison with that of the windows for the new collection. And the sacredness of the seasonal sale is not limited to the retail temples, it is celebrated everywhere, from the flagship store to the smallest fashion boutique. Ritual action and the process of creating meaning are not dependent on money. A stone circle can define a holy place equally well. The next shop we pass by uses the same theme as the first shop in the street:

◁ The façade has two show windows and two smaller showcases. In the window are a huge poster and three mannequins. The mannequins are dressed in winter garments: anorak, coat, jacket, trousers and warm pullover. The poster shows a smiling woman with black hair. She is wearing the same trousers as the mannequins, but her upper body is naked. She has covered her breasts with a white board. On this white board is written: "– 50%". A smaller version of this image is used as a price tag on the exhibited goods, but it is significantly larger than the usual size of a price tag. Instead of the reduction in percentage, we can read the price of each item on the board covering the nakedness of the model. The price tag is also used in the smaller vitrines where the lingerie is presented on torsos.

In our culture, public nakedness is nothing extraordinary. We are confronted with it on magazine covers as well as various other media. We do not usually find it in the show windows of fashion boutiques during the year because fashion posters try to stimulate customers to buy things by presenting the garments with pleasing fashion photography. During the sales, however, there is a kind of taboo about using conventional fetish strategies of window dressing to present the dying collection. This is why the model in the above window has to be photo-

[314] Bell (1997:157).

graphed nude, her only reference to the collection being the board announcing the reduction. She thus becomes part of the ritual audience. During the year, the model is seen dressed in items of the latest fashion trend. Customers walking by take it for granted that what she is wearing is in fashion. The poster could change according to the season or on a regular basis – just like the cover pages of fashion magazines. But fashion magazines do not speak about the not fashionable on their covers – show windows do, because they have to. They have to get rid of their leftovers. The predicament, however, is that the logical intention of the place to show the latest things has to be changed, turning it into a place where retailers want to get rid of the not fashionable. The price as a rational component of the sales offer is easy to change. But retail design has a lot of emotional elements in it as well, which is why window dressers have to deal with the emotional side of the drama. Especially when the new collection arrives and the retailer is left with too many pieces from the previous collection:

‹ This boutique for young fashion has a main entrance, which is slightly to the left of the middle axis. Pieces from the new collection are presented on two mannequins in the smaller window. The garments are in fresh spring colours and the price for each piece can be found on a list standing on the floor. The larger window is dedicated to the seasonal sale. Three big red banners partially block the view through the window. Two of the banners are placed vertically and the third one in the middle is positioned diagonally, nearly concealing the two mannequins behind it. The word "SALE" is written on the vertical banners and "WINTERPREISE"[315] on the one in the middle. A red surface with white concentric circles forms the backdrop for the mannequins. The items presented are black and white pullovers and anoraks. Each of them has a red price tag on it. The percentage sign in white is printed, while the price itself is written by hand.

The side with the new collection is not as impressive as the one with the seasonal sale goods. It is evident that the passage rite is still under way. Red is a signal colour that is used for different purposes in several cultures, and red is the dominant colour in this dramatisation of the seasonal sale as well. Turner describes the mythic figure in the following excerpt:

"Exu, whose ritual colours are black and red, is the Lord of the Limen and of Chaos, the full ambiguity of the subjunctive mood of culture, representing the indeterminacy that lurks in the cracks and crevices of all socio-cultural 'constructions of reality', the one who must be kept at bay if the framed formal order of the ritual proceedings is to go forward according to protocol. He is the abyss of possibility; hence his two heads, for he is both potential saviour and tempter.

315 "Winter prices".

He is also destroyer, for in one of his modes he is Lord of the Cemetery."[316]

The trickster god Exu describes perfectly the ambiguous nature of the seasonal sale window. The show window also has two functions during the sales: It must seduce, but it must also destroy. It must symbolically bring death to the past collection, and in the moment when the passage rite reaches the last phase of incorporation, it must seduce people with the qualities of the new collection. The separation phase is not very significant. Most often, the windows are directly transformed into the seasonal sale look.[317] People only take note of the change in fashion because of the seasonal sale. The trickster god brings chaos, just as the sales bring visual chaos in visual merchandising. According to marketing literature about how to "create interest":

"A backdrop for a retail setting does not have to be bland or without its own character. For example, you can make both the floors and the walls the same bright colour, such as red. The idea is that when you use this much of a strong colour, it becomes a background colour but has stronger visual appeal than a typical neutral tone."[318]

Of course, red is not only the colour of chaos in retail design, and painting the backdrop of a seasonal sale window will not be seen as a symbolic ritual action by the window dressers. But it means something different when it is painted in the bright colours of spring fashion. Creating ambiguity is much more difficult than creating a clear message. Here the fashion system has already decided for the new collection and the retailer has to execute this decision. The window dresser has to take the paint and prepare the ritual place where the past collection is going to be sacrificed. "–50%", and the pieces are dead for the fashion magazines. The next show window has also staged the old and the new simultaneously:

This lingerie boutique has two windows, which are separated by the entrance. There is a single mannequin and one torso in the left window. Both of them are wearing black and white lingerie. The banner in the back is inscribed with a lot of percentage signs in various sizes. The words "SALE – SALE – SALE" are emblazoned in the middle. The letters grow paler from word to word so that it seems as if they are fading away like an echo. The graphic design expresses disorder. In the right show window also has one torso and one mannequin. Both of them are wearing red lingerie. Instead of the sales banner, there is a smaller advertising visual showing a blonde model looking over her shoulder.

316 Turner (1982:77).
317 Since not all retailers start their sales on the same day, the separation phase is rather a macro phenomenon of the shopping street.
318 Kliment (2004:71).

The sacred and the profane are once again visualised with the help of the abstract disorderly use of symbols placed on a solid colour ground, and a conventional advertising visual. The background lends meaning to the scenario. This is clearly visible here as the mannequins and their decoration alone will be unable to express the difference between the past and the forthcoming fashion collection. In his book about ritual in architectural form, Kari Jormakka describes the difference between presentation and representation:

> "We may characterise ritual meaning as presentation (or, in some cases, possession) rather than representation through iconic or symbolic signs. [...] Like the masked man of the Zunis, the ancient Greek actor on stage is also possessed by the god, and the saint is actually presented in the mystical icon."[319]

The backdrops lend different meaning to the mannequins in front. It seems that the two stages work differently. One works with an abstract backdrop, staging the death of the winter collection, while the other one shows the new spring collection with the same mannequin actors. The ritual dimension becomes immediately social when we decide to attend one of these enactments. We could either save money to buy the old collection, or we could buy the new collection in order to be up to date. The next window provides only one option:

⊲ This rather large window is at the corner of the main shopping street. The niche is painted white, just like the interior of the store. Three mannequins are placed in front of a back wall occupying almost the entire length of the show window. The backdrop, which is painted white, is almost entirely covered by the red posters attached to it with the vertical inscription "SALE". The mannequins are wearing winter garments. A red horizontal banner attached to the show window at the height of their pelvis separates the mannequins from the public sphere. A sculptural object hangs on the back wall, between the mannequins. Made of red coat hangers it looks like a skeleton, which has replaced one of the mannequins so that there are actually four of them in all. On the floor in front of the sculpture are several hangers that are not attached to the main skeleton.

Three mannequins and a skeleton is what we have here. While our association to Eliade and the myths of creating life out of bones might appear strange, there is no doubt that death is being staged in this setting. It is like a "memento mori" of the fashion industry. All new fashions will die. And they will die very quickly, to be precise, in half a year. But because this is a kind of religion as well, we can believe in the return of fashion, which is presented to us here as death.

319 Jormakka (1995:21).

It will perhaps not return immediately, but in the future. We move on and discover yet another archaic reference:

◁ The windows of this fashion boutique are placed inside the niches of the façade. A green poster hanging on the show window covers its entire height and almost its entire width. Only a narrow stripe is left transparent. The inside of the niche is painted white. On closer inspection, we discern two mannequins inside we were unable to see when passing by the window. The only information we are given is the sales poster. On a green background is a red circle on which is written "SOLDES – SALDI – REBAJAS – SOLDEN - SALE".

A mix of languages is used here to inform us that the sale is on. Surprisingly enough the German term is missing. This combination of languages in consumer rituals can also be observed during Christmas. International as well as global fashion retailers use different languages to announce the advent of Christmas. This possibly highlights that fact that the feast is celebrated around the world, that it shares the same associations and values and thereby connects us with the entire world. But what values are transported globally during the sales? When compared to the festival itself, telling us that it is a period in which garments are cheap may not be a strong enough motive. Language being a strong element in rituals, retailers often use their own language. The mixture of different languages corresponds very well with the ambiguous character of passage rites, especially when the profane language of the everyday is not used during the ritual. And this is precisely why it appears sacred to us. A poster on a big department store says:

◁ "SALE – REDUZIERT"[320] is printed in bold white typeface on a solid red square. The advertisement covers two storeys of the department store building and is hung in such a way that it can be seen from afar.

It seems to us that this advertisement has reached a transcendental state. It is no longer speaking for the department store alone, but celebrating the time of the seasonal sale, and it is speaking for the whole shopping street. This is the "liminal" state of advertising in which a colour is used that neither belongs to nor can it be related to a brand. Different languages, and last but not least: no logo! The sanctity of the holy red, with the holy words on it does not allow the profanity of the brand name on the same surface. What we are witnessing here is the sacred space in advertising. Although we previously believed that a brand name creates a sacral sphere, it turns out that there are institutions like the seasonal sale in which the importance of the individual brands vanishes for a

[320] "sale – reduced".

certain length of time. A hidden myth beyond the individual myth created by the brands exists. Marketing literature has often pointed out that in order to satisfy contemporary consumer needs, brands have to create their own brand worlds. One aspect of these worlds is the old cultural technique of story telling. Since brands tell stories because they want to sell their goods, the text is only a carrier of the message that goods must be bought. It turns out that it is good to hide the concept lines so that the consumer is more involved in the process of meaning making. There are several scripts in our mind, which are used according to the respective purpose of marketing:

> "Mythical scripts are always deployed where basic needs – victory and defeat, lofty feelings and eternal questions – are concerned. However, for coffee or dish liquid advertisements, marketing draws on a different pool of experience: slice-of-life scripts. These sols contain the knowledge about how to conduct ourselves in certain everyday situations. [...] Sols are mechanisms for dealing with life; they help us adjust to the situation. Usually one is unaware of these processes." [321]

Marketing uses old myths as well as scripts of everyday behaviour in order to sell goods. When marketing employs a mythological script for seasonal sales, then consumer society can be sure that a fundamental issue is at hand. We will now look into the next show window and find this out:

◁ A horizontal red poster attached at eye level to the show window, and covering its entire length, says: "LETZTE REDUZIERUNGEN". [322] Behind it is a rack with black and white shirts on hangers. There are several pieces of each design on the rack as well as in the stockroom. A few shoes and a handbag are placed on the floor. Each piece has a large price tag. In the background is a white wall with red and orange striped posters announcing: "–70%".

All fashion retailers today stage the seasonal sale in a surprisingly similar manner; they are simply throwing away the reservoir of knowledge about good merchandising techniques.

◁ This trendy fashion boutique has two show windows: a smaller one to the right of the entrance and a larger one to its left. The freshly arrived spring collection is presented in the larger one of the two. One of the two headless mannequins is dressed in formal clothes and the other in a more casual style. The smaller window also shows two mannequins in winter clothes. The word "sale" is written on the window in bold, pink typeface at the height of the pelvis of the mannequins,

[321] Mikunda (2002:22)*.
[322] "Final reductions".

covering both of them. Although each fashion item bears a big price tag, there is a price list on the floor as well. Each item is listed by its original price. But since the price has been struck out, we have to read the price on the tags attached to the mannequins. There are two price lists, one for each mannequin. The price lists are written by hand with a thin felt pen, while the striking off is done with a thick marker. We now return to the window with the spring collection. The two price lists here are printed.

Since this shop does not have a backdrop – usually an important factor in creating ritual space – the differences are more subtle. While the decoration of the spring outfits does without price tags on the mannequins, since the price list is printed, the seasonal sale window has visible pricing on the mannequins. The price tag has been an important information factor from the very beginning of retail design. Here is some advice from the discipline's genesis:

"In order to distinguish between good and bad showcase price tags, it is also necessary to keep in mind how such decorations should never be used. One often sees price tags and description of goods scribbled in pencil or colour pencil on a piece of white paper; such bits of paper are almost repulsive." [323]

What follows is the figure of a handwritten price tag on a man's shirt for twenty-nine fifty. The frame is drawn with a trembling line and the numbers are vague. Such deterring price tags are used for the seasonal sale. Their message is clear: "Although we can easily print what we need for the show window, we do it by hand. We do it to draw the outline of the ritual circle."

FAVORITEN STRASSE

Customers who do not have much money to spend on their shopping frequent this street. When speaking of fashion design today, this is not the place we think about first. This street is not really a model for excellent retail design even during the year. Although similar shops exist in every city, we have never seen such an environment in books about retail design. But they probably make

[323] Schönberger (no year:17)*. This course book for window dressers was published before 1929.

more money than fashionable boutiques do. They form the base of the retail pyramid. A design exhibition in Linz[324] in 1980 was also not the focus of interest. Entitled *Design ist unsichtbar*,[325] the exhibition presented several international design positions that usually stood in context to the radical design movement. However, the title does not refer to this expressive design attitude but to the everyday, and to the "design" of relations between the designed objects and their dependence on influences outside the traditional design process oriented thinking. "Invisible" design is the design of the meaningful act. Alessandro Mendini, the leader of the radical group Alchemia conceived the part of the exhibition that showed thematic aspects of design. He created the categories "space design", "fashion design", "banal design", "illusionary design" and "ritual design". Ritual design corresponds to the main title of the show. How can rituals be exhibited? The Japanese designer and theorist Kasuko Sato was commissioned with the section on ritual design:

"Within the framework of the topic "Ritual Design" assigned to me, I wanted to portray a world that was a spatial and temporal void. I wanted to achieve this by using objects with ritual meaning which were imported from China with Zen Buddhism since the twelfth century, and which underwent a deep transformation thereafter according to the spirit of Japanese culture."[326]

Sato built a white pyramid to show the Zen Buddhist objects. The pyramid was dark inside, and in its centre stood a pedestal with a low table with sacrificed food on it. On the wall facing the entrance were masks from No theatre. She presented objects for the Japanese tea ceremony on the other side. The cup used in the tea ceremony became the paradigm of ritual experience at the beginning of the 1980s after the writer Cees Nooteboom published his popular novel called Rituelen in which a Japanese teacup plays an important role.[327] The teacup evokes images of complex foreign rituals around it. Kakuzo Okakura, ambassador of Japanese culture, wrote:

"Those who cannot feel the littleness of great things in themselves are apt to overlook the greatness of little things in others. The average Westerner, in his sleek complacency, will see in the tea-ceremony but another instance of the thousand and one oddities which constitute the quaintness and childishness of the East to him."[328]

In the meantime, more and more Europeans have acquired a sense for

[324] Linz is the provincial capital of Upper Austria.
[325] "Design is invisible".
[326] Sato (1981:634)*.
[327] Nooteboom (1995).
[328] Okakura (1989:31).

this ritual, but this does not necessarily mean that they understand its meaning. Of course, this complex ritual comprising more than a hundred rules of etiquette is foreign to us, as we cannot read most of the symbolic actions that it involves.[329] We have a mental image of this piece of handmade pottery, and we relate it to complex symbolic actions. Soshitsu Sen used more than 450 images in his book on the tea ceremony to illustrate the complex ritual action.[330] Pierre Bourdieu, on the other hand, draws a line between the useful properties of an object and its social use:

"To hypothesise, as one of them does, that consumers perceive the same decisive attributes, which amounts to assuming that products possess objective or, as they are known, 'technical' characteristics which can impress themselves as such on all perceiving subjects, is to proceed as if perception only seized on the characteristics designated by the manufacturers' brochures (and so-called 'informative' publicity) and as if social uses could be derived from the operating instructions."[331]

When rational properties do not necessarily lead to the expected use of an object, what about its symbolic, irrational properties? An article in the catalogue of the Design ist unsichtbar exhibition goes back to the relation between ritual and design:

"It is conspicuous, which to a certain extent even legitimises the concern with design, that our civilisation (especially that part of it which has so proudly called to life its ubiquity) is not merely characterised by the production, distribution, purchase and use of an article. In the minds of their planners, producers, dealers and buyers, a specific value is ascribed to these objects, regardless of the price paid for them. On particular occasions, this value can trigger a behaviour that can be easily delineated by the popular meaning of the term ritualisation."[332]

Also Hans Hollein referred to ritualised behaviour in the design exhibition he did for the Cooper-Hewitt Museum in New York in 1976. The exhibition MAN transFORMS challenged the academic view of how design is perceived and its relation to daily life. Hollein drew a map for the arrangement of the interrelated design subjects: "space", "tools", "body", "face", "politics" and "behaviour". The tea ceremony appeared beside smoking and gesture in the category "behaviour".[333] While Lefebvre pointed out that the ritual has become transformed into gesture,[334] Vilém Flusser made a distinction between the profane and the sacred

329 Grimes (1995:47).
330 Sen (1998).
331 Bourdieu (2005:100).
332 Priessnitz (1981:23)*.
333 Hollein (1989:22-23).
334 Lefebvre (1991:117).

gesture. Smoking a pipe in our culture is a useless activity and happens within the context of meaningful life, but it is not possible to rationalise it. It is a profane gesture. The tea ceremony, on the other hand, is taken as an example of the sacral, the "aesthetic gesture".[335] For Flusser, the absurdity of the sacral gesture is a necessary condition.[336] We now stop before a shoe shop:

⋖ In front of the façade are several tables with shoes on them. The tables are covered with yellow plastic tablecloths decorated with percentage signs in various sizes. The show windows are totally covered over with red posters announcing various reductions in percentage.

The shoes are piled up on the tables like offerings in a temple. The table-cloth creates a sacred sphere for the shoes. We are certainly not used to seeing shoes on a tablecloth. Mary Douglas pointed out that shoes are usually not perceived as impure, but they become impure as soon as they are put on the dining table.[337] The seasonal sale places the goods outside their normal context of purity. The creation of impurity has to be added to the list of strategies used for staging the seasonal sale. This aspect is mirrored in the next shop on our shopping street:

⋖ The huge windows of this fashion retailer are totally closed off. A red nontranspar-ent film covers the window's entire surface. Written in huge white letters is: "SCHLUSS-VERKAUF".[338] The words are slightly inclined, making them look as if they were toppling.

The shop of an international fashion brand is radically changed. The trans-parency of the show windows has been banished by darkness. Anthony Vidler points out that darkness has been frequently used in architecture to create anxiety. After all, darkness prevents people, things and truths from being perceived.[339] The loss of display creates an effect that Vidler calls the uncanny and it is like the loss of the traditional façades in modern architecture. Many people are still not happy about this development. We now pass by the next shop without a window display.

⋖ The show window consists of several glass panels held by a black frame. Posters are used to create the effect of a wall. They go from the floor up to eye level and are as wide as the glass panels. It is a repetition of the same information: "SALE −70%". The writing on the white posters is printed in red. The graphic design of the information is cold; in fact, the white area in the letter "A" is designed like a snow crystal.

[335] Flusser (1994:181).
[336] A summary of literature based on the development of the term ritual in design theory and consumer research from the 1980s onwards is given by Gruendl (2005).
[337] Douglas (1970:48).
[338] "Final Sale".
[339] Vidler (1992:169).

The use of snow crystals turns the sale into a winter sale. We are stand-ing in front of this wall and cannot see what is going on behind it. The poster wall creates a boundary between what is happening inside as well as outside the store. Creating borders is important for creating meaning in the ritual process:

"Ultimately, what is seen as 'dirty', 'impure', 'disgusting', etc. in a society is insignificant; it is essential to draw certain symbolic and moral limits since binary distinctions such as good and bad, pure and impure, sacred and profane, loyal and subversive, etc. introduce order and system into the cultural world."[340]

According to Nietzsche, in Greek tragedy the choir was used as a live wall to resist the attack of reality.[341] Poetry needs much thicker walls than seasonal sales. Our next shop sells sports apparel:

◁ The complete interior of this display window is painted white and is empty but for one mannequin, which is placed close to the window's pane. The mannequin is bound with a white plastic and a black and white traffic ribbon. Its head is covered with the plastic and the ribbon is tightened around the neck. If a real person would be treated in this way, death would soon result. Some red and yellow banners claim: "AUS. SCHLUSS. RAUS."

This brutal scene is quite shocking. When we apply the claim of the slogan to the represented mannequin, then it is like the execution of an aberrant delinquent. As the mannequins stand for fashionable customers, this treatment is astonishing. Here, the ritualised body is part of the concept of ritualisation:

"A ritualised body is a body invested with a 'sense' of ritual. This sense of ritual exists as an implicit variety of schemes whose deployment works to produce sociocultural situations that the ritualised body can dominate in some way. This is a 'practical mastery', to use Bourdieu's term, of strategic schemes for ritualisation, and it appears as a social instinct for creating and manipulating contrasts."[342]

The window dresser has indeed created a striking contrast between the mannequin, which presents the seasonal collection with a smile, and the prisoner in the moment of death. Foucault gave us a detailed account of ritual power and how it is applied to the prisoner.[343] Performance studies, on the other hand, describe our method in a performative (consumer) culture:[344]

[340] Belliger/Krieger (1998:16)*.
[341] Nietzsche (2000:44).
[342] Bell (1992:98).
[343] Foucault (1995).
[344] See as well Debord (2004).

"Urban planning, architecture and design make our surroundings seem like staged 'environments' in which individuals and groups clad in changing 'outfits' exhibit themselves and their 'lifestyles'. 'Shopping' becomes an adventure in which the buyer moves about like an actor in the different scenes designed by clever marketing strategists." [345]

The skills of marketing are indisputable. But we do not think that the seasonal sale window here is done in a totally rational way. And if it is, we must be truly frightened because the term control is not foreign to the retail business:

"Display takes place predominantly within the windows of large department stores. These are generally fully enclosed, offering the display artist total control of the environment. [...] Clever displays manage to create a spectacle as well as providing information." [346]

MEIDLINGER HAUPTSTRASSE

Several years ago, this shopping street was very popular among middle class customers. Later, the big brands moved to Mariahilfer Straße or to shopping centres on the outskirts of the town. This shows that the street is increasingly losing its social status. Stores like to call themselves "Trend Outlet Stores" but in reality, the goods are not trendy. Here, too, the seasonal sale has reached the final phase:

< This small store has only one show window and the entrance door is to its left. Numerous Posters are attached to the glass façade. On top of the window is a sticker listing the names of the fashion cities: "Wien – Mailand – Paris – Florenz – London – Rom – New York". The window is covered with cheap brown paper, from the ceiling down to knee level. Written on the brown paper are the words: "LAGER VERKAUF". [347] When we look into the store, we find that it really looks like a warehouse. The word, "AuSVerKauf" is written on yellow paper. Each letter is printed on letter-size paper. It looks like a blackmail letter for which the characters

345 Fischer-Lichte (2002:291)*.
346 Din (2000:95).
347 "Warehouse sale"

have been cut out of various newspaper headlines. A list with items on sale follows: "Marken-Mäntel-Jacken-Westen-Krawatten".

Mary Douglas created a model of cultural theory for ritual studies.[348] This model was further developed for consumer research in order to categorise customer types:

> "Individualistic and hierarchical cultures define time as something that can be planned and integrated into life and actions, but the egalitarian and fatalistic ones do not include time into this frame."[349]

The ritual phase disrupts both strategies of dealing with time. The four types of customers and their conceptions of time, which refer to their brand worlds, are overwhelmed by ritual time. Rituals create a feeling of timelessness; the moment in reality is related to mythology. An empty surface is used in advertising to express the code of the elite.[350] However, this principle loses its validity during the sales. The neutral backdrop in a seasonal sale window relates rather to the timelessness caused by its relation to myth than to the code of the elite and its search for the "classic". But timelessness can be related to ecstasy as well.[351] And this is much more akin to what we face here. Another small shop selling men's shirts.

⊲ A rack full of shirts is placed in the show window. Each shirt is different. Big orange letters on the show window spell the words: "ABVERKAUF BIS −70%".[352] There is no backdrop or any other decoration.

During the last hundred years, several design tendencies were born of the intention to create objects that could be used by both poor and rich.[353] Marketing does the opposite. Goods are designed to separate. The radical design group Alchemia also wanted to create objects which could be used both by members of the punk movement as well as by bank directors.[354] Taking everyday objects and blending them with high arts was their strategy in creating an aesthetic of the "betwixed and between":

> "For Alchemia, objects must be both 'normal' and 'abnormal'. Their ordinariness makes them flow together into the everyday reality and into the need for humdrum standardisation, whilst their exceptional character removes them from

[348] Douglas (2000:60).
[349] Karmasin/Karmasin (1997:132)*.
[350] Karmasin (1998:331).
[351] Karmasin (1998:283).
[352] "Sale – Reductions up to −70%".
[353] For example the Mart Stam cantilever chair for the Bauhaus.
[354] Sato (1988:70).

habit and connects them with the need for the unexpected and the accidental, for difference and transgression."[355]

This incidentally summarises the condition of the seasonal sale window as well. A huge shoe store is our next stop:

◁ The show windows guide the customers into the store. The entrance is set back into the building so that the window's display surface is enlarged. One single poster covers a large part of the window's surface. The upper part of the poster is red with "STARK Reduziert" written on it in white letters.[356] The remaining square surface is yellow. Three red arrows point downwards. The posters are hung in two horizontal stripes. The posters hang flush against each other in the upper row so that we cannot see what is behind them. In the lower row, however, only every second poster is hung which is why we can see some shoes inside Posters cover up the other half.

The arrow is an old sign with a long history that goes back to the birth of humankind. Adrian Frutiger describes the archaic connotations of the sign:

" The arrow sign is taken in two stages: as the flying weapon with the arrival of the wounding point and the barbs holding it into the flesh."[357]

The arrow is not just indicative of the downward direction of price; it is also an archaic weapon capable of killing the commodity on a symbolic level. Though the sign is abstract, it can in the same moment also contain an intuitive dramatic aspect that draws us back into ancient times where animals were sacrificed with the ritual weapon. The rival shoe shop across the street uses a less intuitive visual language:

◁ The façade of this shop is full of question marks, black and white ones. This forest of question marks is interspersed with vertical strips of striped white and red ribbons. Piles of shoeboxes fill the interior of the store. One unpacked model lies on each of the piles. The whole shop is a veritable mess signified by the question marks overlaying the scenario.

This shop is an instructive example of ambiguous visual design strategies. Using the signs of today, it creates an intuitive image of archaic beauty. What Hans Hollein pointed out in architecture can be applied to the store window as well. Since design moves between the poles of rational function and the ritual,

355 Mendini (1988:7).
356 "Big reductions".
357 Frutiger (1989:49).

that is, the cultic, [358] this window is undoubtedly located at the pole of cult. It transcends the clear message of the percentage sign and the tangibility of words.

INNERE STADT

Vienna's first district is not only home to extremely expensive boutiques but also to more reasonably priced, middle-class fashion stores. The customers are a mix of tourists and local people. We recognise the very first signs of the seasonal sale of the autumn/winter collection when we read the weekend issue of a newspaper a few days before New Year's Eve.

⊲ We find a full-page advertisement on page three, right in the middle of the section on politics. It's a rather dark photograph, a close-up of a water drop in the middle of a brushed steel surface and two smaller drops. The motif looks like an eye with two tears running down steel skin. When we look deep into the eye, we discern a word we had not seen before. It is a combination of the brand name and the word "sale" at the end, written in the same typeface as the company's logo. A small notice at the bottom of the advertisement says: "AB 29. DEZEMBER 2003".

It is Monday. We continue to leaf through the paper and then on page five, between two articles on international terror attacks, is a black surface with a few words on it. It looks like similar sized death announcements that appear in this newspaper from time to time.

⊲ The advertisement is black and white, whereby black is used to cover the entire surface. On the top centre is the brand logo, beyond it, "autumn/winter collection". After a few empty spaces come the words, "sale begins today". The advertisement ends with an address in one of Vienna's most expensive shopping streets in the first district, where flagship stores of major couture brands are also located.

Flagship stores have increasingly acquired the status of tourist sights. Shopping is a rubric featured in all city guides, although the shopping streets in most major capitals look the same. It is the same brands, and corporate design

358 Hollein (1981:32).

unifies the shops around the world. Our visits to stores are gradually replacing visits to churches and other sightseeing attractions. Orientation in the commodity cosmos is consuming a lot of our attention.[359] And as we know, not all churches are the same. Some places are more holy than others, which is why pilgrims visit them. The same holds true of the holy places of consumption. Rituals structure religious life, and they structure consumption as well. The seasonal sales count among the calendar rites of consumer culture. They are not only performed by mass-market brands but also by couture brands. We find the two brands that announce their sale on the same day in the newspaper interesting to compare because the mass-market brand imitates the merchandising style of the couture brand, especially in the design of its show windows. The mass-market brand creates a distinctive show window by using a few expensive mannequins, good lighting and fashionable clothing, which is at times very close to the original.[360] It will be interesting to see how these stores stage their seasonal sale. We resumed our search after the weekend, and started with this couture shop:

≺ The show window is painted black: the sidewalls, the back wall, the floor and the ceiling. One mannequin is standing alone in the centre of the big black window. This headless mannequin is dressed in a black cocktail dress. Behind her, white petals fall from above. Black evening sandals stand among the white petals, which cover the entire floor. It seems as if it were snowing inside the show window. At first glance, nothing seems to announce the seasonal sale. Are we too early? And then we discern a small metal label among the petals on the floor saying: "merchandise on sale inside the shop". That was all. No pricelist for the clothes on the mannequin. Once inside the shop, we look around in the shoe department. The shoes of the autumn/winter collection are presented nicely on the expensive shop fittings. Only a metal label on each of the shelves says: "sale"!

It is not far from the couture shop to the other retailer. Just a few minutes later we find ourselves before the seasonal sale façade of the mass-market brand:

≺ The show window has a black backdrop. All the mannequins have been put away. Two scaffolding pillars hold a seasonal sale poster. The poster has a black background with white dots. When driving fast by it in the night, the dots on the poster look like snowflakes. In the centre of this dynamic creation is written: "up to 50%". The number fifty is large, while the other information is in rather small print. When we enter the store, we find ourselves in front of tables with topsy-turvy piles of boots.

359 The biggest producer of food in the world owns 8 500 local brands. See Schwarz (2000:17).
360 As the mass-market brands are very fast in copying collections, the fashion pieces are often also similar in style.

Darkness and falling snowflakes. The theme of this window is the same, only the execution creates the distinction between the two brands. The window dresser of the couture shop has used silk petals and mounted them artistically along the back wall so that they look as if they are falling naturally. In contrast, the sales poster of the mass-market brand is printed. After all, they only had to attach it to the scaffold. But both dramatisations create a feeling of loneliness and coldness in the dark. The significant difference lies in the way they announce the sales. In the case of the couture shop, we have to read the newspaper or search for the hidden advice on the floor of the show window. The mass-market window announces the sale more aggressively, for "50%" is a clear message to the customers. Inside the shop, everything is disorderly and in piles, the merchandise is presented properly under normal circumstances. There is no marked difference inside the couture shop, except for the discreet tags saying, "sale". But the Dionysian nature of the upper-class sales lies below the distinguished artistic surface. It is a sublime form of ugliness:

"By further habituation to an appreciative perception of the marks of expensive-ness in goods, and by habitually identifying beauty with reputability, it comes about that the beautiful article which is not expensive is accounted not beautiful."[361]

Therefore, the seasonal sale items die twice for the rich: firstly, through the change in fashion, and secondly through the reduction of price. But not all the expensive retailers stage the passage rite with equal subtlety:

⊰ This is a small fashion boutique. Only one window is decorated with a smaller back wall and three torsos with arms. The back wall is painted white. The three mannequins are wearing a ritual dress made of rough natural brown canvas that looks like a gunnysack pulled over the mannequins with short, attached arms. The four black letters sewn onto each of the dresses read: "SALE".

Rituals have the function to "cook" inevitabilities and make cultural regularities out of them.[362] In the fashion system, it is inevitable that the fashion of a season becomes cheap[363] and out-moded. The seasonal sale "cooks" this fact through the consumer ritual of the seasonal sale. And the preparation is sometimes quite archaic, as we can see here. Our next stop is in front of a small vitrine, which is an outpost for a small boutique:

⊰ Several torsos are presented here in winter clothes. In the centre is a torso wearing

361 Veblen (1934:132).
362 See Lévi-Strauss (1996).
363 See Pfabigan (2004) and Bosshart (2006:11) on the trend that people buy cheap offers more and more. Surprisingly, both of them do not mention the seasonal sale as an institution that reduces prices regularly.

a signal-red pullover. Its arms are knotted at the back. Written thrice on the abdomen is the word: "Sale".

The legs of the mannequin are cut off so that it does not need much space. In the 1960s, the Austrian artist Christian Ludwig Attersee proposed that fashion models should have their legs amputated to establish new criteria for beauty. The intention was to attack commercialised codes of fashion, natural beauty and the rapid changes in fashion.[364] At the same time, Ernest Dichter, a pioneer of motivational research, developed less radical ideas. Like Barthes he, too, referred to the excitement of the female customers in spring:

"Why do women or, let us be frank, why do all of us get so excited about new shapes and new fashions in clothing? And why does this happen especially in spring? When asking this question we have to extend it to cover the behaviour of all human beings, since many animals, too, show a comparably curious behaviour. True, they don't have hat stores. But they can grow new feathers instead of having them pasted on. And it would be a robin indeed who would not renew his plumage at least once a year."[365]

It would be interesting to see how Dichter would have described the sales period. What motivates the consumer society to enact the seasonal sale as a Dionysian feast? According to Dichter, the human wish is the basis of our behaviour.[366] Rituals do not merely persuade us, they force us into behaving in a particular manner. And force is not the subject of consumer research.[367] We walk by a window that is totally covered in red ("Final Sale"), and stop a bit later:

< The window of this men's fashion boutique is completely covered with one red, one yellow, and yet another red fabric. The effect is that of a flag that is slit crosswise in the middle so that the tension in the fabric rips a hole through it. In the hole is a cross made of tape with "ABVERKAUF" written on it. We can see the window display through the small incision: The mannequins are dressed in winter clothes and have big price tags attached to each fashion item.

Marketing has borrowed numerous symbolic gestures from the past and Warburg was the first to point out this phenomenon.[368] It is a trivialisation of old myths and of human fears and wishes. Does the seasonal sale reproduce an old myth like the soap advertisement, which Warburg placed within the context of other mythological illustrations?

364 Koller (1987:104).
365 Dichter (1964:76).
366 Ibid., p. 53.
367 Dichter (1985).
368 Warnke (1980:126).

‹ The huge façade of this boutique for young fashion is decorated with several mannequins. They are standing upright like soldiers. And they are wearing a red paper roll with the following inscription in white letters: "SALE".

Yet another case of the sacred ritual dress. The mannequins are white; their hair is abstracted. Since they are not wearing any clothes that would help identify their gender easily, they look androgynous. The sacred dress de-sexualises the body, creating an impression of saintliness.[369] The holy paper dress of the seasonal sale also perfectly fulfils what Turner has prescribed for the dress of the liminal phase, namely, that it should not be mundane, nor should it be worthy or express a social role.[370] And we can add the following rule for our consumer society: it should not be purchasable.

[369] Keenan (1999:389).
[370] Turner (1997:95).

Regent
Street

New Bond
Street

Knightsbridge

Oxford
Street

London

| "Winter sales are best reached by underground." [371]

371 Slogan on a cubist poster for the London Underground by McKnight Kauffer in 1924. See Pevsner (1971:427).

Regent Street

It was nearly the end of the winter sales when we arrived in London. According to our observations, the degree of dramatisation increases as the seasonal sales approach the end. The initial enthusiasm about cheaper shopping has taken wing, but the stores try to mobilise bargain hunters once again by indicating further reductions:

◁ This modern storefront has a huge show window. In the back is a wall painted magenta. The word "SALE" covers almost the whole surface of the backdrop. Two clothes racks hang from the ceiling in front of the wall. Presented on each of these racks are five different men's shirts on hangers. Beyond the rack are four pairs of shoes. To its left and its right are male mannequins dressed in formal suits. Additionally, on each side is one mannequin wearing a winter coat. Written in white letters on the show window are the words: "FURTHER REDUCTIONS". A price tag is attached to each of the fashion pieces. These price tags that are magenta and white are larger than the ones normally used. On the white part are two lines indicating the currency. The normal price is written in black and then crossed out in red. The new reduced price is written in red. Written on the magenta part is "SALE".

The aim of the window to communicate the cheapness of the fashion items is attained by means of basic merchandising techniques. A book on window dressing of the 1920s, describes three standards of display.[372] The "open display" uses very few things, thus promising the discovery of more booty inside. The second type is the "open display with side dressing". All the lines of the offer are represented in the show window. This technique is meant to inscribe all these lines in the public's mind, even when the place in the show window is limited. And the third type is what we see here, the "stock display". This window type has three main functions:

"1. Strongly push the quantity idea of goods bought in bulk.
2. Advocate cheapness and low-priced merchandise.
3. Strongly appeal for direct sales."[373]

[372] Timmins (1922).
[373] Timmins (1922:45).

Although a lot of things have changed in the field of merchandising, it seems that the pioneers of the discipline discovered the rules very early on. While the fashions have changed, the basic rules of meaning-creation in the show window are fixed. When the mannequins are removed from the window and replaced by the clothes rack, we do not require any words to guess that the fashion is changing. The message of the next boutique is not as obvious. Although we have browsed throught a lot of merchandising literature from the past until today, we have found no instructions for windows like this:

◁ This fashion boutique is located in an old traditional store. The storefront has huge windows with cast iron details in the frame. The entrance is in the middle, and on the right side is a blue poster with black letters saying: "final reductions up to 70% off". Inside the shop are as many clothes racks as possible full of merchandise. On top of the racks are a lot of posters indicating that items have been reduced by fifty percent. It looks more like a warehouse than the fashionable boutiques featured in interior design magazines. As the show window has no back walls, the "stock window" effect is attained with this type of dramatisation as well. The window on the left is covered by two white curtains. These curtains are usually used when the windows are being changed, to be read on both of them is: "Window change". We see a mannequin lying on the floor through the gap between the two curtains whose upper body supported by one bent arm is in an upright position. This totally undressed female mannequin is lying on a surface covered with newspaper title pages. It is always the same page.

Since this window has no back wall and all the curtains for the window change have not been installed, the naked mannequin is quite prominently exposed. Seen from the street, however, she is only hidden when customers are directly in front of the window. Its nakedness is unprotected from the side and from inside. The scene mimics the act of trimming the window. But there is no window dresser in sight, nor all the things used for window dressing. Besides, the window is not totally covered, and the dressing of the window is usually done when not too many people are about in the streets, for instance, at the night. But how does this scene become meaningful in relation to the change of fashion? The normal action of window dressing is free of transcendent meaning. Catherine Bell explains how such actions become meaningful:

"[...] an action can be meaningful only when it is detached from its initial context and objectified as an autonomous entity, and when its autonomous

significance is addressed for any relevance or importance that can be addressed to 'an indefinite range of possible readers'." [374]

In our case, the action of window dressing has become meaningful by the act of detaching the scenery from its utilitarian purpose. Here, the action, which is normally hidden and only for a short time, is continually dramatised during the sales period. The action of changing the decoration for the window stands for the changing of fashion. This meaningless action transcends into a meaningful message of the seasonal sale, which is performed year after year. Inside we have the appearance of a stockroom. No piece stands out. Everything is made equal by means of the presentation and the universal belief in paying half for everything. It is the state of "communitas" of the merchandise during the passage rite from one fashion to another. [375] The warehouse is the place where the garments wait in darkness. It is the state prior to merchandising and before the window dressers start their dramatisation of the goods in the retail theatre behind the show windows, before the curtains can be opened. The next store with a striking seasonal sale decoration is a jeans boutique:

< The two windows are separated by an entrance in the middle. The shop's floor begins immediately behind the show windows. We can see directly into the store because there is no area dedicated to window display, nor any back walls. There are two transparent posters with red arrows in the left window. The arrows point downwards. Suspended from the ceiling is a huge three-dimensional arrow, which looks as if it was made of stone, and it is painted red. The arrow sculpture seems to be jagged along the edges like chipped stone. Big red letters on the window say: "FINAL WEEK. 75% OFF (on selected items)". Inside the shop, everything is just the way it is during the year. No posters, and no piles of fashion items. The right show window is dressed with a white pedestal and two pairs of jeans that are shown by using only the legs of a mannequin. The upper body has been detached. The imprint on the show window says: "NEW SEASON (in store now)".

The presentation of the new collection while the reduction is still going on is significant for the incorporation state of the passage rite. The ambiguous scenery with the arrows and the high reductions is still present while a forerunner of the new collection is already being presented. But both conditions are dramatised in a very abstract way as no merchandise is used, except for the two pairs of jeans. We find the next show windows between the marble pillars of an old traditional building:

374 Bell (1992:51).
375 Turner (1997:96).

◁ With the exception of one window, all the windows of this fashion boutique are blocked out by a white nontransparent film. Written in the middle in the 1970s retro typestyle is the word "sale".[376] The single letters consist of five parallel coloured lines, which form the letters with abstract lines and circles. The lines range from pink to orange and brown. The only transparent window has the same inscription, but with a supplement: "further reductions". The window is dressed with two headless mannequins wearing items of the winter collection. In front of them are two shopping carts. The shopping carts are painted white and contain several items with a mix of home accessories and clothing, literally flung into them.

The shopping carts are the central element in this window, which is why they have been painted white as well as to make them distinguishable from the everyday shopping cart. The way they are filled makes it look as if the things were being thrown away rather than presented. When people shop, they prefer to select their purchases with great care. But the message here is quite clear: things that were prestigious a few weeks ago are now being thrown away. It is a desacralisation of the merchandise and a clear message that the items have lost their status as fashionable pieces. Fashions are changing with great speed, and it does not take much time to forget them:

"Since old stock is regularly removed from the boutiques and supermarkets, these sectors of the industry have a short memory. The introduction of the new functions primarily as a revival, though one cannot say instantly to what extent such a revival corresponds with the historical model. In order to be able to do that, one must create a special fashion archive, which for a normal customer would be largely irrelevant. Therefore, the market cannot dictate innovation as often assumed. Rather the market operates in a zone of indistinguishability between new and old. The mass consumer consumes what pleases him – without a clear criterion of distinction between old and new"[377]

In reality, it would be difficult to differentiate between the old and the new, but the symbolic language of the seasonal sale helps us orient ourselves. Dionysian aesthetics wipe out our memory, making our minds free for the new collection. The ambiguous situation between the old and the new is structured by means of emotion and symbolism instead of the intellectual construction of an archive. Creating sexual desires is the target of the next show window:

376 Andy Warhol's Area Rug Sale from 1976-86 shows a very similar logotype. See Groys (2002:61).
377 Groys (2002:59).

This window is dominated by an orange poster, which goes across from one side to the other. On the stripe is the silhouette of a woman outlined against the orange. She is positioned horizontally in a provocatively erotic posture.[378] Printed on the window is a dotted frame in the middle of which we can read: "(now showing up to) 70% OFF".

This is not the show window of a sex shop but the window of a boutique for young fashion. Obscenity is part of Dionysian aesthetics.[379] And this is the effect being played with the help of graphics. There is no naked mannequin here but just the designed graphics of naked women, the kind of graphics used by sex shops. The obscene is a category of the ugly and the ugly is being presented here in the form of the obscene. But during the sales, not only does the obscenity of graphic design exist but also that of the commodity, as Jean Baudrillard points out here:

"Marx already denounced the obscenity of the commodity, linked to the abject principle of its free circulation. The obscenity of the commodity comes from its abstraction, formal and light, against the weight and density of the object. The commodity is readable: contrary to the object, which never confesses completely its secret, the commodity manifests always its visible essence, which is the price."[380]

The obscenity of the price is over-emphasised during the seasonal sale. The reduction undresses the commodity entirely, not exposing it as naked but as waiting in an obscene posture for the satyr.

New Bond Street

Boutiques in this street address the upper strata of society. There are fewer people here than in Regent Street. The first boutique with striking sales decoration works with an intuitive image, which can be easily related to sacrificial rituals:

[378] The posture is ambivalent, but the interpretation given here would be shared by most of the spectators. It imitates the graphic design of sex shops.
[379] Liessmann (2000:159).
[380] Baudrillard (1990:67).

◁ This little boutique has just one largish show window. Two mannequins wearing winter clothes are placed in it. Each piece has a large price tag indicating that the price on it is the seasonal sale price. The tags have an orange frame and bold lettering saying "SALE". The surprising detail in this window is a large poster behind the mannequins. It shows a flaming inferno. "SALE" is written on it in bold black letters.

It appears to us as if the mannequins are being sacrificed in the fire. The intention of the graphic design may of course have been slightly different. Perhaps the idea was burning the prices, but burning down the mannequins along with all the fashion items is a more seductive interpretation, which takes us back to the archaic origins of sacrifice. James George Frazer described in his *Golden Bough* numerous rituals based on the concept of sacrificing the corn god.[381] The corn god is sacrificed at the beginning of spring and his resurrection magically awakens Nature, who had been symbolically transformed into a victim before. So there is a link between Nature and the god. With the resurrection of the god, Nature will start its new life in spring. Frazer's way of describing this philosophy of magic was the main point of Wittgenstein's critique:

> "Frazer's account of the magical and religious notions of men is unsatisfactory: it makes these notions appear as mistakes."[382]

Wittgenstein pointed out that dealing with symbols does not rest on any opinion, and error is a matter of opinion.[383] He concludes by saying:

> "Just how misleading Frazer's accounts are, we see, I think, from the fact that one could well imagine primitive practices oneself and it would only be by chance if they were not actually to be found somewhere. That is, the principle according to which these practices are ordered is much more general than Frazer shows it to be and we find it in ourselves: we could think out for ourselves the different possibilities."[384]

The seasonal sale uses a symbolic visual language with many references to "primitive" sacrificial practices. There is no articulated magical belief on the surface, but it would be possible to introduce it. It could be said, if we follow Frazer's idea of the corn god, that the new fashion receives its power through the sacrifice of the old. The mannequins, and the fashion pieces sacrificed in the fire will be reborn in spring with the spring

[381] Frazer (1993). Hubert and Mauss (1981:77-94) dedicated a chapter of their classic study of sacrifice to this mythology.
[382] Wittgenstein (1979:1).
[383] Ibid., p. 3.
[384] Ibid., p. 5.

collection and endowed with new power. The fashion system acquires the power for the new collection from the death and rebirth of the garments. But maybe this notion is a mistake. And so, we walk on and stop again in front of the next boutique:

⊲ This fashion boutique is on a street corner. One of its windows shows a mannequin in a white dress and pink belt. On the show window is the discrete message in the same shade of pink: "Sale / Final Reductions". The show window is partly covered with a yellow transparent film. A photo covers the entire surface of the window's backdrop: a black and white photo of a workshop where hundreds of female workers are sewing clothes.

It seems as if everything is possible during the seasonal sales. This window's decoration points out that the origin of couture is often in sweat-shops that exploit human labour. This is a problem of the fashion industry, which has not change until today:

"Fine, individualised and hand-done work was carried out in appalling sweated labour conditions in the late eighteenth century and in the nineteenth century, both in Britain and elsewhere. Although the original tailors had been men, by the time of the industrial revolution there were many dressmakers making the delicate clothing now in vogue for women, and Engel's description of the working conditions of these young girls in the 1840s would have applied for many years, both before and afterwards."[385]

The idea of relating merchandise to its place of production was already born at the beginning of the twentieth century. Here is a suggestion for a cotton fabric retailer to attract attention with the show window:

"A small reproduction of a small cotton wool plantation in full blossom and the seeming diligence of mainly black plantation workers. While we may have some problems with this reproduction, many other similar scenes have greater appeal and are easily staged in a show window."[386]

The next window does without the context of the sweatshop. It is a retailer for children's clothing:

⊲ The show window has no backdrop. We have an unhindered view into the store. Four child mannequins are placed on the frame of the window. Each of them is wearing a white dress with a red letter on it. The letters form the

[385] Wilson (2003:72-73).
[386] Austerlitz (1904:1)*.

word "S – A – L – E". A handmade poster next to the entrance says: "50% (off)".

We have the feeling that the upper classes do not really welcome the seasonal sale. Following the theory of class imitation, the purchase of the unfashionable would not be a good idea for a class which defines its social status by buying the latest trends. A friend in China recently told us a story about a friend who works for a European couture brand in Beijing. This store also reduces the prices during the seasonal sales. One day a woman came in, found a dress and wanted to pay for it. When she was informed at the cash desk that the price of the piece had been reduced, she was furious. She wanted to buy the dress at the original price and explained to the sales person that she could afford to buy it at any price. In the end, she went out after paying the original price instead of the reduced one. The customer saw the reduction as a kind of gift. Marcel Mauss explains the power relations based on the concept of gift giving:

> "To give is to show one's superiority, to be more, to be a higher in rank, magister. To accept without giving in return, or giving more back, is to become client and servant, to become small, to fall lower (minister)." [387]

Thus, the customer had the feeling that the salesperson, who was not her equal in status, had acquired power over her by reducing the price. She was giving a reduction, and a customer who accepts this gift also accepts degradation with it. The "poor" sales person had thus acquired power over the "rich" customer of European fashion couture. The next window belongs to a show boutique:

⊲ This show window is not featuring any information about reductions. But on second glance, we discern a bag in the corner of the window. The dates of the seasonal sale are written by hand on paper bags in red, printed frames: "29th December 2003 / 31st January 2004".

The shopping bag is an important medium for advertising. People who walk through the city with shopping bags are living advertisements. We observed that during the sales, special bags are printed to announce the sales of the retailer. The fetish of the bag is turned into a container of sacrifice for the period of sales. What is in the bag is out of fashion. The telltale plastic bag announces to everyone on the street that we have bought for a

[387] Mauss (2002:95).

lower price, and where. What could be a thing of shame during the seasonal sale turns into a thing of pride during the year:[388]

"The notion of paying extra because of where a shop is, or for a particular name and address on a plastic bag, may seem to be the most extreme and delusional form of commodity fetishism."[389]

Knightsbridge

Two famous department stores and a lot of smaller fashion boutiques especially for young people characterise the shopping area around the underground station. One of the boutiques seems to be staging a period of mourning:

⊲ The windows are totally black. It is only possible to look into the show window through the cut-out letters of the "SALE" announcement and the underlining. This transparent line also bears the information: "FINAL REDUCTIONS". Only some of the visible mannequins are dressed in black trousers and a black T-shirt. On the front of the T-shirt is the imprint of an orange barcode, and instead of the bar code numbers alongside the origin of the item are the words: "sale soldes rebayas".

One department store has even dressed its huge windows in black:

⊲ Each of these windows is divided into three parts by the frames of the glass panes. Seen from a distance, it seems as if the windows are totally blocked by a black nontransparent film. A white circle in the first third announces: "Further Reductions". On coming closer we realise that we can see through the lines of an abstract drawing of a woman in the middle segment. Inside, there is a female mannequin floating in an orange evening dress with her head bent downwards and her legs turned upwards. The mannequin is attached to a rope, which is wrapped around her. It is not clear whether she is dead or alive.

388 Of course, there are customers who are proud to have bought things 50% cheaper. But the target group in New Bond Street would not be so amused about getting a bag that questions their social status in public. But there are several discount retailers, where even the rich can buy without loosing social status.
389 Bruzzi/Gibson (2000:11).

The two show windows create an atmosphere of the presence of death. This is reached by the massive use of black. The view of the customer is limited to incisions in the black surface. What we see in both cases is not attractive: A woman falling dead and some mannequins wearing things we cannot buy. The windows do not contain more information than that the seasonal sale is going on inside the stores. The following window gives us more detailed information:

◁ This window is covered with two huge red posters, covering almost the entire surface. On the left poster is a list of items with the prices, for example: "COATS (from) 50, JACKETS (from) 30, TROUSERS (from) 15, SKIRTS (from) 12,)". On the right poster is the following list: "sale, soldes, rebajas ...". When we walk by, we realise that behind the posters are still the mannequins that normally wear the things listed on the poster. But they are all naked, and there are a large number of them hidden by the sales poster. A ladder leaning against the wall on another side is totally smeared with paint. In the entrance area inside the boutique are additional clothes racks. The garments on them are organised by price. Each of these clothes racks belongs to a different price category.

Finally, we arrive at the corner of the other traditional department store. The nice show window dressing during the rest of the year is replaced by a black surface with a sales poster. But we are even more surprised by what we observe on the corner of the building:

◁ The name of the department store is normally announced at the corner of the building. Its name is written vertically in huge letters, one below the other. Numerous light bulbs form each letter. But when we look up toward the corner, above the colourful emblem of the store, all we see are the shadows of the letters. The letters of the name seem as if they had burned to ash. Out of these ashes emerge four new letters: "SALE". They are illumined with hundreds of light bulbs, the way the department store's name had been earlier.

The sacrifice of the brand name during the sales period is exemplified here. Although we usually speak of the power of brand names and their social effects,[390] our example makes us conclude that the power of brands depends on their being sacrificed regularly. The death of the brand name becomes the starting point for a new way of theorising the sanctity of names in our consumer culture. The permanent transformation of brand

390 Pavitt (2001).

images is a pattern that is overlaid by a mythical pattern of death and life. Although it is generally believed that brands must be unique and precise, what we learned from observing the seasonal sale showed us that also brands have to suffer a temporary state of "communitas" during the sales. They are burned to ashes in order to be reborn from them with the power of the new fashion collection.

Oxford Street

Oxford Street is a very busy shopping street, and not just during the sales period. Both cheap and expensive things can be bought throughout the street. A lot of international brands also have their outlets here. But our main destination is a traditional department store on Oxford Street. The founder, who also gave the store its name, was one of the innovators and pioneers in the history of department stores. His career began at the end of the nineteenth century in one of the new department stores in Chicago, where he would hold annual sales to make way for the new goods.[391] We are curious to see how the innovative department store that wants to be the best store in the world[392] will dramatise its sales.

The long façade of the building has numerous show windows. The entrance in the middle is not very well articulated and people enter the department store through a rather discreet door. The lower part of all the show windows is covered in a flashy red plastic material, a long red band running along the entire length of the façade that is stuck on the outer side of the panes. The artistically designed show windows that usually invite people for window-shopping are no longer attractive. Huge bold white letters are printed on the red surface of the band so that each of the windows has two or three letters on it. Since it is impossible to read the entire message while standing directly in front of it, we walk over to the other side of the street. At an adequate distance now, we read "BU-YER – BE-WA-RE", then comes the entrance followed by the next part of the message: "BUY-IT – FOR-GET – IT". We change the street side once again to go into the store.

391 Cummings/Lewandowska (2000:80).
392 The creative director of Selfridges in an interview with Schirrmacher (2004:48).

On the window that says "FOR", someone has written by hand: "Don't buy it". On the entrance-level is the fragrance department, which is not involved in the sales. Red signboards with some text in black on a white line saying, "Buy me. I'll change your life" or "It's you. It's new. It's everything. It's nothing" are hanging from the ceiling of the first level. On the first level is the fashion department with all the couture brands. When we get here by escalator from the fragrance level, we find ourselves in front of clothes racks on wheels. Posters on which these slogans are repeated are hanging above them from the ceiling. When we look at the floor, we find the same red squares with the information: "You want it. You buy it. You forget it." The couture brands are displayed in the shop-in-shops. But the messages are everywhere. Special price tags indicate the reductions. They are red and have two white surfaces for the price. On top of the smaller surface is printed "was" and on the bigger one "now". When we see the merchandise on the clothes racks from the other side, we realise that the price tag is printed on the back as well: "This is you". We now go to the basement level where the shirt and underwear department is located. Here, too, there are flags with the puzzling slogans. These posters hang on the back wall as in a gallery, one next to the other. Additional furniture is placed in the centre. A poster on red gondolas says, "Buy me. I'll change your life" and the next one says, "Underwear 50% off". The sale items are simply thrown into red baskets made of red plastic or wood. It is a mess of various colours, styles and sizes. We pass by another red signboard: "I shop therefore I am".

This is the language of carnival. The world has been turned upside down. Hierarchies are reversed. We can say what we do not dare to during the year: "You buy it. You forget it". The promise of luck is replaced by the death of the commodity, simply forgotten in our wardrobe. There is no punishment for those who dare to disclose marketing secrets, because people buy in spite of it. They rummage about in the red baskets, looking for things that will fit their identity. "This is you", is the promise on each price tag. "Retail Therapy" is the term the creative director of the department store uses to describe shopping as a leisure activity in a playful environment.[393] Rituals also play a therapeutic role in making relationships stable. What the store is doing here is in fact therapy. All the hidden promises are articulated, black on white. We can listen to them as to the psychoanalyst while lying on the couch. And it costs us only 50 percent of the regular price. Consumers are confronted with philosophical problems in the everyday environment of the shop. "It is everything. It is nothing" hangs above the basket with underwear.

[393] Schirrmacher (2004:52).

"In fact, it goes against consciousness in the sense that the latter tries to grasp some object of acquisition, something, not the nothing of pure expenditure."[394]

This is what Georges Bataille wrote in his essay "The Accursed Share". It is perhaps a bit too long to place above a pile of socks, but it expresses our fears quite well. When Don Slater presented the artist Barbara Kruger in his book on consumer society, he may not have imagined that a big department store would invite the artist to dramatise especially the seasonal sale:[395]

"Barbara Kruger's incisive summation of the 1980s cultural revolution, 'I shop therefore I am', crystallizes the link between the enterprising consumer and the Enlightenment man. At first glance, the phrase simply suggests that people have been reduced to a superficiality in which they have an identity only by buying and consuming things: it evokes the postmodern consumer who exists only through commodity-signs. Yet the reference to Descartes' cogito brings out the depth and superficiality of this figure: "I think therefore I am" is the most powerful western statement of the relation between individualism, reason and freedom."[396]

During the seasonal sale, the wishes and fears of the consumers are accumulated in one single experience. The change of the commodity signs cannot be hindered, so it becomes ritualised. The red baskets full of cheap fashion items are like coffins where the body is no longer one with the spirit. The department store calls for the shaman, but it is the artist who comes.[397] We walk out of the place and see on the other side of the street the façade of a fashion boutique, which is totally covered in red. The people going in and out of it are not shoppers, but workers. The store is still under construction. The nontransparent façade hides the construction work. This is a very nice analogy because change in fashion can also be compared to the refurbishment of a store. In the one case, the red wall conceals the change of merchandise but in the other, it hides the change in furnishing. And there must be a deep-seated reason why we treat them both similarly. Determining the symbolic dimension of the seasonal sale's materiality is our approach to the phenomenon of sacrifice.

[394] Bataille (1991:190).
[395] Barbara Kruger had previously done an installation on the façade of a department store. During the exhibition Shopping in Frankfurt in 2002, she made an intervention on the façade with two giant visuals of an eye and two slogans saying: "DAS BIST DU – DAS IST NEU – DAS IST NICHTS – DAS IST ALLES" and "DU WILLST ES – DU KAUFST ES – DU VERGISST ES". See Hollein (2002:220-221). The "advertisement" was such a success that the department store wanted Kruger to change all the façades of its stores, but she refused.
[396] Slater (2003:38).
[397] The department store started its collaboration with artists during the 1990s. See Cummings/Lewandowska (2000:152). The artists work in close cooperation with the store's design team for window dressing.

Daniel Miller uses the ethnography of North London in his *Theory of Shopping* to generalise the idea of shopping as sacrifice.[398] We will try to discuss his text in the context of what we have found out until now. But there are several differences in the points of departure. In contrast to Miller, whose basic material is an ethnological fieldwork based on interviews, the basis for our work is visual material only; we have not done any interviews with shoppers. While Miller analyses the shopping behaviour of people in a street in North London, we studied the shop façades in Central London's high streets. We will find a more or less neutral place to discuss both findings if we base our discussion on the chapter in which Miller develops his more abstract idea of shopping as sacrifice.[399] The discussion in this chapter is not as based on his own material as on literature that can be used in discussing both approaches. While Miller is working on a general theory of shopping as sacrifice, the focus of our interest lies in discovering the particular nature of the seasonal sale as a sacrificial ritual. This is an important difference because everyday shopping cannot be compared to shopping under dramatically changed conditions during the seasonal sale. The seasonal sale is not merely a special case of everyday shopping but a time when several parameters are turned upside down. This is not only true of the aesthetic aspect of window dressing, but also of its social aspects as well as of the consumption of fashion items that are no longer in fashion and are dramatically reduced in price. Miller mentions the seasonal sale as a major factor in the shopping strategy of his informants. Some of them use the sales to buy certain goods in a more strategic way, while others are less strategic.[400] In some cases, informants have bided their time for a sale in a special store in order to do their shopping. Saving money is their main argument. Even those who bought more than they had originally planned to explained that they save more money when they buy more. But for the further development of shopping as sacrifice, only the argument of thrift remained. Nevertheless, shopping during the sales is not everyday shopping. Customers have to wait for seasonal sales to begin in order to get bargains. For the not so strategic ones, however, the seasonal sale is a time when they buy more than they originally intended to. When shops clear their stock, prices are reduced, but not all sizes and models are available. This is where the difference between shopping at the beginning of a season lies. Although the level of motivation to buy new clothing is not always the same, the emotional readiness to buy new clothes is especially high at the beginning of spring.[401] But we shall go back to the seasonal sales before the myths of spring enter the show windows. The

398 Miller (1998a).
399 Miller (1998a:73-110).
400 Ibid., p 55.
401 Dichter (1964:76).

customer described by Miller is not the sole representative of the complex segmentation of consumer behaviour. Since thrift is not a relevant argument for everyone, it may prove difficult to make it the basis for a general theory of shopping as sacrifice. For Miller, there is no major difference between saving money during everyday shopping or during the seasonal sales. For us there is, because our argument is based on the dramatisation of the retail environment. And we claim that the decoration of places to make them ritual places does matter to people.[402] People have a sense for ritualisation and they enact them differently. Decoration splits apart the sacred and the profane. And this is what happens during the seasonal sale when all the fashion retailers create a similar sacred sphere in shopping streets dominated by this kind of business. This does not merely entail the rational argument of customers to save money, for shopping during the sales is also an emotional experience. This is when we see fashion pieces, presented as fetish objects during the year, being treated in a surprisingly different way. The presentation that had initially created a desire to buy the objects is replaced by the dramatisation of the ugly. The dress with the flowers is no longer presented on the mannequin in the show window but simply thrown into a red basket along with several other pieces. What was new then is now out of fashion; the dress that people buy during the sale is not same one. Its price has changed and it is no longer new. This creates a different social use for it than if they had bought it at the beginning of the season. Even the architecture of the retail space usually changes. The way people choose their goods now differs from the everyday. There is less assistance, and we have to find our own way through the merchandise, which is now presented like in a stock room. Pullovers are no longer folded into neat piles of the same colour, but randomly thrown into a basket along with several other models, colours and sizes. Goods are no longer displayed but reduced to their availability only. Another difference we ascertained at the beginning of the discourse should be mentioned here. While our theory is rooted in the context of the fashion system, it is not important for Miller whether people buy pizza or clothing, as both acts can be used to reaffirm transcendent goals. For Miller, the true sacrificial act is an act of devotion to the divine, but he also discusses the sacrifice for the benefit of society:

"To make an analogy with shopping I would therefore have to demonstrate that shopping is a regular act that turns expenditure into a devotional ritual that constantly reaffirms some transcendent force, and thereby becomes a primary means of which the transcendent is constituted."[403]

402 See Miller (1998b).
403 Miller (1998a:78).

Miller mainly used two key references to demonstrate this. His first reference is René Girard, who deals with the violent aspects of rituals. This aspect is totally rejected by Miller, because it focuses too strongly on the single act of killing. The second one is Georges Bataille's "Accursed share". While Miller takes up the idea of the equation of sacrifice and consumption, he rejects Bataille's discourse. Like Miller, we, too, will base our discussion on our fieldwork. And we will use both of these references as they fit our purpose quite well. We approach the problem keeping in mind that many social practices are now related to commerce in the consumer society. Thus, we can conclude that several modes of consumption have ritual aspects. We are not so convinced by Miller's idea that each individual act of buying is sacrificial in nature because when everything is a ritual, then nothing is a ritual. We can probably reach this conclusion if we do not question the fact that shopping is a ritual of devotion per se, and instead point out that there are different types of sacredness. And the seasonal sale, because of its dramatisation, is different to the everyday routine sacrifice. Sacredness is constituted by means of oppositions. And this might be the reason why we have to discuss our findings so differently.

We will start our discussion with Bataille. The aspect of fashion and the production of luxury goods are not central to Miller's discussion. In contrast, Bataille differentiates between expenses for everyday life and "unproductive" expenses. Unproductive expenses are the ones made for luxury items, games, prestigious architecture and cults.[404] Luxury is created by spending a fortune. Jewels are worthy objects because of the sacrifice of capital rather than their materiality. This definition of sacrifice is opposite to that of Miller, who bases his theory of sacrifice on thrift. But maybe this is not a misinterpretation of historic and ethnographic sources, which Miller holds against Bataille.[405] The difference is that the economy of luxury goods cannot be compared to that of the everyday goods we find on the supermarket shelf. Bataille discussed the violent, bloody sacrifice as well as the concept of potlatch. The description of the potlatch provides us with the first clues for our discussion of fashion and sacrifice:

"The industry of archaic luxury is the basis of the potlatch; obviously this industry squanders resources represented by quantities of available human labour. Among the Aztecs, they were 'cloaks, petticoats, precious blouses'; or richly coloured feathers ... cut stones, shells, fans, shell paddles... wild animal skins worked and ornamented with designs."[406]

404 Bataille (2001:12)
405 Miller (1998a:87).
406 Bataille (1991:76).

According to Mauss, potlatch is an archaic form of contract.[407] In order to achieve dignity, luxury goods are destroyed in a competition between rivals. The system is based on gift giving. To give, to receive and to respond are its three obligations.[408] At times, even destruction is transferred to the receiver of the gift. The symbolic dimension of this process of giving away the present has been interpreted by Bataille as waste or excrement.[409] Couture brands invest a lot of money in the promotion of their fashion collections. These designs are no longer in fashion at the end of the season, so the retailer has to get rid of the garments. Here, too, we find an accumulation of luxury, which is sacrificed at the end of the season through the seasonal sales. Jean Baudrillard worked out another aspect common to fashion and potlatch:

"It is especially fashion in dress, playing over the signs of the body, that appears 'festive', through its aspect of 'wasteful consumption', of 'potlatch'. Again this is specially true of haute couture."[410]

The Aztec example shows an early case of destroying luxury garments for the purpose of the potlatch. If we want to transfer this example to the context of today, we would need to find the competitive destruction of wealth in the fashion system in order to attain dignity. Of course, the prices are dramatically reduced and the retailer may sell the garments without profit. But is the announcement of minus seventy percent a compromise in dignity between the retailers or between the retailer and the customer? Of course not, and as we have seen, the luxury boutiques are rather discreet in announcing the sacrifice of the past collection. Bataille argues that an excess of resources accumulated at certain points can only be consumed by wastefulness because there is no way of using this surplus for the growth of productive forces.[411] Miller interprets this as a vision of point-lessness that repudiates utility. He argues that traditional sacrifice and most shopping activities are concerned with achieving specific purposes.[412] But also wasteful consumption creates dignity and therefore a transcendental purpose. However, Miller rejects Bataille's interpretation of the potlatch:

"The argument developed here is almost the opposite of that of Bataille. Bataille sees the utilitarian as his enemy and feels that it is in transgression that people come to a sense of their humanity. I would argue, by contrast, that under conditions of modernity we constantly fantasize

407 Mauss (2002:6).
408 Ibid., p. 91.
409 Bataille (2001:19).
410 Baudrillard (2004:94).
411 Bataille (1991:72).
412 Miller (1998a:98).

extremes of freedom and constraint, of which Bataille's vision of excess would be an example."[413]

Wasteful consumption is a phenomenon related to luxury and the fashion system. The myth of creativity of fashion designers who create "new" collections year after year can be related to Bataille's vision of excess. Like the sun, creativity shines down upon the fashion business, which creates two collections every year. Archaic rites are performed in order to ensure that the sun keeps shining, like the Aztecs did in ancient times. During the seasonal sale, the accursed share will be consumed pointlessly. While our arguments are based on the waste of money, Miller develops a sacrificial pattern based on thrift. He argues that although excessive expenditure is practiced, for "most people" it is not the regular form of shopping. And so he develops a negation of the vision of excess:

"Based on ethnographic observation, there can be little doubt as to what plays the analogous role as the central ritual transformation of shopping. Most shopping expeditions begin as acts of intended expenditure, but the actual practice of shopping, its skills, its labour and its primary goals, become increasingly directed to the possibility of thrift. By the time the act of shopping is completed the experience has been transformed into an ethos that is the very negation of expenditure, being thoroughly absorbed in the vision of money saved."[414]

The paradox about the seasonal sale is that although their theories are contrary, Miller and Bataille are both right. The fashion system sacrifices the collection of the past season, turning it into the waste of the fashion system. The consumption of the accursed share by the shoppers is turned into the vision of saving money. If we further develop Miller's idea of shopping as an everyday ritual of thrift, we could conclude that the seasonal sale, which is an orgy of thrift, is an important calendar rite of saving money.

From this discussion of sacrifice as thrift or expenditure we will now switch over to the discussion of sacrifice and violence. Miller rejects those debates on sacrifice in ancient Greece that emphasise the aspect of violence.[415] René Girard's *Violence and the Sacred* is a prototype of such literature and thus becomes a scapegoat for Miller:

"It is not, however, necessary to involve such a primitivist conceptualisa-

413 Ibid., p. 87-88.
414 Miller (1998a:100-101).
415 Miller (1998a:79).

tion of violence in order to accept that violence has an essential place in sacrifice as the mechanism for the destruction of the sacrificial victim."[416]

While Miller continues to develop a more abstract interpretation of sacrifice, we will develop our case study in the contrary direction. As many aspects of the seasonal sale turn our expectations upside down, the discussion of violence could lead to interesting insights. For this part of the discussion, we will use René Girard's "Dionysus" chapter.[417] Girard enters the discussion with some general thoughts on rituals and one of his main interests is the violation of established laws during festivals. The seasonal sales are a good example for showing this aspect of rituals. The first striking violation of laws is the use of the ugly in the general visual economy of beauty. Seasonal sales are dramatised with Dionysian aesthetics; things are thrown into boxes instead of being presented on a mannequin. The stockroom, normally hidden behind closed doors, is exposed in the show window. And the obscene, which belongs to the Dionysian, is not only a tolerated but seems to be even a required practice.

The seasonal sale is a violation of merchandising rules. Window dressers do the reverse of what they usually do, and what they have been taught to do. The ritual inversion is prescribed, although we have not yet found any evidence of written instructions for it. Another point is the elimination of differences. In traditional rituals, this means that social hierarchies are temporarily suppressed or inverted. We found evidence for such practice in the uniform and abstract dramatisation of the sale. Fashion boutiques are highly differentiated in their use of merchandising techniques during the year, but during the sales, we observed a rather similar window dressing. Boutiques for young customers are dressed like those for elderly customers. For example, they are blocked by a poster in such a way that people cannot see through the show window. High-fashion boutiques also dress their mannequins in paper dresses in a manner similar to the middle-class boutiques. And when high-fashion boutiques use a more costly dramatisation then it is often related to a sublime form of the ugly or the artistic expression of "communitas". The temporary act of erasing brand names is yet another strong evidence of the power of the ritual to mark the differences in contemporary retail.

Purifying rituals[418] are yet another interesting aspect for this discussion. These rituals are performed on a regular basis with the aim to get

416 Ibid., p. 89.
417 Girard (1995:119-168).
418 Girard (1995:121).

rid of impurities that have accumulated over time. It is quite easy to create a parallel to what slowly happens in fashion. After the new collection has been introduced, the things start going out of fashion. Fashion magazines do their part by constantly defining what is "in" and directly or indirectly defining what is "out". After a while, more and more things defined by the fashion magazines as "impurities" within the fashion system begin to accumulate, and the system has to get rid of them. In this sense, it could be argued that the seasonal sale can also be interpreted as a purifying ritual. The system separates the pure from the impure. The waste is thrown into red baskets, waiting for bargain hunters. But violation can be interpreted in a more abstract way. Baudrillard describes the violent nature of ceremonies as follows:

"In itself, the connection of signs in ceremony, the fact that they can succeed and engender on another solely according to the rule of the ritual, already constitutes a violence done to the real. And the fact that every ceremony is linked according to a cycle is a violence done to time. And the fact that it is organized solely on the basis of signs – thousands of pure signs whose supra-sensual relation it recovers – is a violence against meaning and the logic of meaning."[419]

For Baudrillard, the seductive forces of the ritual are grounded in the barbaric, which resists the culture of sense. We have decided to follow the path indicated by violence. It takes us to the Greek legends. Girard explains the basic patterns of sacrifice:

"First comes the violence, spontaneous and senseless: then comes the sacrificial explanation, genuinely sacrificial in that it conceals the senseless and basically intolerable aspect of violence. [...] These stories may represent the minimal form of mythological fabrication. A collective murder that brings about the restoration of order imposes a kind of ritualistic framework on the savage fury of the group, all of whose members are out for one another's blood."[420]

A murder becomes sacrifice when the victim undergoes a special sacrificial preparation. The selection of the victim is central in this process:

"The victim should belong both to the inside and the outside of the community. As there is no category that perfectly meets this requirement,

419 Baudrillard (1990:170).
420 Girard (1995:124).

any creature chosen for sacrifice must fall short in one or another of the contradictory qualities required of it. It will be deficient in its exterior or its interior connections, but never both at the same time. The goal is to make the victim wholly sacrificeable. In its broadest sense, then, sacrificial preparation employs two very different approaches. The first seeks to make appear more foreign a victim who is too much a part of the community. The second approach seeks to reintegrate into the community a victim who is too foreign to it."[421]

The leftovers of fashion collections perfectly fulfil the requirements of a victim. They are excluded from being in fashion. This exclusion is materialised in the way the pieces are treated. It is not only an abstract concept of a victim, but a real aesthetic practice. Hubert and Mauss have also pointed out that in traditional sacrificial practice, victims are treated symbolically by means of decoration.[422] The social relations, or, as in our case, the social use of the victim is an important part of the dramatisation of the ritual. The fashion collection, which will be replaced by the new collection, is excluded from being integrated in the fashion practice; it will no longer be featured in magazines, nor will it be presented as a fetish in the stores. Victims, however, are clad in a different dress. The same happens with the seasonal sale goods. The most powerful sign of a commodity is its price, and the change of the price tag is one of the most important symbolic practices during the sales. The price tag becomes bigger, the original price is crossed out, the reduced price is written in a different colour, and so on. Traditionally, the victim would also face a similar fate. There is a compelling logic behind this system based on contradictions. Turner describes the ritual of "scolding the future chief". The future chief is treated like a slave in the night before his accession. Admonished and beaten, he is not allowed to sleep and all the citizens are allowed to insult him.[423] He must bear all these affronts with humility, and there is no consequence for the people involved in his torture. Fashion, too, is tortured in a similar way. And the closer the arrival of the new collection approaches, the more aggressively it is treated. Fashion is treated in the same way as garments are in a cheap flea market. It is no more than a slave in the night before its coronation.

We will now continue the discussion of Girard's example of *The Bacchae.*[424] Girard applies his concept to the festival of the myth of Dionysus, as portrayed in Euripides' tragedy, in order clarify his thesis on the role of violence. But there is a larger aim behind his contention:

[421] Ibid., p. 272.
[422] Hubert/Mauss (1981:28-45).
[423] Turner (1997:100-101).
[424] Girard (1995:126 ff.).

"We must generalize the problem of *The Bacchae* so that it applies to all cultures – religious and nonreligious, primitive and nonprimitive. Our problem will relate to culture's violent origins, previously hidden but now discernible in the rapid disintegration of the last sacrificial practices in the modern world."[425]

The bacchanal festival begins with the destruction of distinctions. Wealth, sex, age and so on are made equal. We have already pointed out that many aspects of the seasonal sale are in keeping with this pattern – from the removal of the brand logo to the same price for all the fashion items. The first worshippers of Dionysus were the women of Thebes and the first bacchanal was celebrated along with Dionysus' aunt, his cousin and the women of Thebes:

"Idyllic at first, the bacchantes' revel soon becomes a bloodthirsty nightmare. The delirious women hurl themselves indiscriminately on men and beasts."[426]

We will try to illustrate the ancient myth with images of the seasonal sale today on the basis of our findings in the archive of the department store on Oxford Street. It was surprising to find that, unlike the show windows, the archive had no photos of the seasonal sale decorations. Instead, we found pictures most probably taken by the internal staff and photos made by newspapers. But these photos were not about window dressing, as is the case with almost all the other photos in the archive; they were about how people conducted themselves during the sales. We will follow the three steps of the dramaturgy accompanied by a selection of three images. The first, a cartoon that was published in a daily newspaper,[427] goes very well with the above quote:

◁ There is a fight going on in front of the show window of the department store on Oxford Street. The window is nontransparent and the two posters attached to it announce: "SALE". Dozens of mainly female shoppers are fighting each other with their hands, handbags, walking sticks and umbrellas. It is a violent spectacle where the reason and the target of the brawl are not obvious. Lost shoes and handbags lie about on the street. An amusing aspect is brought into the scene by a survivor of the fight. He is pointing into the crowd and shouting: "Madam! Yes, you Madam! Would you consider playing for the British Lions?"

425 Girard (1995:139).
426 Ibid., p. 126.
427 The cartoon was published in *The Standard* on Tuesday, 8 January 1981. It was republished in *Honeycombe* (1984:219).

But this is only the beginning of the story. What we see here is that the notion of the abstract sacrifice, as Miller termed it, has to be dismissed. The nature of the seasonal sale is based on violence. And what starts as a fight in front of the show window turns into real battle inside the store:

"Entire armies of resolute housewives charged, ready for close combat to reach their goal in a head-to-head race. Their faces mirrored a range of emotions: from the determined severity of medieval crusaders to the fierce courage of Japanese samurais and Wallenstein's pillaging lansquenets. Ultimately, a cluster of loyal grapes, now reduced to price raisins, began to lay their hands on a few trophies. [...] It was not surprising when one true soldier while unpacking her straw basket at home found a bushel of her rival's hair, lost in the struggle for the same dress."[428]

Two motives, which relate to the myth of *The Bacchae*, appear clearly in this comment on the seasonal sales. The first is the violent behaviour of shoppers and the second is the comparison between grapes and prices. Bacchus is the god of wine. And drinking wine is part of all the festivals related to the god Dionysus. Reduced prices, compared here with the dried grapes, cause an orgy of violence in the department store. Girard designates this as a sacrificial crisis. Like the "strange illness" that afflicted the ancient Greek city and compelled victims to act irrationally.[429] The shoppers are described as warriors fighting for bargains.

The next step in the tragedy by Euripides is the murder of Pentheus. Dionysus is responsible for the murder. It is the culmination and resolution of the crisis, which is caused by the god himself. It is revenge for the failure of the Thebans to pay homage to him. Thus, murder shall bring back peace and harmony to the town:

"The murder itself is performed in accordance with Dionysiac practice; it includes the distinctive sparagmos, or dismemberment, which we have already encountered in other sacrificial contexts. In addition, (1) all the bacchantes participate in the killing. This satisfies the requirements of unanimity, which figures in so many rituals. And (2) no weapon is used; women tear the victim apart with their bare hands. Such a performance is not peculiar only to the Dionysiac cult."[430]

The death of fashion is also an act of collective violence.

[428] Jogo (1974:45)*.
[429] Girard (1995:127).
[430] Girard (1995:131).

Dismemberment takes place on the counters during the seasonal sale. We found a photo of women in front of the bargains in the department store's archive:

◁ A long counter separates the shop assistant from the shoppers. On top of the counter is a huge basket full of seasonal sale garments. As many shoppers as possible squeeze up in front of the pile of goods. They are burrowing into the pile with just one or both hands. Their faces look stressed and nervous. One customer is pushing herself forward to tear out one of the pieces in the basket.

The scene looks as if the women were gorging out the bowels of a huge corpse. Hands disappear into the piles and come out again with parts that will be thrown back immediately. It can happen that two buyers tear out the same piece. They seem to do it with both rage and contemplation. Metaphorically speaking, this is the dismembering of the fashion collection. Shoppers intoxicated with the big reductions are furiously tearing apart the body of fashion. Dionysus was wholly responsible for Pentheus' murder, and thus became the master of the events. The catastrophic consequences of the sacrificial crisis are symbolised by the destruction of Pentheus's palace.[431] The chorus bends down before Dyonisus and the divine tremor brings the palace to fall. But this drastic image can also be found in the context of the seasonal sales. Here it is the tremor of the rampaging shoppers, who destroy the department store. Yet another cartoon in an English newspaper of 30th December:[432]

◁ The entrance level of the department store is empty. We see only two men standing in the middle of the scene. One of them is injured and has an arm in a plaster cast. He has a black eye and his trousers are torn at the knees. There is a big hole in the back wall of the department store through which we can see the passers-by on Oxford Street. We see a few counters in the background, but they are empty, and the seasonal sale posters have fallen down on them. The floor is totally covered with the silhouettes of flattened shoppers. The injured sales assistant asks the other man: "Well, can you remember what colour coat she had on?"

The retail palace has fallen. The walls have crumbled. In Euripides' drama, peace is restored to Thebes. According to Girard, the sudden collective outbreak is not oriented to violence, but to peace.[433] We are now back

431 Girard (1995:133).
432 The reproduction of this cartoon can be found in Honeycombe (1984:218).
433 Girard (1995:136).

to the beginning of the discussion on Miller and Girard. And we have found an aspect of shopping that differs from those stated by Miller. The seasonal sale is a violent sacrifice; it is in fact brutal. It is not just a "battle of prices", but also a battle amongst the shoppers in the store. As a conclusion we will compare the protagonists and begin with Miller:

"Love is here the dialectical transformation of the generality of devotion back into particularity. Having become sanctified through her agency in the self-sacrifice of thrift, she returns with the blessing of love to her family."[434]

Here the aim of the woman is to perform a devotional ritual by shopping for the wellbeing of her family. Love is the outcome and the driving force of the sacrifice. Girard's women act with the objective of peace. He explains the preponderance of women in the Dionysian cult as follows:

"We can [...] postulate a mythological substitution of women for men in regard to violence."[435]

We thus have violence, murder and peace on the one hand, and devotional rites for the beloved on the other. Surprisingly, both chapters close with a discussion on the role of the female in rituals. And this is Miller's conclusion:

"To that extent we can conclude that for all the pressures of secularisation and the Enlightenment, the desire to subsume the individual in acts of devotion remains at the heart of modern female identity, even if the ideal that 'God is Love' has tended to be transformed within the experience of the contemporary family into 'Love is God'.[436]

434 Miller (1998a:108).
435 Girard (1995:136).
436 Miller (1998a:110).

30 West
50th Street

107 East
2nd Street

Fifth
Avenue

NY

"Faced with the modern challenge of merchandise, art can find no
salvation in a critical posture of denial (which would reduce it to
'art for art's sake', visibly and ineffectually holding up a mirror to
capitalism and the inexorable advance of commerce). Its salvation
lies in taking to extremes formal, fetishistic abstraction of mer-
chandise, the magical glamour of exchange value. Art must become
more mercantile than merchandise itself: more remote from use
value than ever before, art must take exchange value to extremes
and thus transcend it."[437]

437 Baudrillard (2003:18).

30 WEST 50TH STREET

There is a connection between the show window and art (theatre, painting, performance art ...), fashion, design (shop design, window dressing, graphics ...), architecture, and marketing (consumer research, merchandising ...).[438] In literal terms, our chapter is set in New York, because we associate a lot of our reading material with this place. We will, however, not enter into an art historic or design theoretic discussion here. We have not undertaken any visual research in New York, but we will use a few selected historic examples in order to throw light from different directions onto our study of the seasonal sale window. The first relation we will be studying is that of art and show window design. In 1929, Frederic Kiesler published the book *Contemporary Art Applied to the Store and its Display*. He promoted the idea of using contemporary artistic techniques to improve the appearance and efficiency of the storefronts.[439] But Kiesler was not solely preoccupied with the design of retail environments, he designed Peggy Guggenheim's art gallery Art of this Century where he experimented with new ways of displaying her collection of mainly surrealist art.[440] From the 1920s onward, more and more artists were commissioned to do window dressings for elegant department stores.[441] We believe that it is the works of artists that influence window dressing and not a specific show window designed by an artist; show windows usually hold little importance in the oeuvre of most artists. Particularly Surrealism has held an outstanding position in relation to window dressing. Even today, we see on 5th Avenue mannequins à la Salvador Dali, with extended arms so that thirty handbags can be presented on just one arm.[442] Show windows have a greater task than to entice customers into a department store:

> "They sustain a tradition by blending advertising and street theatre into a very public form of installation art, understandable at a glance."[443]

[438] We are mentioning only the ones we will discuss later on.
[439] Kiesler (1929).
[440] Bogner/Boeckl (1988:103).
[441] Schleif (2004) cites examples from 1900-1960.
[442] Moreno (2004:93).
[443] Ibid., p. 92.

It is of course the luxury show window in relation to installation art and street theatre that we are discussing here. It is a "beautiful" show window. And André Breton argued as early as in 1942 against the misinterpretation of surrealist art:

> "Surrealism is already far from being able to cover everything that is undertaken in its name, openly or not, from the most unfathomable 'teas' of Tokyo to the rain-streaked windows of Fifth Avenue, even though Japan and America are at war. What is being done in any given direction bears little resemblance to what was wanted." [444]

This is also true of the many other art movements cited in the show windows. The surrealists were not all that interested in the beautiful; they wanted to overcome the clichés of perception by using inter-subjective ways of creation. They worked out various techniques to overcome the consciousness:

> "Automatism reduces inhibition and therewith censorship which exercises the authority of the superego, of the culture business and public expectations. It deploys an anaesthetic, which enables us to evade control by family, tradition and society. Once again, we encounter exactly the two modes that Nietzsche draws on in *The Birth of Tragedy*. In this context, it is the 'separate synthetic worlds of dream and intoxication'. The dialectics used by Surrealism for arriving at new images can be explained by this 'duplicity of the Apollonian and the Dionysian', which connects Nietzsche with the development of art." [445]

Their anti-bourgeois attitude was also not a good basis for being incorporated into the economy of beauty. However, there was one aspect that attracted the merchandising departments of the stores: surrealistic art's ability to shock people. This meant that people would pay attention to the dramatisations in the show window. [446] Merchandising literature regards the impact of surrealistic art with a degree of scepticism:

> "In 1938, Sigmund Freud's introduction of the concept of Surrealism had an effect on the art of display. The application of psychological dream analysis to merchandising interrupted the growth of display

[444] Breton (2005:282).
[445] Spies (2002:30)*.
[446] Salvador Dali's scandalous windows for Bonvit Teller became famous. See Schleif (2004:177-188).

windows, did stop people as they passed, but only for laughter."[447]

The art of display (the beautiful?) is placed here in contradiction to surrealist art. The Dionysian does not enter the surrealistic show window in a ritualised form; it only varies the normal show window and the everyday perception of the beautiful. An interesting point is that the artists used automatism to let things that are normally unimaginable emerge. Things suddenly break out that lie deep within our subconscious. When we go back to the seasonal sale window, we ask ourselves what lies behind the Dionysian aesthetic practice? We do not think of it is an artistic concept, the way Surrealism was. But what is it then? Nietzsche explains the nature of Dionysian art in the following:

"At this point it now becomes necessary for us to launch ourselves with a bold leap into the metaphysics of art, repeating the earlier principle that existence and the upper world appear justified only as an aesthetic phenomenon: in this sense the tragic myth has to convince us that even ugliness and disharmony is an artistic game which the will plays with itself in the eternal abundance of joy."[448]

One of the few examples of the description of a seasonal sale window in glossy show window literature starts with a rejection of the ugly. This is why even Surrealism is not the most influential art movement here:

"A sale is not an excuse to leave windows unstyled and merchandise shabby and shoddy. […] Window display meets Pop art as graphic shapes and colour-blocking assault the eye. Stop-'em-dead colours – red, yellow and black – pull no punches and the glass is used as the canvas for the display."[449]

The dichotomy between the ugly and the beautiful is an often-discussed issue in visual merchandising literature. Although the window described above is a piece of art according to the writer, it is also commensurate with many of the properties developed in our seasonal sale window. The windowpanes are painted, making it impossible to look through them. This is not a form of attracting but of attacking, and there is a total excess of colour. Andy Warhol, one

447 Mills (1982:22).
448 Nietzsche (2000:128).
449 Portas (1999:118).

of the icons of Pop Art had a more subtle view of the phenomenon of sales.[450] He portrayed a shop in a series of photos eight days before it finally closed.[451]

⊲ A huge billboard says, "GOING OUT OF BUSINESS". It is posted on top of the storefront in place of the store's name. The windows are covered with posters: "Last 8 days", "Cash register for sale", "30 to 50% on everything". It is nearly impossible to look through the window.

A few days before it ultimately died, this shop showed most of the seasonal sale characteristics. The difference lay in the fact that there would be no ritualised resurrection to give new power to the merchandise. In the words of visual merchandising the show window looks "disordered, unplanned, with poor display technique, dull and careless, bad taste, negative effect", in short "unorganised charlatanism".[452] All these properties refer back to the past of window dressing. Today's windows are "planned, professional, up to date business" which means "systematic, methodical, artistic value, bright and careful, attractive, tasteful, positive".[453] The seasonal sale window and the everyday fashion window decoration can replace this dichotomy of past and present. It must be especially mentioned here that a lot of good investigations were made at the beginning of the discipline, and books were as just as intelligent, if not far more intelligent than the ones today. It could, however, be difficult to find out what is meant by "artistic value". In all fairness, we must concede that art has influenced the art of window dressing, and that the show window in turn has inspired artists. From 1964 to 1967, the artist Christo made several sculptures in the form of storefronts. They were a further development of his "show windows" from 1963. Christo's storefronts are life-size and placed inside buildings. The glass windows in original scale are covered with a fabric, colour or packing paper, so that the spectator cannot see the inside, making it possible for us to imagine that something like a transformation going on behind the window.[454] But a German window dresser was not inspired by storefronts while doing a spring window in 1970, but Christo's wrappings:

| "Try to imagine this window three or four years ago. Impossible! Just

450 Warhol wrote on window-shopping, "Looking at store windows is great entertainment because you can see all these things and be really glad it's not home filling up closets and drawers". He ends his article on window-shopping with: "When you think about it, department stores are kind of like museums". In: Warhol (1985:21).
451 Hamburger Kunsthalle (1999:150-151).
452 Mills (1982:22).
453 Ibid.
454 See Bourdon (1964), Hollein (2002:162-163), Vaizey (1990:28)

as unimaginable as much else was a few years ago. Today, our show windows are as liberated as fashion is, liberated of many things that were once part and parcel of the show window. [...] This campaign, 'liberated fashion', resulted in fashion disclosures in the literal sense of the word. Raw linen appeared all over like a rash, and we saw figures both cloaked and exposed. The trend was of starkly contrasting ware – eye-catching and imaginative use of minimal means produced astounding results. This work drew its inspiration from the wrappings by the renowned artist Christo."[455]

It is interesting that the phase of incorporation in this case is prolongated into the phase in which the new collection is introduced. The packed mannequins are partly leaning against the wall; some of them are frozen in the phase of unpacking while others are already unpacked. Haug criticised art for being in the service of capital.[456] Does this critique also apply to the art of window dressing? Contrary to American artists, German window dressers are described as "commercial artists".[457] But the show window was not accepted as an appropriate medium even in the field of fine art.[458] We have already related the seasonal sale window to ritual. If we now relate window dressing to art, it might be interesting to throw a brief glance at the relation of art and ritual. Performance art is an art form that is closely related to ritual:

"In contrast to performance which dealt with formal properties of the body in space and time, others were far more emotive and expressionistic in nature. Those of Austrian artist Herman Nitsch, beginning in 1962, involving ritual and blood, were described as 'an aesthetic way of praying'. Ancient Dionysian and Christian rites were re-enacted in a modern context, supposedly illustrating Aristotle's notion of catharsis through fear, terror and compassion."[459]

Catharsis is the assumed motive in Nitsch's Orgies, Mysteries, Theatre projects. For Nitsch, art is an expression of ritual and by the same token, the ritual is an artistic expression.[460] His artistic dramatisation of archaic sacrificial rites as performance art give us an opportunity of getting directly in touch with ancient ritual practices, to feel archaic fear, terror and comparison again. Understanding the

[455] Anonymous (1970:10)*.
[456] Haug (1986:127).
[457] Schleif (2004:150).
[458] Weibel (1980:17).
[459] Goldberg (1979:106).
[460] Nitsch (1999:103).

seasonal sale in its archaic Dionysian dramatisation, as a catharsis of the visual economy of beauty, would be a valid option. At a time when the art of the individual window dresser is replaced by a collective representation of ugliness, representing the ritualised change from one fashion to the other, amounts to a collective representation of the sacrifice of beauty.

107 EAST 2ND STREET

"Looking through the glass into the show window is really like looking at the stage – with this difference: the actors, in art terms, are speaking plastics in motion, whereas the merchandise is a silent, static object."[461]

The show window is related to art, but also to theatre. Frederic Kiesler provides some examples in which he shows images of avant-garde stage settings of his day so that their artistic principles can be applied to the creation of backgrounds for the retail theatre.[462] We will point out another relation in order not to loose the relation to our observation of the seasonal sale window, which takes us back to our central topic: the relation between theatre and ritual. Richard Schechner was one of the first to apply ritual knowledge to the art of theatre as well as theorising it in the field of performance studies:

"Both animal and human ritual actions are very close to theatre. In theatre, too, behaviour is rearranged, condensed, exaggerated, and made rhythmic. [...] The violence of ritual, like that of theatre, is simultaneously present and absent, displayed and deferred. The ritual actions are displayed even as the 'real events' are deferred."[463]

But in the reality of the street, there is no substitute for the ritual sacrifice of the past collection.[464] For Schechner, violence,

461 Kiesler (1929:110).
462 Kiesler (1929:111-113).
463 Schechner (1995:230-231).
464 If we assume that the ritual is the sacrifice of "fashion", then the seasonal collection would be its substitute.

sexuality, and theatre are deeply related to Western, Greek and Hebraic-Christian, traditions.[465] For him, contemporary performance art relates to the same traditions as the orgiastic ones against the body in the Middle Ages.[466] The discussions on window displays often refer to the theatrical, but not to the ritual. Sara K. Schneider focuses on the performance design of show windows:

> "Members of the visual merchandising industry routinely talk about their work as theatre. Display directors speak of the mannequins as actors, among whom they circulate as authors of a total, three-dimensional vision. In fact, directors create a dramatic situation by placing the mannequins strategically – the static equivalent of stage blocking – and costuming them and propping their environment to maximize their impact. Display directors strive above all to control the ostensible emotional relation between mannequins and the impression their actors make on the public. Theatre directors and display directors are interpreters of a like nature – one makes the literary theatrical, the other makes the visual theatrical."[467]

Several live performances have tried to blur the borders between art and life, commerce and art. In 1978, the artist Colette presented one such performance in the show window of an Italian fashion boutique in Upper East Side, as part of a series of events organised by its fashion brand.[468] Colette created her own brand called "Colette is Dead Company" aiming to take the movement away from the commodity cosmos towards art as practised in Pop art. She called it "Reverse Pop", and this art was to flow back into the everyday. The "Colette is Dead Company" created fashion collections, fragrances, furniture design, post cards and a mannequin of the artist under the name "Beautiful Dreamer Products".[469] She presented the new collection in the show window in a Dionysian way:

◁ The decoration of the window made it look as if a basket full of miscellaneous objects and fabrics had been turned over on the floor of the show window. Some ripped apart pieces of fabric were also fixed to the side of the window. Reposing in the middle of the pile of garbage was the artist herself dressed in a raffled skirt, which was lifted by a rope dangling from the ceiling. Her naked legs were pointing at

465 Schechner (1995:231).
466 See Fischer-Lichte (2004) for the aesthetic dimension of performance, as well as for violence in performance art.
467 Schneider (1995:1).
468 Schneider (1995:40-43,141).
469 Almhofer (1986:115).

the spectator and her eyes were closed, so she could be either dead or asleep.

The window bore all elements of a typical seasonal sale window. Colette had reversed the logic of the commodity world once again, dramatising the introduction of the new collection as its death. As we have already shown, documentation of the idea of staging the seasonal sale with discarded pieces exists from various times before.[470] Colette performed the retail drama in an artistic manner, and she also found a poetic interpretation for the "life" of the mannequin.[471] Clothing played a central role in this performance, and there were references to Surrealism as well. Elizabeth Wilson reflects on Fashion and Surrealism by focussing on the fetish:

"For Breton and the surrealists the fetish bore a relationship to their concept of the Marvellous. The Marvellous came about as the marriage of what they called convulsive beauty and objective chance. These chance encounters, unexpected places and found objects all exemplified the Marvellous. Their accidental occurrence or the unexpected manner in which the surrealists became conscious of them invested them with the same sort of magical meaning as had been attributed to the fetish. In fact, the found object was very similar to fetish".[472]

This concept runs counter to the production of the commodity fetish and the representation of beauty. It is the counter world that also breathes life into the seasonal sale window. The surrealists would have adored the accidental beauty in them. Unfortunately, the relation between fashion and art cannot be discussed in detail here. We will, therefore, only give a short description of a possible way of drawing a border between them. According to Rainer Metzger:

"The difference between art and fashion is not that one is additive and seasonal and the other cumulative and organised along fixed margins, which were the explanations put forth by modernism and particularly by Walter Benjamin, the postmodern explanation is that fashion is different from art because fashion is dependent on world-wide currency in order to reach the small lives of those who feel obliged to follow it, whereas art focuses on the marginal, incidental

[470] See Austerlitz (1904:89) and Anonym (1957:35).
[471] See also Benjamin (2004:693-697) on the "fairy-like" appearance of the mannequin.
[472] Wilson (2004:381).

and idiosyncratic in order to endow it with symbolic power, and to distil a general validity from the details of the everyday."[473]

Colette reflected on such currencies from different directions. And during the seasonal sale, the everyday (the Marvellous) can thus sit on the throne of fashion for a couple of days. This is not to be confused with the artistic transformation of the everyday. The state becomes stable after the artist's transformation. But in the case of the seasonal sale, it is only a temporary switch of roles. The passage rite from one fashion into the other is performed by agents of the everyday who unfold their beauty through accidentalness. Victor Turner and Richard Schechner tried to enact various ethnographies with the help of performance theatre. In a theatre workshop actors re-enacted a "social drama" of the Ndembu. Banal objects of the modern everyday were used as an index for the real ritual tree. Although the two never used language in their performance workshops, there was a deeply intuitive understanding of the conflict of the aforementioned ethnological case.[474] Human action is the main focus of performance studies. Performance is action.[475] And this is the critical point of our study. The dramatisation on the stage of the "street theatre" is frozen. The mannequins do not move, and herein lies the ambivalence, because in relation to ethnological case studies they are perhaps not allowed to move in their "liminal" state. Does the fashion show window transform into a showcase of an ethnographic museum during the sales? Carl Jung, who introduced the idea of the archetypical symbols of the collective unconsciousness, claimed that intuitive images like the rising sun can be inscribed into objects and become part of the meaning of things.[476] Cognitive sciences further developed this idea of "universality". The cognitive scientist Donald Brown points out that basic cultural needs cause cultural responses.[477] And these "human universals" are similar in all times and societies:

"Human universals comprise those features of culture, society, language, behaviour, and psyche for which there are no known expectations to their existence in all ethnologically or historically recorded human societies. Among the many examples are such disparate phenomena as tools, myths and legends, sex roles, social

473 Metzger (2004:58).
474 Turner (1982:96).
475 Schechner (2003:1).
476 Csikszentmihalyi/Rochberg-Halton (1999:24).
477 Brown (1991:67).

groups, aggression, gestures, grammar, phonemes, EMOTIONS, and psychological defense mechanisms."[478]

If the seasonal sale window is a dramatisation of a basic human need in our culture today, then it would be interesting to know of which need. But this question is part of the discussion we defined at the beginning.

FIFTH AVENUE

"Whatever has been portrayed onstage is now seen as not the real thing at all but only a representation, one made benignly to provide vicarious involvement for the onlooker. (Indeed at curtain calls actors routinely maintain the costume they wore when the curtain came down, but now the costumes are worn by individuals who do not fill them characterologically but slackly severe as mere hangers, a hat off or a scarf missing, as though to make a point that nothing real is to be attributed to guise.) In brief, make-believe is abandoned."[479]

If we perceive the show window as a "stage" and the mannequins as "actors", then it would be interesting to apply to the show window Erving Goffman's frame analysis of the theatre. For ancient Greek theatre, the street or some other public space was the stage.[480] The audience was integrated into the scene as if they were standing across the street. All actions had to take place under the sky. The frame prescribes the behaviour of the participants of an action and also how the actions are to be interpreted. The frame of the theatre splits actors and audience, both prescribed with different ways of acting. Let us go back to the shopping street. When we apply the frame of the "retail theatre" to the show window, we can interpret the window shoppers as the audience.

478 Brown (1999:382).
479 Goffman (1986:132).
480 See footnote 15 in Goffman (1986:139).

Being part of the audience in a theatre obliges us to act as if our own knowledge, as well as that of some of the characters, is partial. As on-lookers we are good sports and act as if we are ignorant of outcomes – which we may be. But this is not ordinary ignorance since we do not make an ordinary effort to dispel it. We willingly sort outthe circumstances in which we could be temporarily deceived or at least kept in the dark, in brief, transformed into collaborators in unreality."[481]

But the theatre ends, and the actors come to the stage front. The play is over, and striking similarities to our retail theatre emerge. The play lasts for a half year with many different scenarios, and then the curtain falls and the mannequins lose their roles as performers. The destruction of illusion plays an important part in the dramatisation frame of the theatre. And it is perhaps equally important in the frame of the retail theatre. Jean Baudrillard describes a similar phenomenon in the reception of advertisements:

"For this is not a logic of propositions and proofs, but a logic of fables and of the willingness to go along with them. We do not believe in such fables, but we cleave to them nevertheless. Basically, the 'demonstration' of a product convinces no one but it does serve to rationalise its purchase, which in any case either precedes or overwhelms all rational motives. Without 'believing' in the product, therefore, we believe in the advertising that tries to get us to believe in it."[482]

The reception of the advertisement, or in our case the retail theatre in the show window", can be compared with the reception in the theatre. The audience fills this role in the frame of the theatre. It is not on stage but in the darkness of the auditorium, it laughs when an actor cracks a joke, and it applauds when the dramatic performance is over. John Austin, who coined the word "performative" to describe speech acts as "I name this ship the Queen Elizabeth", explained this concept of the performative. Performatives according to him, do not describe or represent actions, they are the actions. They are often combined with physical acts, like the bottle of Champagne that is smashed against the ship. Performative utterances have to fulfil several conditions in order to succeed.[483] When we assume that

481 Goffman (1986:135--36).
482 Baudrillard (1996:166).
483 Austin (1986:14-15).

"SALE" is such a performative utterance, then the seasonal sale has to be a procedure with a predetermined result in which the word "sale" is uttered at the right moment, in our case at the end of the season. People and circumstances have to fit the evoked procedure. All those involved have to execute it fully and in the right way. And finally, when opinions and feelings are expressed during the procedure, all those involved have to intend to behave according to these expressions. At the end, all the people involved must behave as intended. Should any one of these six rules be violated, the performative utterance would fail. "SALE" means that the seasonal collection of the past season is no more in fashion. According to Austin, the sale can fail, for example, when the seasonal sale is not announced at the end of the season. When one single store announces the seasonal sale a few weeks before Christmas, it could confuse the customer for it is not the time set for it. Neither would it work if we were to enter a shop and proclaim "sale", for it is the retailer who utters the words not the customer. Austin gives another example of misuse where the procedure fails. He hypothesises that if we happen to be at a ship's christening ceremony to which we are not invited, take a bottle, smash it against the ship and give it a wrong name, the performative gesture would fail because although we fulfilled all the formal criteria we were not responsible for naming it.[484] The same happens when a new collection is introduced. "NEW" is also a performative utterance. Like Austin's speech acts, the "new" also changes social reality. People who wear the new things are in fashion; they find this fashion good, because it is new. The interesting thing about performative utterances is that they are neither right nor wrong. They are either accepted or they are not.[485] And the same has to be considered for rituals. Stanley Tambiah referred to Austin's speech acts in his performative theory of the ritual:

> "Ritual is a culturally constructed system of symbolic communication. It is constituted of patterned and ordered sequences of words and acts, often expressed in multiple media, whose content and arrangement are characterised in varying degree by formality (conventionality), stereotypy (rigidity), condensation (fusion), and redundancy (repetition). Ritual action in its constitutive features is performative in these three senses: in the Austinian sense of performative wherein saying something is also doing something as a conventional act; in the quite different sense of a staged performance that uses multiple media by which the participants experience the

484 Austin (1986:23).
485 Ibid., p. 153.

event intensively; and in the third sense of indexical values – I derive this concept from Peirce – being attached to and inferred by actors during the performance."[486]

The word "SALE" symbolically kills the seasonal collection. The Dionysian setting of the window is the backdrop for its naked mannequins, which indicate the death of the collection. Once the word "sale" is uttered, there is no going back; the collection is simply out of fashion from this moment on. It is a definitive act. The window dresser Simon Doonan decorated a show window in 1981, which proves this notion.

◁ Four naked mannequins were placed in the show window, covered with just one black letter each. Together they formed the word "S-A-L-E". A ribbon was wrapped several times around the lower part of the window making it look like a fence. This created a clear border between the inside and the outside of the window:

"Pink towelling ribbon used to minimize the need for window merch during sale time when it all had to be available to customers inside the store."[487]

Beyond this rather rational statement by the window dresser, we find a highly symbolic language of staging the seasonal sale: It is an interaction of the performative utterance of the word "SALE", which is dramatised as the sparse cover for the naked mannequins. The customer is symbolically excluded from the symbolic nakedness and emptiness behind the fence of pink towelling ribbon. The border brings us to the question of architecture and its relation to ritual. In 1983, a special issue of *The Princeton Journal: Thematic Studies in Architecture* dealt with the subject of ritual. As the architect Michael Graves explains:

"The question of ritual became particularly interesting to me some years ago when I was asked to give a seminar on the thematic content of architecture. It has always been apparent to me that while literature is involved with text and narrative, architecture, in its abstract nature, is not necessarily bound by story-telling but instead by the enactment of rituals. Rituals may represent general narratives or even the aspiration of society, but by nature they are inconclusive.

[486] Tambiah (1979:119).
[487] Among hundreds of photos of windows, this is the only one of the seasonal sale window. See Doonan (1998:37-38).

Because of this, we realize both their importance and their fragile character in any composition."[488]

And instead of extending this questions to "real" architecture, Graves described his set design for the ballet FIRE on the theme of the "bacchanal".

Dionysian rituals were not the subject of consumer research, yet even in this field there was an increased interest in rituals at that time. As in architectural theory, there was a striving to transform ethnological terms like the "ritual" into the context of the modern environment:

"Yet, if much buying and consumption behaviour is as intensely motivating as Erikson and many others suggest, then many common household and market rituals are more than mindless habits."[489]

But if the seasonal sale is not a "mindless habit", as Dennis Rook termed it, what is it then? Is there nothing in the window because the retailers needed everything inside the store, or is it more meaningful? Grand McCracken pointed out that consumers influence the flow of meaning from the consumer product to the individual consumer by means of different "consumer rituals".[490] The way consumers shop during the sales differs from their normal shopping behaviour. On the one hand, it is more functional shopping because of the bargains, but on the other it is more symbolical because it is here that the death of the seasonal collection is acted out. Russel Belk, Melanie Wallendorf and John F. Sherry conducted a research on how the profane turns into the sacred in our consumer culture:

"An ordinary commodity may become sacred by rituals designed to transform the object symbolically. Much ritual behaviour in the contemporary consumer culture has been secularised – in effect reduced to ceremony or habit – but some ritual may be reclaimed, or singularised, and consciously returned to the realm of the sacred. These rituals may be public or private, collective or individual."[491]

If the seasonal sale is related to a myth, we have to reflect on how advertising transports rituals today. Marc Ritson and Richard

[488] Graves (1983:52).
[489] Rook (1985:258).
[490] McCracken (1988:72).
[491] Belk/Wallendorf/Sherry (1989:14).

Elliott conducted a study on the ritual use of advertising.[492] It is about the social use of the advertisement, and how commercials are transformed into rituals based on language. Muniz and O'Guinn spoke of rituals that are not detached from the relation to the brand. They also introduced the term "brand community":

"A brand community is a specialized, non-geographically bound community, based on a structured set of social relationships among admirers of a brand. It is specialized, because at its centre is a branded good or service. Like other communities, it is marked by a shared consciousness, rituals and traditions, and a sense of moral responsibility."[493]

In this context, the seasonal sale could become an important tool for stablizing the relationship between the brand and the brand community. The store makes a sacrifice to the brand community twice every year. The periodical repetition and the mythological dramatisation may be an emotionally important "religious" service to the customer. A transcendent ritual of transformation from one fashion into the next is accompanied by the "common meal" of the brand community. This fits in well with Tom Peters' tips on future marketing:

"Imagination, myth, ritual – the language of emotion – will effect everything from our purchasing decisions to how well we work with others. Companies will thrive on the basis of their stories and myths. Companies will need to understand that their products are less important than their stories."[494]

There is a difference between the way a story or a myth can be related. Stories are a collection of facts, and the storyteller is responsible for his narration. The speaker of a myth is not responsible for its content. Mythical language is based on declarations like, "this is not my story, I heard it somewhere else".[495] This is the death of the author, as Roland Barthes termed it.[496] In archaic cultures, the myth had no origin; it was not invented by a person, and the shaman was merely its transmitter. And this seems to be one of the few myths that have remained in this world of individual brand stories, and none of the fashion brands can make it their own. Marshall Sahlins contended

492 Ritson/Elliott (1999).
493 Muniz/O'Guinn (2001:412).
494 Peters (2001:34).
495 Sennett (1996:81).
496 Barthes (1977:142).

that our culture is not radically different from "savage thinking" because of our belief in symbolic rationality:

> "The final alienation is a kind of de-structuration. Marx wrote that primitive society could not exist until it disguised to itself the real basis of that existence, as in the form of religious illusions. But the remark may be truer of bourgeois society. Everything in capitalism conspires to conceal the symbolic ordering of the system – especially those academic theories of praxis by which we conceive ourselves and the rest of the world." [497]

[497] Sahlins (1976:220).

Mönckeberg
Straße

Spitaler
Straße

HAMBURG

"For this reason fashion, which represents the variable and contrast-
ing forms of life, has since then become much broader and more
animated, and also because of the transformation in the immediate
political life, for man requires an ephemeral tyrant the moment
he has rid himself of the absolute and permanent one. The frequent
change of fashion represents a tremendous subjugation of the
individual and in that respect forms one of the essential complements
of the increased social and political freedom."[498]

[498] Simmel (1971:318).

Ever since Douglas and Isherwood pointed out that consumption is a ritual process, marketing theorists have tried to make this insight fruitful for their activities.

> "To manage without rituals is to manage without clear meanings and possibly without memories. Some are purely verbal rituals, vocalised, unrecorded, but they fade on the air and hardly help to limit the interpretative scope. More effective rituals use material things, and the more costly the ritual trappings, the stronger we can assume the intention to fix the meanings to be. Goods, in this perspective, are ritual adjuncts, consumption is a ritual process whose primary function is to make sense of the inchoate flux of events."[499]

Instead of developing greater consciousness in producing and nurturing this social practice with social responsibility, marketing tried to misuse the concept of ritual power solely for its own economic goals. Rituals became the new weapons of marketing, whereby consumers were not only to buy and consume, but also to enact a ritual. The proclaimed collapse of religion is to be compensated by ritualising the consumption process. Consuming was the new religion, which welcomed the advent of the "primitive" as an alternative to the more and more abstract world we live in. And consuming needed new rituals, of course with ritual power in the production sector. The brand community was to be held together by means of rituals. Bolz and Bosshart articulated all this and dreamed the following marketing scenario:

> "When we think to the end the demands of rituals, it is easy to see that it is possible to enforce ritualisation with even tougher means. In this way, one could achieve a kind of dependence which is very difficult to overcome or not at all."[500]

It is sheer madness to want to produce consumer junkies, who are possibly hooked to a particular brand. While Simmel feared that the consumer could become a slave to the trend industry, to the fashion industry in particular, Bolz and Bosshart go a step further. The relation of master and slave is replaced by the relation of dealer and junky. Both concepts are frightening. Here, Miller's notion of consumption as a sacrificial act of devotion undergoes a primitive

[499] Douglas/Isherwood (2002:43).
[500] Bolz/Bosshart (1995:260)*.

transformation, turning shopping into an act of devotion to the brand.[501] But in both concepts, the god is replaced by other more secular, "transcendental goals". It might, therefore, not come as a surprise that during the seasonal sales the visual dramatisation also "transcends" the everyday window dressing practice:

◁ The window display of this fashion boutique is illumined by several spotlights. Six naked female mannequins are placed in it, wrapped with a red and white striped ribbon, the kind used for cordoning off construction sites, so that it looks as if they are wearing bikinis. The back wall is empty and painted white. On the floor lie a few pairs of shoes and some handbags. Written on each of the glass panes are the words: "WIR SCHLIESSEN – EINZELTEILE (bis zu) 50% REDUZIERT".[502]

Instead of designer clothing, the mannequins are dressed in a ribbon used at construction sites. The ribbon normally signals that entry is prohibited. But what does it mean on the naked body of a mannequin? Maybe that the garments are under construction and the new ones will be introduced soon? What should we buy if all the mannequins are only wearing ritual dresses? As we find no answer, we go on and stop again a few storefronts later:

◁ In the show window of this fashion boutique are four mannequins. A sales poster hanging from the ceiling shows the black and white image of an ancient Egyptian pharaoh. The mannequins are wrapped in a transparent plastic sheet. This could be interpreted as dress, but also as mummification. They are all wearing gold bracelets, but the one in the back dons a golden cylindrical hat or crown. Its arms point forward. Thick black eyeliner and golden eyebrow pencil make the eyes of the mannequins look Egyptian. A few gold vases and bowls are placed on the floor. Written over the entire height of the show window is: "1/2". The scene is reminiscent of an ancient Egyptian ceremony from pharaoic times.

In his "mythologies", Roland Barthes, reflecting on the nature of plastic, called it an alchemic substance that represents the idea of endless transformation.[503] Going by this premise, it is also the best material during the seasonal sale as replacement for everyday garments on the mannequins. It truly transcends everyday clothing

[501] Miller (1998a:78) and Bolz/Bosshart (1995:254).
[502] "We are closing. Single pieces reduced up to 50%".
[503] Barthes (2000:97).

and becomes the endless transformation of fashion. But this dramatisation also has a more tangible dimension. The staging of an ancient Egyptian scenario – a scenario evoking associations to mummies and pharaohs – turns the show window into the stage of a low cost production. Instead of prestigious garments and gold jewellery, we see transparent plastic and gold-sprayed pottery. But beside artistic concerns, we also found a critique of the retail theatre. Wolfgang Fritz Haug was among the critical voices against the commodity theatre. He described shop fittings as "aesthetic weapons" in the fight for the consumer. And he commented the trend among the stores to create stages for their commodities as follows:

"The exhibition of commodities, their inspection, the act of purchase, and all the associated moments, are integrated into the concept of one theatrical total work of art which plays upon the public's willingness to buy. Thus the salesroom is designed as a stage, purpose-built to convey entertainment to its audience that will stimulate a heightened desire to spend [...] This aesthetic innovation of the salesroom into a 'stage for entertainment' on which a variety of commodities are arranged to reflect the audiences' dreams to overcome their reservations, and provoke a purchase was a pioneering exercise at the time marked by general change in the selling trend."[504]

Haug included the way goods are presented, and how this presentation has changed the shopping experience, in his critique of commodity aesthetics. The goods are dispersed in the dramatisation; the consumer no longer faces a product but a scenario.[505] For the seasonal sale, the nullification of the commodity is the overall concept. No other product is used, and the pure scenario remains. The seasonal sale is the radical formulation of the tendency by which the things disappear in the scenario so that only wishes and fears remain as the basis of the dramatisation. Use value and exchange value of the commodity transcend into the fear of the new fashion trend's arrival. Surprisingly, more and more contemporary writers are now corroborating the "new" trend of the shop as theatre:

"The new entertainment twists, caught in phrases like 'retail theatre' and 'experiential' selling, gives the old bricks-and–mortar setting an edge."[506]

504 Haug (1986:69).
505 It should be noted that the use of scenarios is not so new. It goes back to the very birth of the big department stores.
506 Molotch (2003:157).

While "retail theatres" stage the wishes of the consumer during the year, during the seasonal sales, the fears of the consumers are expressed in the form of a Dionysian drama. The fashion god is dead. The products have disappeared form the stage. Nakedness remains, sparingly covered with transparent plastic, representing the endless change of fashion.

MÖNCKEBERG STRASSE

"German design may not be as decorative or beautiful as the products Italian or French designers place in their boudoirs, but even in its ironic and so far horrendously unpoetic nuances it is honest and credible."[507]

During the 1980s, Hamburg – beside Düsseldorf, Cologne, Stuttgart and Munich – was one of the centres of radical German design.[508] New German design was the counter movement to the notion of "good design".[509] In contrast to German industrial design, the emphasis of this movement was mainly on arts and crafts. Significant here was the use of everyday objects as a starting point for the design process. Design was more akin to art than to the social dimension of the everyday object:

"Form, function and material are liberated of their dependencies, whereby the freedom of disposition is undoubtedly trailed by the dependence of disposition. And this alone is of consequence: away with social worker culture! This means that the designer is first and foremost a designer and does not have to be a sociologist, but it also does not mean that he takes no notice of social conflicts or has no opinion about them. But a designer is never a sociologist, and a sociologist never a designer. Social worker culture means that

507 Albus/Borngräber (1992:7)* on the German radical design movement of the 1980s.
508 Albus/Borngräber (1992:37).
509 For a design historical discussion, see Selle (1994) and Fischer (1988).

social benefit should be apparent immediately and the protest must be trend-setting."[510]

The protest was not only directed against beautiful German "good design", but also against the notion of the involvement of design in social processes, as Gert Selle pointed out a few years ago in his "social theory of design". The ugly seemed to make the beautiful uncanny:

"'Timeless', 'eternal' design is a product of fear. We proclaim unrest as the normal state, restlessness as resting place. We take loving care of our neuroses. We rejoice in the onset of emotional confusion."[511]

The German seasonal sale window is not any different from the ones in the other cities we have visited. Since it, too, stages the ugly, the following would be a fine homage to German radical design:

◁ A chrome rod held by chains hanging from the ceiling is the central element in the show window of a men's fashion boutique. On the rod are several jackets on wooden hangers. Each of these fashion items bears a red price tag. Folded shirts are exhibited on the right side, and each of them seems to be crossed out by a tie. Written on the window is: "SALE SALE SALE SALE SALE..."

The symbolic capital of the retailer, the image risks being damaged to augment the commercial capital.[512] The next show window takes us back to design and sociology:

◁ The two huge show windows are located in a modern building. The decoration of both windows is identical. One half of each window is totally blocked out with red, paper posters, while the other half is open. Four mannequins clad in red T-shirts and black trousers stand in a row. Each T-shirt bears one big white letter: "S-a-l-e". The backdrop, the sidewalls and the floor are painted white. On coming closer to the window, we see that one of the posters is damaged. When we peer through the gap, we see several naked mannequins behind a red wall. And behind them is a huge red flag with the word "sale" written on it.

510 Borngräber (1987:13)*.
511 Brandolini (1990:20)*.
512 For the different capital types of market agents, see Bourdieu (2002a:192).

In his outline of a "social utopia of design", Gert Selle questioned the impact of good and bad design on society. Contrary to the radical German design movement, he was convinced that a progressive approach in design should be based on sociology. He was angry about motivational consumer research, for him the outcome of design based on it was merely styling.[513] He argued that social behaviour ought be just as designed as the materiality of objects.[514] For Selle, communication is a key function of design. And he sees his utopia in a communication that is no longer under the influence of commercial forces:

> "Since the social utopia of design insists that falsified norms of communication be dismantled and at least the potential for a non-hierarchical communication be ensured in the design, we must find ways of undermining the norms of product conformity that falsify meaning."[515]

Selle argued that instead of producing culture, the system is only reproducing the commodity fetish.[516] The seasonal sale window is the bridge between the fetish generations. The temporarily sacrificed symbolic capital of the retailer fills the vacuum between the fetish generations. Thus, social utopia of design is related to the deep-seated basic needs of the consumer:

> "It is of utmost importance for the strategies of concrete design utopias to correspond to the probably suppressed structures of con-sumer need/demand in such a way that a spontaneous expression of demand/need results."[517]

But especially the seasonal sale, with its intuitive symbolic communication, would have the possibility of fulfilling these premises of utopian design. It is a shame that the seasonal sale is not free of the commercial power of the production sector. Is it only possible to achieve utopian design when production forms and targets are redesigned?[518]

◁ The show window of a men's fashion boutique shows three torsos. The torsos are placed shoulder to shoulder. The first and the third

[513] Selle (1997:117).
[514] Ibid. p166.
[515] Ibid., p. 135*.
[516] Selle (1997:104).
[517] Ibid., p. 162*.
[518] Selle (1992:174).

ones display winter-garments, while the middle one is wearing a red pullover with a white inscription on the front: "SALE !" The backdrop of the window is bare and white, but then we discern tiny red arrows attached to the individual items. The arrows are pointing to the scarf, to the pullover, to the tie and to the striped shirt and they are attached to the items with pins so that they seem to be floating with only their points touching the fashion pieces. On coming closer we found that the little red arrows bear the word "sale!"

Lucius Burckhardt claimed that "design is invisible". With this notion, Burckhardt wanted to describe those achievements of design, which do not remodel material but our social life and environment.[519] And our show window does not show invisible design. It is hidden somewhere between the fashion items and the little red arrows. This "invisible design" in the seasonal sale is beyond what we see. It is not the red painted backdrop or the packing paper dress of the mannequin, it is the periodical redesign of social interaction based on changing fashions. The ritual is the perfect "material" for "invisible design" because rituals shape social practices. We stop in astonishment before a huge storefront. It is nearly empty, invisible design quite obviously needs little materiality:

◄ The show window is very long. There are only two elements inside it: a sales poster and a clothes rack with just a few items. Both elements are supported by two scaffolding rods. The backdrop is white. The show window is unusually empty; its army of mannequins has been removed.

This is very functional and cheap show window dressing; it is a window chock-full of emptiness. We have the feeling that we have come too late. Everything has been sold out. The battle against the irrational was fought by the Hochschule für Gestaltung Ulm in Germany after the Second World War:

"In Ulm the dominance of the rational is rooted in many things. Firstly, we all remember fascism as an experiment that robbed people of their rationality and consciously enslaved them with the help of symbols and irrationality."[520]

Belief in the rational ignored all design issues that dealt with

[519] Burckhardt (1995:31).
[520] Lindinger (1987:83)*.

fashion and taste. "Those monks on the hill"[521] dealt with only those areas in which they could work on the basis of rational reasoning:

> "By excluding from the very beginning art as well as products of good taste and fashion from education, we have to some extent also liberated ourselves of the emotionally charged and irrational character of these fields. We initially operated in areas where we could celebrate rationality unencumbered."[522]

Design that is free of aspects of fashion, taste and art was a short-lived utopia. Rituals are not technical matters and cannot be solved by technical means.[523] But as we have seen, the use of irrational symbols in the field of design raises the question of ideology. The main question why rationalistic design denied ritual constructions is answered by Catherine Bell's definition. According to her, if a cultural action serves no practical purpose, then it is a ritual.[524] This is reason enough to banish the ritual from the rational design process. The ritual of the seasonal sale belongs to this "irrational" area of fashion and its dramatisation of the seasonal sale. Red again in the next show window:

< Fixed to the back wall between two dressed mannequins is a large seasonal sale poster. It shows a huge percentage sign in dark red against a paler red background. On the floor between the mannequins stands a three-dimensional percentage sign highlighted by a spotlight.

We have already heard about the irrational use of symbols. Can this also be said of the percentage sign? For the graphic designer Adrian Frutiger, this sign is only used in literature on economics.[525] But the percentage sign is the powerful logo of the seasonal sale. We see it everywhere and it is not limited to a single language. It is a sacred symbol that shoppers worship. Whether handwritten, or as a poster; on the back wall, alone or together with the amount of reduction in percentage, the percentage sign indicates the sacrifice of the past fashion. It is the ritual knife, which cuts the throat of the commodity. And so it is the red which usually accompanies the irrational symbol of consumer culture. When it appears twice a

521 Branzi (1988:40).
522 Lindinger (1987:85)*.
523 For Slater (2003:86) modernity, according to the Frankfurt School, sees all problems, including those of identity as technical matters that can only be solved by technical means.
524 Bell (1997:46).
525 Frutiger (1989:218).

year, the consumers go into a frenzy. Otl Aicher, founder of the Ulm Accademy of Design, found the irrationality of rituals and their articulation in design objects highly annoying:

"The ritual consecrates just about anything, from nonsense to even inhumanity."[526]

For Aicher, objects that lose their functional properties in favour of heightened symbolic communication are merely ritual adjuncts. They should rather be for sacrificial purposes than for everyday use. Design theorist Michael Erlhoff asked whether it is the designer or the artist who should design the ritual object for liturgical (sacrificial) use. And his solution is surprisingly not the artist, but the designer.[527] The answer to the question whether the object acquires its aura by its use or by materiality can be found in Walter Benjamin, who describes the origin of art in the context of the ritual. The aura of a piece of art is always connected to its ritual function,[528] and the use value of art comes from its ritual use. This was before art liberated itself of its parasitical dependence on the ritual through technical reproduction.[529] Erlhoff reasons his insight by explaining that the artist thinks from the point of view of material and form, while the designer, with his social knowledge, develops the idea in view of symbolic communication and the ritual. But designers often forget that myths are not narrated by authors, but by storytellers. New burial rituals that introduce a symbolic language not shared by the community would fail in this endeavour. They would cause a ritual crisis, as described by Clifford Geertz in a report about a burial in Java.[530] The corpse could not be buried because no one could be found to perform the right rituals in time. And what right rituals are is not a singular idea (of the designer), but a notion commonly shared by a group of people. The official in Java said that he had no knowledge of the ritual that had to be performed for this particular cultural group. The mastery of the rituals for the seasonal sale is possessed by the fashion industry. Its agents are the retailers. When the burial of the past collection is prepared, all the customers are invited to participate in the ceremony. The reaction of the fashion consumer is quite similar to the reaction that accompanies a death. The recurrent death of fashion collections triggers reactions that are mediated by the ritualisation of

526 Aicher (1992:117)*.
527 Erlhoff (1998:54).
528 Benjamin (2003:256).
529 Ibid., p, 256.
530 Geertz (1973:142-169).

the burial. We should not run away in panic (this does not only mean buying the leftovers), but neither should we follow the corpse into the grave (that is, stick to the old fashion and wear that instead of the new one). So, the dramatisation is carefully orchestrated as a performance of mythical character. As we have so far observed, the degree of invention is limited by a rigorous ritual script and a commonly shared symbolic language. Consumer culture ensures the death of the commodity. The commodity's burial is more unified than the ways in which people are buried according to their religious beliefs today. Continuing on our walk, we spot one of the few windows that has used a photographic image for the seasonal sale:

◁ The entire length of this glass façade is covered by a poster. Half of it is red, and the other half shows the closeup of a face that is distorted into a grimace. The eyes are wide open, the nose seems to be pressed against the glass of the show window, and the mouth is wide open. The expression is somewhere between surprise and fear. The red part indicates one price for several different garments.

According to Nietzsche, the "ugly face" is the result of wild reactions, great physical efforts or fear. Creating fear belongs to the archaic strategies of survival and has thus also become part of the ceremonies.[531] The ugly face, therefore, belongs to the strategies of the ugly; it is a part of Dionysian aesthetics. The distorted face or the grimace is used in all cultures, although the interpretation of each may differ. In any case, it signifies a difference to the everyday facial expression as Richard Schechner points out here:

"All we can be sure of is that both ordinary behaviour and aesthetic behaviour are codified. Ordinary behaviour does not appear to be codified because people perform ordinary behaviour day in, day out – it's as "natural" to them as speaking their mother tongue. Are ordinary behaviours as culturally distinct as spoken languages? The answer is both yes and no. Whole suites of gestures, signs, inflections, and emphases are culture-specific. At the same time, even when persons can't converse in a spoken language, gesturing gets meaning across. Some expressions – the happy smile, lifting the nose in disgust, the wide eyes of surprise, for example – occur in all human cultures."[532]

[531] Liessmann (2000:236).
[532] Schechner (2003:184).

Maybe in former times people would have created masks with stunning grimaces to celebrate the period of bargaining, and processions would be held in the big shopping streets. Thousands of people would celebrate the ritual period of thrift. Masks are related to power. The fixed expression on the face of a god becomes a figure that does not change and is the image that will be worshiped. Elias Canetti, describing the obdurate nature of the mask, said that the mask is the opposite of the permanently changing expressions of our face; it is rigid and constant. The mask does not transform, its power comes from the fixed meaning:

> "The more distinct it is, the darker everything else. No-one knows what may not burst forth from behind the mask. The tension created by the contrast between its appearance and the secret it hides can become extreme. This is the real reason for the terror the mask inspires. 'I am exactly what you see' it proclaims 'and everything you fear is behind me.' The mask fascinates and, at the same time, it enforces distance. No-one dares to lay violent hands on it; if anyone but the wearer tears it off, he is punished by death."[533]

Those who wear the masks have to ensure that their real identity is protected. The mask creates a fear that does not come from the actor. The mask is like a weapon. But even the actor has to take care; under no circumstances may he lose the mask,[534] for the mask is a weapon for influencing the masses. And in the mass, humans beings do not think logically, but in intuitive, in totemic images.[535] According to Werner Jetter, symbolic communication has four properties: (1) Symbolic communication is simple. It is easy to understand, because the material it is built on is quite basic. (2) Symbolic communication is complex. Its layers of meaning do not unfold one after another, but at the same time. Conscious and unconscious are transmitted at the same time, thus the expression can be more complex than language. (3) Symbolic language trespasses, and limitations of class and different world-views do not hinder the communication process. (4) Symbolic communication does not formulate solutions, but involves participation in approaching the symbolically expressed truth.[536] These insights come from religious studies. And as our new religion is consumption, it comes as no surprise that this knowledge has been incorporated

[533] Canetti (1973:376).
[534] Canetti (1973:377).
[535] Warnke (1980:148) is quoting Gustave Le Bon and his psychology of the masses from 1895.
[536] Jetter (1978:48ff.)

into the discussion on design as well.[537] And religion, too, is greatly experienced in using images to create power, especially in Germany, where Luther's influence triggered a war of images. This was a battle between Protestant and Catholic aesthetics.[538] Images are dangerous because they activate intense emotion. Marketing consciously deploys this emotional intensity of images, which, sooner or later, leads to iconoclasm as we have seen in the history of religion. The seasonal sale contains this iconoclastic moment as well because it turns the everyday practice of advertising images upside down. Here, the beautiful face is replaced by the grimace. And there is yet another clue from religious production of images: the images must be opaque;[539] they must obscure vision, and they must redirect attention.

SPITALER STRASSE

The street parallel to Mönckeberg Straße is full of smaller fashion boutiques for young customers. We stop in front of one of them:

◁ This tiny show window is covered by two white posters. Bold red letters on each of them spell out the word: "SALE (bis zu) 70% (reduziert)" [SALE (reduced up to) 70%]. There is a tiny gap between the two posters. In the middle, behind the poster, stands a naked female mannequin. When we peer into the show window from the side, we see that there are two more hidden naked mannequins. Seen from the store's interior, they are hidden by a white paper backdrop.

Hubert and Mauss maintained that the Christian mind was built on ancient models.[540] Going by what we see in the seasonal sale window, we could claim that the capitalistic imagination is also built on ancient models. Examining the dialectics of the Enlightenment[541], Max Horkheimer and Theodor W. Adorno asked how it could be possible

537 Erlhoff (1988) held a conference on the relation of things and rituals. The fetish character of the objects was the subject of most contributions.
538 Hofmann (1983).
539 Latour (2002a:66).
540 Hubert/Mauss (1981:94).
541 Horkheimer/Adorno (2002).

that the Enlightenment was sacrificed in favour of the irrational and the mythical? The cultural industry feeds us with fast food that can be simply consumed in passing. Since the beautiful and the ugly are no longer categories that are irrelevant to the discussions in art, they have entered the discussion of the everyday:

"The more the irrelevance of categories like 'beautiful' and 'ugly' when raising aesthetic questions and finding answers to them ought to become the common sense of an enlightened society, the more they keep sneaking into the discourse like ghostly spectres of themselves through the back door of the everyday, of fashion, advertising and ideologies of design."[542]

According to sociological system theory, the relation between economy and art can be described as the codes of "payment – non-payment" and "beautiful – ugly".[543] But in reality, these oppositions are not so binary and, in the same way as art tries to explore the spheres of the ugly, economy also experiments with spheres of non-payment.[544] Therefore, both the ugly as well as non-payment have not only become new experimental fields for the customer relation management of industry, but also rituals and myths. The Enlightenment man fought against ritualised consumption but, in the end, the dialectics of the Enlightenment are mediated in the consumption act of the consumer.

"He has to accept as a given reality the sacrificial ceremony in which he is repeatedly caught up: he is unable to break it. Instead, he makes sacrifice the formal precondition of his own rational decision."[545]

[542] Liessmann (2000:159)*.
[543] Baecker (2004:44).
[544] Ibid., p. 45.
[545] Horkheimer/Adorno (2002:44). We can use the destiny of Odysseus, as described here, as a metaphor for the modern condition of the consumer, who is caught between the poles of rationality and irrationality.

The Death of Fashion

GUCCI

fall winter collection

sale begins today

Fashion
is judged to death.

Fashion houses
lose their brand names.

||

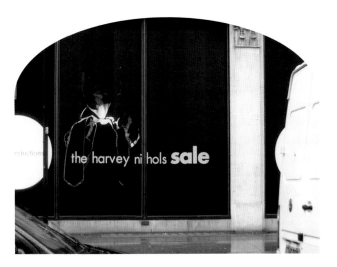

Fashion windows
are clothed in darkness.

Fashion mannequins
are robbed of their clothes.

IV

Fashion mannequins
are dressed in paper clothes.

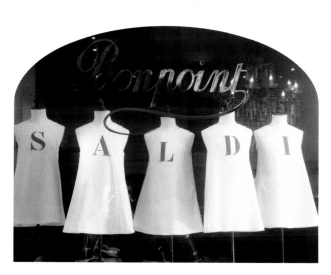

Fashion
is robbed of its individuality.

VI

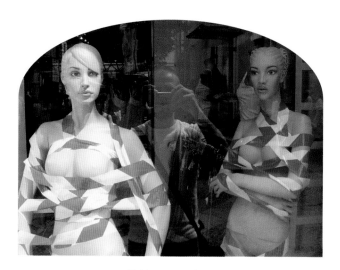

Fashion mannequins
are bound.

VII

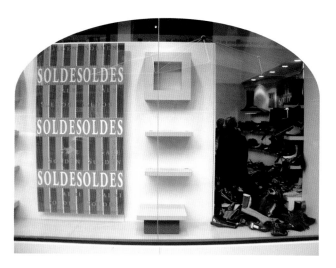

Fashion is removed
from the pedestal of fetishism.

Fashion is thrown
into the rummage box.

IX

Fashion is laid
down on the sacrificial altar.

Fashion's throat
is cut by the percentage sign.

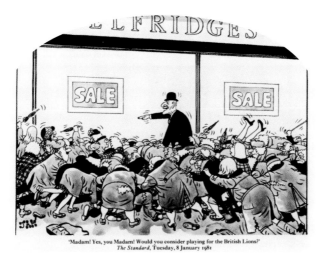

'Madam! Yes, you Madam! Would you consider playing for the British Lions?'
The Standard, Tuesday, 8 January 1981

Fashion is attacked by its infuriated victims.

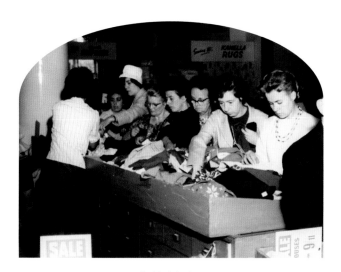

Fashion's body
is torn apart with bare hands.

XIII

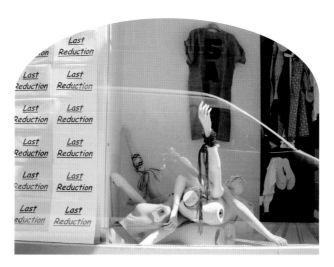

Fashion's dismembered body
is buried in its grave.

Summary

"Fashion prescribes the ritual according to which the commodity fetish demands to be worshipped."[546]

The last chapter will try to throw light on the nature of the seasonal sale and its dramatisation of the ugly as observed by us on our walks through main shopping streets in Paris, Vienna, London, New York[547] and Hamburg. Roland Barthes decided to use the fashion magazines of only one year (1958/59) for his discussion of the "fashion system".[548] As we pointed out at the beginning, we have followed an idea that, though articulated, was not developed by Barthes when comparing the feelings of female customers during the advent of the spring collection with the emotions of the female followers of the ancient Greek Dionysian festivals. He assumed that an ancient myth was returning from the darkness of the past as part of the fashion system today. The end of a collection, the rite of passage, and the launch of the new collection are the critical turning points of the fashion year. We need to enlarge our field of vision in order to discuss this and relate it to the idea of the return of an ancient myth. We must first ask ourselves what the content of the myth could be. What story does the fashion system want us to believe in? The second question deals with the ritual launch of a new collection. The ritual of the catwalk presentation will be at the centre of this discussion. Thirdly, we will bring in our observations of the seasonal sale, which we originally interpreted as a rite of passage between the old and the new fashion. Involving the catwalk presentation of the new collection raises the question of the function of the aesthetic death of the fashion pieces as transition between the representation of the new collection on the catwalk and its real

546 Benjamin (2004:18).
547 As discussed, New York represents here an excursion into the field of performance studies and art.
548 Barthes (1990:12).

arrival in the show windows. We therefore imagine that these three steps are part of one and the same dramatisation of fashion mythology. Irrationality in the dramatisation of the fashion system will be discussed as a fourth point with an excursion into the perception of the magical in our consumer society. As a fifth and last point, we will focus again on the seasonal sale window in order to relate the aesthetic with the economic practice in the fashion system.

Mythology

"[A]s a season, spring is both pure and mythical at once; mythical, by virtue of the awakening of nature; Fashion takes this awakening for its own, thus giving the readers, if not its buyers, the opportunity to participate annually in a myth that has come from the beginning of time; spring Fashion, for the modern woman, is like what the Great Dyonysia or the Anthesteria were for the ancient Greeks."[549]

Roland Barthes related the advent of the spring collection to the myth of the awakening of nature. The motivational researcher Ernest Dichter, too, pointed at the existence of a relationship between the awakening of nature and the excitement among fashion followers.[550] If we assume that there is some truth in this observation, how can we link it to the ancient Greek Dyonisian rituals? Can the celebration of the new collections be interpreted as a worship of the ancient Greek god Dionysus? Several festivals in and around ancient Greece had the cult of Dionysus as the pivot of their activities.[551] The ritual performed in spring was the Anthesteria. It was performed in the month of Anthesterion, which was approximately February/March.[552] This must have been about when Barthes analysed the fashion maga-

[549] Barthes (1990:251).
[550] Dichter (1964:76).
[551] Wissowa (1894:1010-1046).
[552] Wissowa (1894:2375).

zines, because it was the March issue that introduced the spring collection.[553] However, from this point on, it would be difficult to find parallels in addition to the calendar, but we will try to do so. The Anthesteria is the type of festival that has dramatised the advent of the new harvest/fruit/wine all over the world by a sharp break with the existing order.[554] It was a time in which the social order was disrupted, a time of "anti-order".[555] The focal point of the festival was the advent of the new wine. The god Dionysus was celebrated with excessive drinking. The wine, drunk from jugs containing three litres of the intoxicating fluid, was to be drained as quickly as possible. The ritual of celebrating Dionysus was created as a negative rite to the normal practices.[556] We can now relate the advent of the new fashion collection to this type of festival, to which the Anthesteria belongs. It could thus be said that the advent of the spring collection is also a kind of "grande festa" and belongs to the important rituals of consumer culture. If we continue with our interpretation, the excessive consumption of the new wine can be compared to the excessive consumption of the new fashion, either through fashion magazines or by shopping. In doing so, we exclude the seasonal sale from our discussion – although we are quite sure that it is part of the ritual. So, we will change the time of storytelling to when Barthes conducted his studies. Let's listen to the "myth" of the introduction of the new fashion in 1958:

"The spring collections are here! There's much excitement in Paris. Journalists and buyers are pouring in from all corners of the world to get inspired by the laboratories of fashion. They are here to stimulate their fantasies with thousands of new ideas floating around like opalescent soap bubbles, and with the extravagant new fashion lines that Paris invents twice a year for those who believe in its immortal gift of renewal."[557]

The renewal of the power of nature is a strong motif in many ancient rites, and this quote from a fashion magazine clearly shows the motif of the renewal of fashion. The modern belief in the renewal of fashion can thus be compared to the ancient belief in the renewal of the forces of nature. And the way all rites

553 The Parisian magazine *Vogue* introduced the spring collection of the year 1959 in its March issue. See Charles-Roux (1959:97-135). The introduction of the spring collection in the fashion magazines has shifted to January or February today.
554 Bremmer (1999:50).
555 The slaves were treated as equals during the Anthesteria. See Bremmer (1999:19).
556 Bremmer (1999:47).
557 Charles-Roux (1958:I-III)*.

have their centres of worship, our Mecca of fashion is Paris. Pilgrims from all over the world come to Paris in order to celebrate the new collections and confirm the myth of creativity. And the priests of the cult point out the significance of the event and its effects on everyday life:

"Dear reader! This is the great month of collections in which new fashion is born in Paris. Your choice, your style, your entire behaviour will depend on it."[558]

Let us now return from the place of worship to mythology. Although we would be more at ease with our explanation that the fashion ritual is part of the same type of festival as the Anthesteria, we will examine whether it is possible for myths to change or whether they are partially replaced by other contents. Nietzsche was not convinced that this is possible:

"It seems scarcely possible to transplant a foreign myth with lasting success, without irreversibly damaging the tree in the process: the occasional tree may perhaps prove sufficiently strong and healthy to exercise the foreign element through a fearful struggle, but must more usually consume itself in stunted infirmity or in rampant but sickly growth."[559]

Myths are capable of changing over time. According to Lévi-Strauss, a myth can create yet another myth, and the myth can also survive when it is transferred from one society to another. It is also possible that the formula changes during the transformations, though its "figure" is still recognisable.[560] Things become more complicated when the myth is related to a ritual, because the relation of ritual and myth is still not sufficiently clear today.[561] The Greek's did not have an all-encompassing category of ritual, as three different types of ritual acts existed.[562] The elaborate Greek festivals had a limited number of basic ritual acts,[563] the procession and the sacrifice being the most important elements in them. This is why we will try to fill this basic structure of the ancient Greek festival with the dramatisation of the contemporary fashion system.

558 Charles-Roux (1959:VI)*.
559 Nietzsche (2000:125).
560 Lévi-Strauss (1978:256).
561 Graf (1993:52).
562 Bremmer (1999:38).
563 Bremmer (1999:39).

Procession

"Twice each year, the fashion industry succumbs to the allure
of pure, exhilarating spectacle. Seventh Avenue traffics
in fantasy, myth-making, and romance. Audiences assemble
around the catwalks in anticipation of the clothes, the models
... the magic."[564]

It is clear today that the fashion taste and the development
of new design are not only influenced by the ritualised presenta-
tion of the new fashion through couture shows in the major
fashion capitals.[565] Nevertheless, we will focus on the phenom-
enon which has not changed over so many centuries, and there
is no doubt that the circulated images are synonymous with the
introduction of fashion.[566] Fashion shows are held twice a year
and a couple of months before the new collection appears in the
show windows.[567] The fashion shows of the major fashion brands
are held in the creative centres of fashion. Only a handful of
designers present their new collections to a small group of
journalists, buyers and celebrities. The ritual audience is strictly
limited. What happens behind the closed doors? Fashion author
Michael Gross describes the search for truth undertaken by the
ritual audience:

"What happens is that every season, the collective unconscious
of the designers, the media, and the stores have to agree on
what they call a story. And a story, in the business, doesn't need
a beginning, a middle, or an end. All it needs is a word – and
that word can be Red, or that word can be Mod. And the minute
they have that word, they have their story. And that gives them
the fuel that they need to run on for the next six months."[568]

[564] Givhan (1998).
[565] Du Gay (1997:141-149).
[566] According to Gross (1995:40), the catwalk presentation was introduced in Chicago in 1914.
[567] The introduction of the new spring/summer collection is currently at the beginning of October. Presentation in the show window starts at the end of January.
[568] Gross (1998).

So, a potential crisis is also implanted into the system. We can imagine that the ritual audience is often as anxious about selecting a trend for the next six months as fashion consumers usually are when asking themselves what they want to choose for the day.[569] Once the oracle has declared its decision, the message is circulated in fashion journals. Since the ultimate consumer is absent at the catwalk presentation, the messages are interpreted by the media.[570] It is, therefore, a live performance in a mediated culture. Ancient Greek festivals were not "live" performances in this sense, because no means of recording existed then.[571] People were physically present when they took place. Today's fashion victim watches the procession from afar, and usually only months later.[572] But by then the spectacle has already been interpreted. The fashion buyers have ordered and fashion editors have made their picture selections and layouts for the upcoming issues. The reportage is split into two parts. While some of the articles appear in daily newspapers in the fashion show period, the larger coverage comes only months later in the fashion magazines, parallel to the launching of the new seasonal collection. The catwalk is a kind of procession with a complex split of audience in time and space.[573] The involvement of young female participants in the procession is a phenomenon we are quite familiar with from the study of ancient Greek processions:

"Processions were particularly suited to make symbolic statements about power relations, since they often drew large audiences. For example during the sacrificial procession of the Panathenaea Athenian colonies and allies had to parade a cow and panoply, the daughters of Athenian metics carried parasols for female citizens, and adult metics carried sacrificial equipment; colonies also had to contribute a phallus to the processions of the Great Dionysia. Whereas processions thus demonstrated Athenian superiority, they could also demonstrate modesty. During the Spartan Hyacinthia festival, adolescent girls rode down in a procession to Amyclae, showing themselves off to the community after, probably, an initiatory seclusion at the border area."[574]

[569] Clarke/Miller (2002:192) conducted an ethnographic study about the anxiety of consumers to choose the right dress assuming that the fashion industry and the journalism associated with it may have little concern for this problem.
[570] Kahn (2000:116).
[571] Auslander (1999:51).
[572] An increasing number of fashion boutiques now presents recorded fashion shows in its show rooms. Is this permanent representation of the power of fashion a sign of crisis?
[573] For the perception of rituals through media and about how shared enthusiasm is flattened into spectacle, see also Bell (1997:243).
[574] Bremmer (1999:40).

Two main aspects emerge from this description of ancient Greek rituals, which we will further discuss in the context of the catwalk spectacle. The first aspect is that the procession creates power. The second one is the involvement of young female participants. The power of the catwalk to make symbolic statements was also exploited when a French fashion designer did the first catwalk fashion presentation in Moscow in 1959.[575] The power of the catwalk is well-known in fashion theory:

"The catwalk show is likely to remain an integral part of the fashion industry's marketing armour. It provides a tried and tested method of presenting products and establishing trends. But as a means of social or political expression, the catwalk show is only ever going to be marginal, destined by design to be ephemeral. The fashion show is an important event, during which nothing is said – at least nothing of substance."[576]

The repetitive performance of the fashion show creates a sense of tradition where the origin is blurred. According to Barbara Myerhoff, the invisibility of the ritual's origin is important for the power of the ritual. People do not want to see the ritual as a product of their imagination, but as a reflection of their wishes and dreams.[577] When people gather in order to perform a shared action, it creates fear in the audience. The communitas of the fashion models marching up and down the catwalk in step with each other – often dressed in similar outfits – creates a sublime atmosphere. Setting a sign, marking, showing and establishing a sense of community, as well as fixing man's position in the cosmos are archaic acts.[578] The authors of these dramatisations are the fashion designers:

"Each designer concocts a carefully choreographed runway 'look' designed to augment, destroy, or revitalize the existing house identity."[579]

The fashion houses invest a lot of money in fashion shows. It is a kind of potlatch, a competitive wastefulness amongst rivals in the couture scene. When the fashion show is over, the designers

575 Charles-Roux (1959:46-51).
576 Kahn (2000:119).
577 Bell (1997:224).
578 Rychlik (2003:174).
579 Doonan (1998:90).

come on stage, go down the catwalk and are applauded by both the fashion models and the audience. This is a ritual of great strength, and it is reminiscent of a ritual that ancient kings were obliged to perform. They had to regularly prove in a competitive race that their powers had not waned, that they still held sway. This ritual was then transformed, and the competition was replaced by a procession of the king.[580] Fashion designers, too, must prove their creative power twice a year. If they fail, they loose their throne. We have also pointed out the involvement of young females in the runway ritual. The fetish of youth and beauty and certain properties, once associated with young females, are still present today:

> "One of the very basic movements of a catwalk show is that of young, classically beautiful and slim women walking up and down a runway. This tradition accedes to the idea of physical perfection – it is so elementary to the idea of the catwalk that it can easily be trivialised or undermined."[581]

All the photos taken during the performances are strikingly similar. They usually show just one or two models. We see the black background of the auditorium and the illuminated runway on which the models, wearing the same garments, walk in a ritualised way. Surprisingly enough, this pattern is not used by haute couture alone. Cheap fashion brands and sportswear are also presented in the same way. Whether the ritual unfolds its power or not does not depend on the style of fashion. And this might be an answer to the above critique that nothing important is articulated during the fashion show, simply because it is not possible tohe various rituals with individual expressions only confirm the power of the ritual, which belongs to the fashion industry. They are only different ways of worshipping the myth of the never-ending creativity of fashion. According to Catherine Bell, the catwalk show fulfils all categories of "ritual-like activities": the traditional link to ancient processions (traditionalism), the use of a restricted code of communication through the way mannequins act (formalism), the disciplined set of activities which are repeated (invariance), the way human action and interaction is channelled (rule-governance), the use of "holy" signs such as the logo or the name of the fashion house or

580 Frazer (1993:157).
581 Kahn (2000:119).

designer (sacral symbolism) and the multi-sensory involvement of the audience by the use of light, actors, and music (performance).[582] We will attempt yet another approach for those who maintain that the street has the power of influencing fashion. The production of meaningful action can be based on detaching an action from its original context. People walk on the street and wear their clothes. We can now detach this action from its original context and objectify it as an autonomous entity by enacting it on the catwalk with a restricted audience. The action of walking up and down the street acquires autonomous status and can then be addressed to an indefinite range of potential readers.[583] A normal action like that of walking down the street becomes meaningful as an action that introduces new trends on the catwalk. Identities are not just assigned but created by performative processes, and this is true for the fashion brands as well.[584] As Clifford Geertz claims, the ritual melts together the imagined world and the real world into a new system of symbolic forms.[585] The everyday experience of the street and the "ideal world" of the fashion industry, where everybody is young and beautiful, are enacted in the ritual of the catwalk show. Realising this requires ritual power, a power that is not necessarily based on rational arguments:

"Rituals are not only in the service of power; they are themselves powerful because, as actions, they live from their power of assertion. Whoever wishes to ritualise actions must also be prepared to implement them. He or she must ensure that the actions are implemented and recognised despite resistance or lack of understanding. Ritual knowledge is knowledge that has asserted itself."[586]

According to Humphrey and Laidlaw, rituals are a quality of action and not a class of events.[587] And ritual action has to be separated from action:

"To recapitulate: action which is not ritualised has intentional meaning (warning, delivering, murder), and this is understand-

582 Bell (1997:138-159). Each scholar creates his own set of categories to define ritual action. In order to prove our theory of the relation to older rites, we have chosen these rather strict ones.
583 Bell (1992:44-51).
584 Kolesch/Lehmann (2002:347).
585 Geertz (1973:112).
586 Belliger/Krieger (1998:28-29)*.
587 Humphrey/Laidlaw (1994:3).

able by means of the ascription of intentional states to its agents. Ritualised action is not identified in this way, because we cannot link what the actor does with what his or her intentions might be. Instead of being guided and structured by the intentions of the actors, ritualised action is constituted and structured by prescription, not just in the sense that people follow rules, but in the much deeper sense that a reclassification takes place so that only following the rules counts as action."[588]

The stagings of the catwalk shows also follow fashion trends. The catwalk can be a raised architectural element extending into the audience, but it can also be an empty passage on the floor, framed just by the seats of the audience. Thus, it is only the ritualised action of the mannequins that creates ritual space. Common to both is a street-like arrangement with space for the audience to its left and its right. The catwalk is usually on the long sides and at the dead end surrounded by the audience, while on the other side we have something that functions like a kind of door through which the models appear and disappear. This door also separates the backstage area from the area for the public. Catwalk shows can be performed in various places, and the installation is usually temporary. But today, several fashion brands also build their own permanent ritual architecture for the sole purpose of catwalk shows. This can perhaps be compared with the time in which temples were built for the performance of religious services. Humphrey and Vitebsky characterise sacred architecture as follows:

"A sacred building comes into a relationship with human worshippers through ritual action. Rites of purification make the building into a suitable meeting point between humanity and divinity. Within this space, the meeting is generally enacted through the central religious act of sacrifice (whether literal or symbolic), which is also developed and elaborated in other kinds of action such as praying and dancing. These human deeds are matched by actions of the gods, who grant favours and bless worshippers within the arena of the building. This two-way communication intensifies the sacred power of a site, sometimes turning it into a magnet for pilgrims who come, often at enormous personal cost, to seek a transformation in

588 Ibid., p. 106.

| their lives at this proven gateway to the gods." [589]

The performance of rituals and ceremonies is the central function of sacred architecture. The catwalk can also be counted as a type of sacred architectural form since it is only built to perform the ritualised introduction of the new fashion collection. By this token, the catwalk is the temple of fashion. But festivals also exist that are celebrated outside the temples in worship of the arrival of the new fashion. We found some examples of processions organised by big department stores, which are also founded in the history of promoting new fashion items: [590]

◁ This procession comprises several trucks with a decorated loading platform. The truck, decorated by a big department store in London, was all white. Even the loading platform was white and bore the following inscription: "THE CYCLE OF FASHION". Several small bicycle wheels were used as decoration elements. In the centre of the platform was a huge white wheel around which young females in white dresses stood waving to the spectators lining the street.

The interesting point in this event is that its staging is totally unrelated to the actual fashion collection. The ritual actors wear dresses that are not "in fashion" but represent the archetype of the white ritual dress. They are young and could as well be followers of an ancient Greek ritual. The dramatisation is the articulation of pure myth. The fashion god is present in the form of a big and several smaller wheels. The prayer is written on the ritual carriage as well: A cycle of fashion. Here, the audience can follow an archaic spring rite, organised by a fashion retailer. We even found one such example in Germany:

◁ The ritual vehicle passes by the department store. Its flat platform is completely decorated with flowers. On the platform is a carriage with two horses. They, too, are fully covered with flowers. In the carriage are a woman and two children wearing the same dress. The dress has a pattern that is currently en vogue. On the side of the car we can read: "modisch dem Frühling entgegen.

[589] Humphrey/Vitebsky (1997:60).
[590] Parrot (1982:35) reports that in sixteenth century Venice, a life-size mannequin was used to present to the Venetian public the new fashions of Parisian Couture on a gondola. This presentation took place during the festival of the "marriage of the doge with the sea".

Flowers were always an important element in the drama-
tisation of the Anthesteria. As a last example, we will quote
Nietzsche's description of the worship of the god of "beauty":

"The virgins who ceremonially approach the temple of Apollo
bearing laurel branches and singing a procession song remain
who they are and retain their names as citizens: the dithyrambic
chorus is a chorus of people who have been transformed, who
have completely forgotten their past as citizens, their social
position: They have become the timeless servants of their god,
living outside all spheres of society."[591]

Sacrifice

"And as society is made up not only of men, but also of things
and events, we perceive how sacrifice can follow and at the
same time reproduce the rhythms of human life and of
nature; how it has been able to become both periodical by
the use of natural phenomena, and occasional, as are the
momentary needs of men, and in short to adapt itself to a
thousand purposes."[592]

When Hubert and Mauss originally published their study
on sacrifice in 1898, they did not perhaps consider applying it
to the seasonal sale. Although it may well be only one of its
countless purposes, the seasonal sale is an important festival
today. When Evans-Prichard edited the study in English in 1964,
he pointed out in his foreword that the findings have "general
application to all sacrificial acts – or at any rate all blood sacri-
fices – everywhere and at all times".[593] Is the seasonal sale a
"blood sacrifice"? In ancient Greece, animal sacrifice was the
most important basic rite for more elaborate festivals beside

591 Nietzsche (2000:50).
592 Hubert/Mauss (1981:103).
593 Evans-Prichard (1981:viii).

the procession.[594] If Barthes is right in his assumption about the ancient Greek myth of the god Dionysus who resurrects from the darkness of old time, in the context of the change of fashion, then perhaps a sacrifice is also involved in the fashion festival. Hubert and Mauss addressed the myth of Dionysus in a chapter dealing with a special case of the sacrificial system, of the sacrifice of the god. Based on Frazer's idea that the agrarian sacrifice is closely connected to the sacrifice of the god, Hubert and Mauss showed how this form of sacrifice is linked to the very mechanisms of sacrifice. The first step involves finding a victim who represents the sacrifier.[595] In an agrarian sacrifice, the sacrifier is the field. The victim has to be in close relationship with the sacrifier. The incarnations of the life of the corn and the wine are the bull and the goat of Dionysus.[596] The victim in the agrarian sacrifice always symbolically represents the fields and their products. The next step is to sacrifice the victim. After the communion, the god resurrects, and this gives new power to the fields and their fruits.[597] In the case of the sacrifice of the god, the victim and the god sacrificed are a homogeneous unity. If we apply this mechanism to fashion, then we have to imagine that the sacrifier is fashion instead of the field. This is not so difficult as there are also many fruits (brands, styles...), and there is a parallel to the seasons as well. We will, for the time being, not change the name of the god in adherence to Barthes' concept. Thus, the sacrifier is fashion and the god is Dionysus. For the next step, we need a victim who stands in relation to the sacrifier. Going by our observations during the seasonal sale, let us assume that this is the seasonal collection. Although it is still linked to fashion, the relation is already weakened because it will be going to be out of fashion very soon. We have found several indications of the "symbolic death" of the past fashion during the dramatisation of the seasonal sale. The seasonal sale has the character of what Baudrillard described as a "collective theatre of death".[598] The haute couture collection and the mass-market garment are all equal in the face of death (the seasonal sale). It is a collective exchange of the symbolic death in a commonly shared festival celebrated in the shopping streets of the city. In his Flesh and Stone, Richard Sennett examined two ancient Greek festivals

594 Bremmer (1999:39).
595 The sacrifier is the subject to whom the benefits of the sacrifice accrue. See Hubert/Mauss (1981:10).
596 Hubert/Mauss (1981:79).
597 Ibid., p. 68.
598 Baudrillard (2004:146).

and their effect on the city.[599] The rituals were performed in close interaction with a spatial setting in the city. This dramatisation helped in supporting the experience of ritual practice.

"Ritual meaning is thus based on the interaction of the ritual-ised body with conventions inscribed within the social body. Such interaction implies a place in space and time, or architecture."[600]

The seasonal sale dramatically changes the appearance of shopping streets. What was once beautiful is now ugly, what was expensive now costs only half for a certain period of time. Sennett points out in his analysis of the Adonia that women shaped a certain environment where they created meaning within the context of the city in an interaction between body motion and architectural space. He compared this performance with poetry and the use of the metaphor. The metaphor com-bines different words into a new word, whereas the new mean-ing is detached from the individual meanings of the words used. Sennett explains "metaphorical space" by using the example of Adonia:

"In the ritual of the Adonia, space made the metaphor work. Normally, fertility and childbearing legitimated women's sexuality. That a person should feel free while on a roof in July at night surrounded by dead plants to speak to strangers about her intimate desires is a bit odd; to combine these unlikely elements together was metaphor's spatial power. A 'space of metaphor' refers, in a ritual, to a place in which people can join unlike elements."[601]

For a certain duration of time, the order of the city is invalidated. The myth replaces the logos. The storyteller is no longer responsible for his words because he is just retelling something he has only heard. This creates trust in a climate of distrust. The shiny façade is transformed into darkness.

"The spaces of rituals created magic zones of mutual affirmation. And all these powers of mythos affected the celebrating body,

599 Sennett (1996).
600 Jormakka (1995:22).
601 Sennett (1996:79).

endowing it with new value. In ritual, words are consummated by bodily gestures: dancing, crouching, or drinking together become signs of mutual trust, deeply bonding acts. Ritual threw a cloak of darkness over the suspicions individuals might have harboured of one and another in the ancient city, quite unlike the mixture of admiration and suspicion elicited by naked display."[602]

Ancient Athenians created parallel contrasts of warm and cold bodies, naked men and dressed women, luminous spaces under the sky and darkened rooms in a cave, or on the roof of a house. The modern city also acquires such contrasts through the seasonal sale. During the sales, normally full windows are empty, windows which usually display only a few pieces are full of stock, the transparency for the visibility of the merchandise is blocked by paper, subtle colours are replaced by striking reds, small price tags are now big, and so on. And the extremely emotionalised bargain hunters dig into piles of reduced ware. In cultural studies, this combination of event and space is called "topos". Mieke Bal describes the interaction of space and event as follows:

"Relations between the various elements on the story level arise because of the way in which they are combined and presented. The relations between space and event become clear if we think of well known, stereotypical combinations: declarations of love by moonlight on a balcony, high-flown reveries on a mountain-top, a rendezvous in an inn, ghostly appearances among ruins, brawls in cafés. In medieval literature, love-scenes frequently take place in a special space, appropriate to the occasion, the so-called locus amoenus, consisting of a meadow, a tree, and a running stream. Such a fixed combination is called a topos."[603]

The topos of the seasonal sale can be best described as the occurrence of the ugly, the Dionysian. The ugly is the metaphorical space for all activities. The topography of the ritual shapes the sense of the ritual. Decoration, costumes, uniforms, music, fetishes, insignias, all these elements are part of the ritual topography. Together with the performative presentation appears the ritual. The materiality of space and symbolic action are in close

[602] Sennett (1996:82).
[603] Bal (1999:137-138).

relationship,[604] the ritual space being a performative space where normal behaviour is turned upside down. Ritual space is oriented towards basic human emotions, such as pain and pleasure, danger and safety, welfare and misery.[605] The seasonal sale window creates the topos for the death of the seasonal sale collection, and the window display is a threshold in urban space.[606] Rituals have a long tradition in all cultures, being transformable into threshold spaces, especially on the threshold of the imagined world and the real world. Having described the topos, we now come to the sacrificial act. How has the blood sacrifice changed in consumer society? Consumer society is defined by its relation to consumption and not by previous relations such as religion or agriculture. There is a power relation between production and consumption. Social power relations create social tensions and, in order to make the power relations stable, rituals have been a way of articulating such tensions since the beginning of humankind:

"Every domination must be bought back, redeemed. This was formerly done through sacrificial death (feasts and other social rites: but these are still forms of sacrifice)."[607]

While Baudrillard further develops this idea in relation to the power of capital and the simulation of power compensation, Sennett puts the question into a different perspective and asks why modern capitalism has not developed rituals of asymmetry:

"When ritual binds people together, Bourdieu more largely observed, it does so by allowing them to 'mutate' material fact into some expressive gesture which can be shared – and sustained. An economic exchange is a short transaction – the new institutional forms of capitalism are particularly short-term. By contrast, a ritual exchange, particularly of this asymmetric sort, creates a more prolonged relationship [...] why doesn't modern capitalism generate them [as well]?" [608]

According to Sennett the reason is that capitalism is based

604 There is a lack of discussion on how architecture or design can develop the quality of a topos in order to raise an associated action. Schuh (2003:193) points out this relationship, but she does not respond to it in her book on the relation of festivals and architecture.
605 Wiedenmann (1991:16). An interpretation of the performative space in performance studies is provided by Fischer-Lichte (2004:187).
606 Sykora (2002:131).
607 Baudrillard (2004:42).
608 Sennett (2003:220-221).

on the symmetry of exchange within a short time. Rituals of asymmetry emphasise the difference and they appear regularly.[609] The seasonal sale (with its Dionysian cult background) can be interpreted as such an asymmetrical ritual. It is the sacrifice of the god (fashion) in the form of the seasonal collection. The sacrificial act involves several people. Fashion magazines not only play a passive role in tabooing the old collection but also an active one in sacrificing the victim:

"DELETE SILVER/KEEP GOLD
Silver and gold are always in battle as the currency of choice but the time has come to throw away the fairer shade."[610]

This command to kill the old collection is directed at the customer who has already bought it at the beginning of the season, but it is also an oracle which retailers should heed in order to choose the right victim. As in any blood sacrifice, the solemn moment of cutting the price is very brief. What follows is a phase described by Baudrillard as the "obscene phase":

"It is then, before drying out and taking on the beauty of death, that the body passes through a truly obscene phase and must at all costs be conjured and exorcized, for it no longer represents anything, no longer has a name, and its unnamable contaminaion invades everything."[611]

And the fashion collection is far from the beauty of death, which will bring it back in several years. So, the fashion windows are enveiled in something like a covering for a corpse. Another significant practice is the removal of decorative elements. This practice is also known from several passage rites.[612] A journal from 1956 for window decorators does not tell us why, but how. In those days the last three days of the sale were high-lighted in a special way:

"The three days for the sale of remainders at the end of a clearance sale should not be forgotten. The few illustrations will do. The goods predominate, there is no cause for extraordinary decoration."[613]

[609] Sennett (2003:209-210) describes an annual ritual between an aristocratic lady and her servants as an example of a ritual in which social asymmetry is made stable through reciprocal respect.
[610] Quick (2004:97).
[611] Baudrillard (1990:57).
[612] Gennep (1960:130).
[613] Anonymous (1956:312)*.

The nameless fashion is naked, and without decoration. And the shop itself seems to be dead. The way the shops cover their show windows reminds us of the way abandoned shops are treated. Everybody is invited to the common meal, even the slaves.[614]

◁ The people gather in front of the sacrificial place, some of them have been waiting there for a long time so that they are the first to enter. Musicians are playing music. Two men guard the door. The next act is the ceremonial opening of the doors. The people are now pushing and shoving their way in.[615]

Inside, the orgy is in full swing. Furious bargain hunters are tearing apart the body of the victim with their bare hands. We have reached the phase of communion.[616]

Magic

"[Thus] religious or magical behaviour or thinking must not be set apart from the range of everyday purposive conduct, particularly since even the ends of the religious and magical actions are predominantly economic."[617]

Here, Max Weber gives us a preliminary idea about how "magic" action is "rationally" involved in contemporary life. So, the conclusion we draw from this quote is that both the production side as well as the consumption side probably use magic action for economic reasons. It is hard to find magic instructions in merchandising literature, but merchandising pioneer Paco Underhill tells us where to look for magic practice:

[614] During the Anthesteria, the slaves had equal social status. See (Bremmer 1999:19)
[615] This description is based on photo material we found in the archive of a big department store in London.
[616] Miller (1998a:107) relates the sacrificial meal to the family and not to the community of shoppers: "Feeding the family then stands for the modern act of consumption in an analogous relationship to feeding the community in ancient sacrifice."
[617] Weber (1978:400).

"To the extent to which there is magic, to the degree to which there are tricks, it's mostly in what we call merchandising."[618]

This quote is taken from a book that investigates why we buy. Do we buy because merchandisers have put a spell on us? This explanation may be a bit too simple. Baudrillard argues against such attempts at making out merchandisers as magicians:

"Comparing advertising to a kind of magic is really giving it too much credit, however."[619]

But in this discussion on how magical the merchandise practice is, one should also ask how the consumer feels when he is confronted with the question of magic. Dichter presents a point of view that comes from motivational research:

"Even the most conservative man has, in a forgotten corner of his mind, a deep understanding and a sympathetic smile for the tales of wizardry, sorcery, and mysterious powers."[620]

We will thus conclude from all this that a sense for magic action exists both on the side of merchandising (for example window dressing) and on that of the consumer. As a next step, we will try to connect the belief in magic to the field of fashion. The main application of magic action lies in all the purposes that make future development uncertain. Bronislaw Malinowski points out this aspect:

"Further, we find magic where the element of danger is conspicuous. We do not find it wherever absolute safety eliminates any elements of foreboding. This is the psychological factor. But magic also fulfils another and highly important sociological function. As I have tried to show elsewhere, magic is an active element in the organisation of labour and in its systematic arrangement."[621]

This reference to hunting could be easily transferred to fashion when it is done under the premise that fashion is

618 Underhill (1999:200).
619 Baudrillard (1996:192).
620 Dichter (1960:302).
621 Malinowski (1954:140).

also unsure to some extent. What colour will be next? What will the consumers buy? And so on. Groys underlines this element of uncertainty in the system of fashion:

"Fashion is, in fact, radically anti-utopian and anti-authoritarian. The fact that it constantly changes means that the future is unpredictable, that it could not escape historical change and that there are no universal truths that could totally determine the future."[622]

Baudrillard develops this condition and points out a possible dangerous end. His description awakens the suspicion that a degree of magic is needed to hold together a system that is hard to control.

"The astonishing privilege accorded to fashion is due to a unanimous and definitive resolve. The acceleration of the simple play of signifiers in fashion becomes striking, to the point of enchanting us – the enchantment and vertigo of the loss of every system of reference. In this sense, it is the completed form of political economy, the cycle wherein the linearity of the commodity comes to be abolished. There is no longer any determinacy internal to signs of fashion, hence they become free to commute and permutate without limit."[623]

We will now interrupt our discussion on the relationship between magic and fashion because, if we follow Malinowski, it is already clear that fashion needs some magical control. Magic entails a doer, the action and the imagination.[624] The magician is the individual who performs the magical action. Mauss points out that magic acts should be strictly separated from social practices.[625] Fantasies of magic are related to magical actions.

"Each ritual contains a representation of how things happen and of the specific process which is to be influenced by magic."[626]

This comment by Horkheimer and Adorno clearly points

[622] Groys 1992:45)*.
[623] Baudrillard (2004:87).
[624] Mauss (1999:52).
[625] Mauss (1999:52).
[626] Horkheimer/Adorno (2002:5).

out the question we must ask ourselves. What does the fashion industry want to influence? We will answer this question in the context of our assumption about the Dionysus rite. We assume that fashion wants to perpetuate the myth of creativity in the same way as the ancients wanted Nature to return with full force in spring and give power to the fields. Every half year, fashion must be reborn with new creative power. Ronald Grimes detaches magic from archaic beliefs so that we can connect it with the merchandising activity of our research on the show windows:

"Magic as used here does not refer to other peoples' rites but to ours as well. It is not a pejorative term but a way of referring rites that aim to effect. The word refers any element of ritual understood as means to an end. If a rite not only has meaning but also works, it is magical. Insofar as it is a deed having transcendent reference and accomplishing some desired empirical result, a rite is magical."[627]

Magic does not work for its own sake; it is legitimated by a system.[628] The treatment of the mannequin will be our example in analysing the magical act of window dressing. The dressed mannequin has sacred ancestors.[629] Statues dressed in real clothes were placed in temples and churches, and they were used in processions as well. We can thus show that there is a tradition of using statues for magical purposes. Hubert and Mauss give two examples of magical treatments in relation to spring rites:

"In one of the Mexican festivals, to represent the rebirth of the spirit of agriculture the dead victim was skinned and the skin was put on the victim that was to succeed it the following year. In Lusitia, at the spring festival, in which the "dead one", the old god of vegetation is buried, the shirt from the mannequin that represents it is removed and immediately placed on the May tree; with the garment, the spirit is also removed."[630]

The above two examples show a magical action in which a skin or garment is used to transfer the vitalising power from the dead victim to the new representative of life. The practice of

[627] Grimes (1995:48-49).
[628] Douglas (2000:150).
[629] Parrot (1982:14).
[630] Hubert/Mauss (1981:73-74).

magic is based on the concept of metaphor and metonymy. The metaphorical relationship is given when A is treated as if it were B (to throw something into the water in order to make rain). We can speak about a metonymical relationship when A is treated as if it is a part of B (the crown as a part of the king). These two principles are similar to Frazer's concept of magic. The law of similarity can be compared to the metaphorical relationship, the law of physical contact relates to the metonymical relationship.[631] Umberto Eco explains the two forms of magical action in the context of the use of signs:

> "In both cases, one demonstrates the magic of signs that stand for something: the image is the metaphor, an imitation of the thing. The object that belongs to something else is its metonymy; it is part for the whole, cause for the effect, container for the content. One has power over things through their signs or through other things that one sees as signs for them."[632]

The mannequins of today do not represent gods, but the ideal of a beautiful body according to the latest fashions. Taste has changed continually over the decades. Mannequins always represent the types of models used in fashion photography and for the catwalk of the respective time. The mannequin in the show window represents the commonly shared belief in beauty. During the seasonal sale, the mannequins are often naked or dressed in a "ritual dress" made of poor materials, such as packing paper. This signifies the state of the victim being sacrificed. The body of the mannequin loses its customary role; it no longer represents fashion. The naked body of the victim only has a presence.[633] This is the state during the sales. The re-dressing of the mannequin in spring echoes a couple of rites, which work with the magical action of dressing the sacred statue in order to show that the god has been resurrected.[634] And as the god is fashion, fashion will rise with new power through sympathetic magic.[635] This is the end of the biggest sacrificial ritual in our consumer culture. We have to wait for another half year until we can attend it again. And as it is natural that rituals transform

[631] Bell (1997:50-51).
[632] Eco (1977:110)*.
[633] Fischer-Lichte (2004:255).
[634] Specht (2000:165) gives the example of Odysseus, who returned from his adventures like a beggar. His social status was recovered when he was re-dressed in appropriate garments. His power was renewed by a product of female labour, and not by that of male labour such as weapons.
[635] Frazer (1993:386).

during this period, we will have to see how it will change in the future:[636]

"But it is the imagination of the creators of myths which has perfected the elaboration of the sacrifice of the God. Indeed, imagination has given firstly the status and a history and consequently a more continuous life to the intermittent, dull, and passive personality, which was born from the regular occurrence of sacrifice. This without taking into account the fact that by releasing it from its earthly womb, it has made it more divine."[637]

The Death of Fashion

In the beginning of this book, we asked how fashion dies. And we decided to choose the fashion show window in the moment of the "death of fashion" (the seasonal sale of the past collection) as our object of research in order to find it. This choice represents an emphasis on the aesthetic aspects of dramatisation, rather than on social or economic reasons for the death of a fashion collection. When we say death, we use the term in a metaphorical way in order to emphasise that the garments are no longer in fashion.

The first answer to our research question is that fashion symbolically dies through the dramatisation of the ugly (the Dionysian). The seasonal sale window stands in striking contrast to the beautiful dramatisation of garments during the year. For a couple of weeks, the economy of beauty is disrupted by the dramatisation of the ugly in the shopping streets of consumer culture. According to our observations, there is no difference in the way the seasonal sale is staged in the four cities we have chosen as examples. Another surprising result of our research

636 Bell (1997:223-252) discusses the change of rituals and gives examples of invented rituals.
637 Hubert/Mauss (1981:81).

was that there are no merchandising guidelines for this staging. It seems that it belongs to the forbidden knowledge of merchandising. This taboo is also respected in literature on the show window. We only found images of beautiful show windows. The reason for this taboo could lie in the fact that more or less all the good counsel about dressing a window is reversed during the sales. While turning the window into a stockroom during the year is not appropriate, it becomes the favourite strategy in the sales period. The show window as the sacral space of the fetish object is desacralised during the sales. There are two major strategies for dramatising the sale. We can call the first one "the dead mannequin" and the second one "the dead shop". The "dead mannequin" summarises all the ways of decoration which, according to Victor Turner, represent a state of "betwixed and between".[638] Examples are the exposure of naked mannequins, mannequins dressed in packing paper, or the total removal of the mannequin during the sales.[639] The second strategy is the "dead shop". The "dead shop" echoes the way show windows are dressed in the phase of abandonment or in the phase of re-dressing and transformation [640] Packing paper covers the window in such a way that it is impossible to get a view of the shop's empty interior. This is also a violation of merchandising rules. The consumer's view is obstructed and the information behind the transparent show window remains concealed. Several other phenomena can be subsumed under Turner's "communitas". Differences in everyday life are made equal during the transition phase of the passage rite. We observed that the individuality of the brands was not visible during the sales; Dionysian dramatisation makes it impossible to distinguish between the brands. Besides, there was often no distinction between couture shops and cheap mass-market shops. Although a few couture shops dramatised the sale in an artistic way, it was always a staging of the Dionysian. While shops invest a lot of money during the year, the show windows are mostly decorated with extremely cheap materials during the sales, bringing out the cheapness of the ware very distinctly. The seasonal sale window is the window "without" decoration. Naked are not only the mannequins, but also the interior of the show window.

638 Turner (1997:95).
639 We have chosen the artist Colette and her performance in a show window in New York as a prototype for this form of representation.
640 Christo's "store fronts" are a prototype for this category. In a conversation with him, Christo made it explicitly clear to me that he does not desire associations with an abandoned show window, for there is something going on behind the covered window.

Communitas also shows the garments inside the store. No longer are they separated by brand or colour but simply thrown together onto a pile in baskets. The order of the merchandise is turned into anti-structure. The price of the merchandise can also be a sign of communitas. It is common practice to present garments on a clothes rack, where all pieces have the same price. At the end of the sales period, there can be a time when the dead collection and the new one are presented in separate windows of the same shop. This is a kind of incorporation phase before the regular life of the new collection starts. These observations can be summed up as the dramatisation of a passage rite where we find striking similarities to what Turner described as the result of his research in "primitive" cultures. According to Turner, nakedness and darkness, as major signs of the transitional phase, echo in what we have called the "dead mannequin" and the "dead shop" in the show window.

Proceeding from this reasoning strictly based on the visual, we opened the discussion toward the production and consumption of fashion in a second step. The inclusion of the ritual of presenting the new fashion on the catwalk and the activities of the bargain hunters in the period of thrift should contribute towards a better understanding of the seasonal sale as a social practise. The suggestion to do so comes from Roland Barthes.[641] He pointed out that the inauguration of the spring collection is comparable to the ancient Greek rituals of the Anthesteria and the Dionysia, and that the advent of the spring collection today is a rite which has returned from the darkness of ancient times. We have followed this clue insofar as we have found two major rites performed during elaborated ancient Greek festivals, which can as well be associated with the life of a fashion collection: the procession and the blood sacrifice. The catwalk show is a procession of ancient pattern. What the fashion designer presents has to be believed unequivocally, there is no question about right or wrong. Performance theory calls this phenomenon performative utterance. When the fashion system says "red" then it is red. The fashion shows are glamorous events, which represent the Apollonian beauty. The sacrifice as the second part of the festival has been fixed to the seasonal sale. We assumed that the sacrifier (the subject who benefits

[641] Barthes (1990:251).

from the sacrifice) is the fashion system and the victim is the past seasonal collection. In a metaphorical setting, we have killed the victim by cutting the price (the aorta) after which the consumers (the ritual audience) are invited to the common meal where the victim is dismembered by the bare hands of the bargain hunters (feeding the community). The customers confirm death consciously by way of enactment. This dramatisation of violence has been discussed as being contrary to the theory of shopping as a sacrifice by Daniel Miller.[642] Both approaches are based on the concept of thrift. A difference emerges from this premise. While Miller analyses everyday shopping as a sacrificial act, we face an elaborated festival of thrift by the fashion industry in the seasonal sale. The sacrifice of the seasonal collection during the sales can be compared with the ancient rites of the sacrifice of the god because the victim (fashion collection) represents the god (fashion). The last step of the sacrifice is the resurrection of the god and is dramatised through the magical treatment of signs. The "naked mannequin" is only re-dressed after the sales period. This magical action also has its ancestors in antiquity. New life was symbolically transferred to the new resurrected god by dressing the statue with a shirt.

The results of this research can also be applied to a more general discussion about the commodity fetish. We would like to transcend the "death of fashion" to the "death of the commodity fetish". The notion of producing ever-newer generations of commodities, which are only based on the change of aesthetic properties, can be enhanced by a new point of view. It is not just the introduction of the novelty that keeps the system running but also the sacrifice of the aesthetically obsolete commodity. The death of the commodity fetish has to be added to the critique of commodity fetish. We see this clearly in the example of the shoe shop in Paris. Since there is a pedestal in the window, the shoes are on a throne during the season. When the seasonal sale arrives, the shoes are thrown onto the floor. The throne is now empty. This symbolic inversion has been successfully deployed since ancient times to moderate tensions caused by an asymmetrical power relation. It is the dramatisation of the death of the king, or, in terms of the commodity culture, the death of the commodity fetish on a regularly basis. Consumer

642 Miller (1998a).

culture does not merely use the strategies for glorifying the commodity.

Tensions caused by empowering the commodity fetish are eased by enacting the symbolic sacrifice of the commodity twice a year. In being incorporated into the ritual, the consumers also accept the system by consuming the common meal offered during the ritual time of thrift. It is the public theatre of death; it is the "danse macabre" of the brands and their branded goods, the dance behind the skeleton, regardless if they are haute couture brands or mass-market brands. They are all equal in the face of death. All fashion goods will be dead in half a year. Without merchandising, there can be no resurrection.

We would in the end like to point out the aesthetic dimension of the seasonal sale. Consumer culture is characterised by a visual economy of beauty. The seasonal sale radically interrupts this aesthetic concept. The Apollonian beauty of the commodity fetish has its opponent in the dramatisation of the Dionysian aesthetic during the sales. Commodity culture has to worship both Apollo as well as Dionysus:

> "Where Dionysian powers rise up so impetuously, as we are now experiencing them, there Apollo must already have descended to us veiled in a cloud; Apollo, whose most sumptuous effects of beauty will probably be seen by the next generation."[643]

[643] Nietzsche (2000:131).

Double Images

" [...] as a season, spring is both pure and mythical at once; mythical, by virtue of the awakening of nature; Fashion takes this awakening for its own, thus giving the readers, if not its buyers, the opportunity to participate annually in a myth that has come from the beginning of time; spring Fashion, for the modern woman, is like what the Great Dyonysia or the Anthesteria were for the ancient Greeks."

Barthes (1990:251)

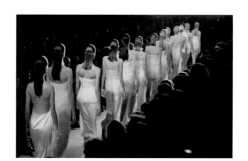

Procession
The procession was an important part of ancient Greek rituals. Donna Karan catwalk show,
fall 1997 A.D. (photo: Lucian Perkins)

Depiction of an ancient Greek procession on a bowl (ca. 540 B.C.).

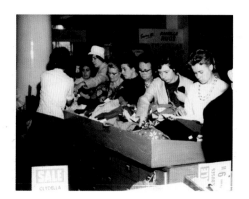

Sacrifice
The ancient Greek ritual sacrifice in which the victim was killed with bare hands
was called sparagmos

Reinterpretation of a Dionysian festival by the artist Hermann Nitsch (photo: Heinz Cibulka) 273

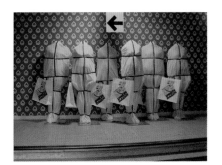

Memento Mori
"Remember your death" has been a favoured motif in art since mediaeval times. Seasonal sale
window of a department store in Uetrecht (2004 A.D.)

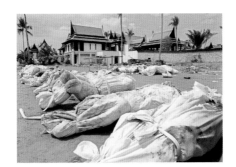

Victims of the Tsunami catastrophe in Thailand (2004 A.D.)

Artistic Prototypes
The dead mannequin and the dead shop are the two prototypes in seasonal sale dramatisation strategies.
Installation by the artist Christo: windows covered with textile showing the state of a shop's
transformation (1964-65 A.D.)

Performance by the artist Colette in a Fiorucci show window in New York (1978/79 A.D)

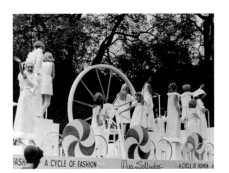

Wheel
The wheel is an old symbol for the mutability of life, the cycles of nature, or the changeability of earthly fortune. Festival of London Stores (1968 A.D.)

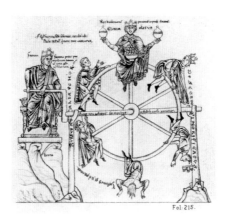

Fol. 215.

Fortuna rotating the wheel of fortune with the rising and falling king (1175 A.D.)

279

Iconoclasm
Holy images have always been attacked by iconoclasts. Acid attack on the painting
of Thomas Apostle by Nicolaes Maes (1656 A.D.)

Seasonal sale graphics announcing the last days of sale in the form of a splash.

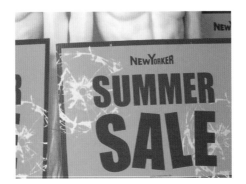

Iconoclasm
Throwing stones is an old technique of attack and punishment. Seasonal sales poster
with sublimated smashed window in Vienna (2005 A.D.)

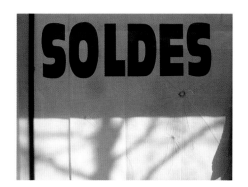

Devastated show window on Champs Elysées in Paris (2004 A.D.)

Index

List of illustrations

p. 272 Sale at Selfridges, garments, no date. By permission of the HAT Archive/Norwich.

p. 273 *Orgien Mysterien Theater, 6 Tages Spiel* [Orgies Mystery Theatre, 6-Day Play], Hermann Nitsch, Prinzendorf 1998; photographed by Heinz Cibulka 1998. By permission of the Cibulka-Frey Archive.

p. 274 Wrapped mannequins during the "Drie Dwaze Dagen" sale at de Bijenkorf, Uetrecht 2004. By permission of de Bijenkorf.

p. 275 Shrouded bodies of Tsunami victims in front of Hotel Sofitel Magic Lagoon, Thailand, 2004; photographed by Rungroj Yongrit 2004. By permission of the Austrian Press Agency.

p. 276 *Four Store Fronts Corner*, 1964-65, Christo; photographed by Eeva-Inkeri. By permission of Christo and Jean-Claude.

p. 277 Window of Fiorucci from the series *Justine of Colette is Dead Co.* for Fiorucci 78/79, Colette 1987, photo worked over with glitter. By permission of Galerie Carol Johnssen, Munich.

p. 278 Miss Selfridges, Festival of London Stores, 1968. By permission of the HAT Archive/Norwich

p. 279 Fortuna turning the Wheel of Fortune, a copy of Hortus deliciarum by Herrad von Landsberg, 1175/90, in Keller/Straub, Herrade de Landsberg, 1899, Austrian National Library, Inv. No. 548085E/Han Fol. 215, Pl. LV. By permission of the Austrian National Library/Department of Manuscripts.

p. 280 *Der Apostel Thomas*, Nicolaes Maes, 1656, after it was damaged by acid in 1977, Kassel, Inv. GK246, Staatliche Kunstsammlungen, Museumslandschaft Hessen Kassel. By permission of the Gemäldegalerie Alte Meister, Kassel.

p. 281 Show window with colour splash, Mariahilferstraße, Vienna, 2005. Photographed by the author.

p. 282 Show window, Mariahilferstraße, Vienna, 2005. Photographed by the author.

p. 283 Covered show window, Avenue Champs Elysées, January 2004. Photographed by the author.

Bibliography

Aicher, Otl: *Die Welt als Entwurf* (Berlin: Ernst & Sohn, 1992).

Albus, Volker/Borngräber, Christian: *Design Bilanz. Neues deutsches Design der 80er Jahre in Objekten, Bildern, Daten und Texten* (Cologne: DuMont, 1992).

Almhofer, Edith, *Performance Art. Die Kunst zu leben* (Vienna/Cologne/Graz: Böhlau, 1986).

Anonymus: "Modische Enthüllungen" in *Das Schaufenster*, vol. 20, no. 7, July 1970 (Passau: Passavia, 1970), pp. 10-11.

Anonymus: "Reste"in: *Das Schaufenster. Monatshefte für moderne Werbung*, vol. 7, January (Passau: Passavia, 1957).

Anonymus, "Sommer Schluss Verkauf" in *Das Schaufenster/Illustrierte Monatshefte für moderne Werbung*, vol. 6, July 1956 (Passau: Passavia, 1956), pp. 312-313.

Aragon, Louis: *Paris Peasant* (Boston: Exact Change, 1994).

Austerlitz, Robert: "Anziehungsmittel im Schaufenster" in *Das Schaufenster. Illustrierte Zeitschrift für geschäftlichen Fortschritt*, no. 21, August 1904 (Prague/Vienna, 1904).

Austerlitz, Robert: "Der Umbau von Portalen" in *Das Schaufenster. Illustrierte Zeitschrift für geschäftlichen Fortschritt*, no. 4, November 1903 (Prague/Vienna, 1903), pp. 25-26.

Austerlitz, Robert: "Ein Schaufenster soll man sehen" in *Das Schaufenster. Illustrierte Zeitschrift für geschäftlichen Fortschritt*, no. 14, April 15, 1904 (Prague/Vienna, 1904), pp. 105-107.

Austerlitz, Robert: "Karneval Dekoration" in *Das Schaufenster. Illustrierte Zeitschrift für geschäftlichen Fortschritt* (Prague/Vienna, 1904), p. 68.

Austerlitz, Robert: "Wie erreicht man, daß ein Schaufenster wirkungsvoll ist" in *Das Schaufenster. Illustrierte Zeitschrift für geschäftlichen Fortschritt*, no. 20, July 15, 1904 (Prague/Vienna, 1904), pp. 89-90.

Auslander, Philip: *Liveness. Performances in a Mediatized Culture*, 1st edn. (London: Routledge, 1999)

Austin, John L.: *How to do Things with Words*, 2nd edn. (Oxford: Oxford University Press, 1986).

Bachelard, Gaston, *Poetics of Space* (New York: Orion Press, 1964).

Baecker, Dirk: *Wozu Soziologie* (Berlin: Kadmos, 2004).

Bal, Mieke: *Narratology. Introduction to the Theory of Narrative* (Toronto/Buffalo/London: University of Toronto Press, 1999).

Barthes, Roland: *The Empire of Signs* (New York: Hill and Wang, 1983).

Barthes, Roland: "The Death of the Author", in Barthes, Roland: *Image – Music – Text* (London: Fontana Press, 1977), pp. 142-148.

Barthes, Roland: *Camera Lucida, Reflections on Photography* (Hill and Wang: New York, 1982).

Barthes, Roland: *Mythologies*, (London: Vintage, 2000).

Barthes, Roland: *The Fashion System* (Berkeley/London: University of California Press, 1990).

Bataille, Georges: "Der Begriff der Verausgabung", in Bataille, Georges: *Die Aufhebung der Ökonomie* (München: Matthes & Seitz Verlag, 2001), pp. 9-31.

Bataille, Georges: *The Accursed Share: An Essay on General Economy* (New York: Zone Books, 1991).

Baudrillard, Jean: "Absolute Merchandise", in Schwander, Martin (ed.): *Andy Warhol. Paintings 1960-1986* (Stuttgart: Hatje, 1995).

Baudrillard, Jean: *Architektur: Wahrheit oder Radikalität?* (Graz/Vienna: Droschl, 1999).

Baudrillard, Jean: *Symbolic Exchange and Death* (London: Sage, 2004).

Baudrillard, Jean: *Fatal Strategies* (London: Pluto Press, 1990).

Baudrillard, Jean: *The Consumer Society* (London/Thousand Oaks/New Delhi: Sage, 2003).

Baudrillard, Jean: *The Singular Objects of Architecture* (Minnesota Press: Minneapolis, 2002).

Baudrillard, Jean: *The System of Objects*, trans. James Benedict (London/New York: Verso, 1996).

Bauer, Maria Lian: *Szenerien. Handbuch zur Warenpräsentation auf der Bühne des Schaufensters* (Frankfurt am Main: Deutscher Fachverlag, 1997).

Beaumont-Maillet, Laure: *Atget Paris* (Paris: Hazan, 1992).

Belk, Russel W./Wallendorf, Melanie/Sherry, John F.: "The Sacred and the Profane in Consumer Behaviour. Theodicy on the Odyssey" in *Journal of Consumer Research*, vol. 16 (Chicago: University of Chicago Press, June 1989), pp. 1-38.

Belk, Russell: "Materialism and the Making of the Modern American Christmas" in Miller, Daniel: *Unwrapping Christmas* (New York: Clarendon Press, 2001).

Bell, Catherine: *Ritual Theory, Ritual Practice* (New York/Oxford: Oxford University Press, 1992).

Bell, Catherine: *Ritual. Perspectives and Dimensions* (New York/Oxford: Oxford University Press, 1997).

Belliger, Andréa/Krieger, David J. (ed.): *Ritualtheorien. Ein einführendes Handbuch* (Opladen/Wiesbaden: Westdeutscher Verlag, 1998).

Belting, Hans: *Likeness and Presence. A History of the Image Before the Era of Art* (Chicago: The University of Chicago Press, 1996).

Belting, Hans: "Echte Bilder und falsche Körper. Irrtümer über die Zukunft des Menschen" in Maar, Christa/Burda, Hubert (ed.): *Iconic Turn. Die neue Macht der Bilder* (Cologne: DuMont, 2005), pp. 350-364.

Benjamin, Walter: "Capitalism as Religion", in Bullock, Marcus, Jennings, Michael W. (eds.): *Walter Benjamin. Selected Writings*, vol. 1, 1913-1926, 4th edn. (Harvard University Press: Cambridge 2000), pp. 288-291.

Benjamin, Walter: "The Work of Art in the Age of Its Technological Reproductibility: Third Version", in Bullock, Marcus, Jennings, Michael W. (eds.): *Walter Benjamin. Selected Writings*, vol. 4, 1938-1940, (Harvard University Press, Cambridge 2003), pp. 251-283.

Benjamin, Walter: *The Arcades Project* (Cambridge: Havard University Press, 2004).

Bergesen, Albert: "The Ritual Order", in *Humboldt Journal of Social Relations*, no. 25, 1999, pp. 157-197.

Boesch, Alexander/Bolognese-Leuchtenmüller, Birgit/Knack, Hartwig: *Produkt Muttertag. Zur rituellen Inszenierung eines Festtages* (Vienna: Österreichisches Museum für Volkskunde, 2001).

Bogner, Dieter/Boeckl, Matthias: "Friedrich Kiesler 1890-1965", in Bogner, Dieter (ed.): *Friedrich Kiesler. Architekt Maler Bildhauer/1890-1965* (Vienna: Löcker, 1988).

Bohnsack, Ralf: "Die dokumentarische Methode in der Bild- und Fotointerpretation", in Ehrenspeck, Yvonne/Schäffer, Burkhard (ed.): *Film- und Fotoanalyse in der Erziehungswissenschaft* (Opladen: Leske + Budrich, 2003a), pp. 87-107.

Bohnsack, Ralf: *Rekonstruktive Sozialforschung. Einführung in qualitative Methoden* (Opladen: Leske + Budrich, 2003b).

Bolz, Norbert/Bosshart, David: *Kult-Marketing. Die neuen Götter des Marktes* (Düsseldorf: Econ, 1995).

Bolz, Norbert: *Das Konsumistische Manifest* (Munich: Fink, 2002).

Borngräber, Christian: "Vor Ort", in Borngräber, Christian (ed.): *Berliner Design-Handbuch* (Cologne: Merve, 1987).

Bosshart, David: *Cheap. The Real Cost of the Global Trend for Bargains, Discounts & Customer Choice* (London: Kogan Page, 2006).

Bourdieu, Pierre: "Das ökonomische Feld", in Bourdieu, Pierre: *Der Einzige und sein Eigenheim. Erweiterte Neuausgabe der Schriften zu Politik & Kultur* (Hamburg: VSA, 2002a).

Bourdieu, Pierre: *Distinction. A Social Critique of the Judgement of Taste* (London/New York: Routledge, 2005).

Bourdieu, Pierre: *Ein soziologischer Selbstversuch* (Frankfurt am Main: Suhrkamp, 2002b).

Bourdieu, Pierre: *Zur Soziologie der symbolischen Formen* (Frankfurt am Main: Suhrkamp, 1974).

Bourdon, David: *Christo* (Milano: Apollinaire, 1964).

Brandolini, Andreas: *Der Haken. Texte über Design* (Kassel: Martin Schmitz, 1990).

Brandstetter, Gabriele: "Le Sacre du printemps/Choreographie und Ritual", in Caduff, Corina/Pfaff-Czarnecka (ed.): *Rituale heute. Theorien-Kontroversen-Entwürfe* (Berlin: Reimer, 2001), pp. 127-148.

Branzi, Andrea: "We Are the Primitives", in Margolin, Victor (ed.): *Design Discourse. History-Theory-Criticism* (Chicago/London: The University of Chicago Press, 1998). pp. 37-47.

Bredekamp, Horst: "A Neglected Tradition? Art History as Bildwissenschaft", in *Critical Inquiry*, vol. 29, no. 3 (Chicago: Illinois University Press, Spring 2003), pp. 418-428.

Bremmer, Jan N.: *Greek Religion* (Oxford/New York: Oxford University Press, 1999).

Breton, André: *Manifestoes of Surrealism* (Michigan: Ann Arbor Paperbacks, 2005).

Brown, Donald E.: "Human Universals", in Wilson, Robert A./Keil, Frank C. (ed.): *The MIT Encyclopedia of the Cognitive Sciences* (Cambridge/London: MIT Press, 1999).

Brown, Donald E.: *Human Universals* (Philadelphia: Temple University Press, 1991).

Bruzzi, Stella/Church Gibson, Pamela (ed.): *Fashion Cultures. Theories, Explanations and Analysis* (London/New York: Routledge, 2000).

Buchanan, Richard: "Declaration by Design: Rhethoric, Argument, and Demonstration in Design Practice", in Margolin, Victor (ed.): *Design Discourse. History-Theory-Criticism* (Chicago/London: University of Chicago Press, 1998).

Burckhardt, Lucius: *Design ist unsichtbar* (Ostfildern: Cantz, 1995).

Canetti, Elias: *Crowds and Power* (New York: Continuum Publishing House, 1973).

Carter, Michael: *Fashion Classics from Carlyle to Barthes* (Oxford/New York: Berg, 2003).

Charles-Roux, Edmonde (ed.): *La semaine moscovite de Dior, Vogue,* August 1959 (Paris: Condé Nast, 1959), pp. 46-51.

Charles-Roux, Edmonde (ed.): "Le code de la mode", in *Vogue Francais,* August 1959 (Paris: Condé Nast, 1959), pp. 26-33.

Charles-Roux, Edmonde (ed.): "Les Collections de Printemps", in *Vogue Francais,* March 1959 (Paris: Condé Nast, 1959), pp. 97-135.

Charles-Roux, Edmonde: editor's note, in *Vogue,* March 1959, German supplement (Paris: Condé Nast, 1959), p. VI.

Charles-Roux, Edmonde: "Paris, Laboratorium der neuen Formen", in *Vogue,* German supplement (Paris: Condé Nast, April 1958), pp. I-III.

Clarke, Alison/Miller, Daniel: "Fashion and Anxiety", in Steele, Valerie: *Fashion Theory. The Journal of Dress, Body & Culture,* vol. 6, Issue 2 (Oxford/New York: Berg, 2002), pp. 191-214.

Csikszentmihalyi, Mihaly/Rochberg-Halton, Eugene: *The Meaning of Things. Domestic Symbols and the Self* (Cambridge: Cambridge University Press, 2002).

Csikszentmihalyi, Mihaly/Robinson, Rick E.: *The Art of Seeing. An Interpretation of the Aesthetic Encounter* (Los Angeles: Paul Getty Museum, 1990).

Cummings, Neil/Lewandowska, Marysia: *The Value of Things* (Basle: Birkhäuser, 2000).

Debord, Guy: *The Society of the Spectacle* (New York: Zone Books, 2004).

Dichter, Ernest: *Handbook of Consumer Motivations. The psychology of the World of Objects* (New York/London: McGraw Hill, 1964).

Dichter, Ernest: *Strategy of Desire* (New York: Doubleday & Company, 1960).

Dichter, Ernest: *Überzeugen – nicht verführen. Die Kunst, Menschen zu beeinflussen* (Düsseldorf/Vienna: Econ, 1985).

Din, Rasshied: *New Retail* (London: Conran Octopus, 2000).

Doonan, Simon: *Confessions of a Window Dresser* (New York: Penguin Studio, 1998).

Douglas, Mary/Isherwood, Baron: *The world of Goods. Towards an Anthropology of Consumption* (London/New York: Routledge, 2002).

Douglas, Mary: "In Defense of Shopping", in Eisendle, Reinhard/Miklautz, Elfie (eds.): *Produktkulturen. Dynamik und Bedeutungswandel des Konsums* (Frankfurt/New York: Campus 1992), pp. 95-155.

Douglas, Mary: *Purity and Danger. An Analysis of Concepts of Pollution and Taboo* (London: Pelican Books, 1970).

Douglas, Mary: *Natural Symbols. Explorations in Cosmology* (London: Routledge, 2000).

Durkheim, Emile: *The Elementary Forms of Religious Life,* 7th edn. (London: George Allen & Unwin, 1971).

Eco, Umberto: *History of Beauty,* 2nd edn. (New York: Rizzoli, 2005).

Eco, Umberto: *Zeichen. Einführung in einen Begriff und seine Geschichte* (Frankfurt am Main: Suhrkamp, 1977).

Eliade, Mircea: *Shamanism. Archaic Techniques of Ecstasy,* 2nd edn. (Bollingen Foundation, Princeton: Princeton University Press, 1970).

Erlhoff, Michael (ed.): *Gold oder Leben. Aufsätze zum Verhältnis zwischen Gegenstand und Ritual* (Darmstadt: Büchner, 1988).

Erlhoff, Michael: "Liturgie als Prozeß", in *form,* no. 161 (Basle: Birkhäuser, 1/1998), pp. 52-55.

Evans-Prichard: Foreword, in Hubert, Henri/Mauss, Marcel: *Sacrifice: Its Nature and Function* (Chicago: University of Chicago Press, 1981), pp. vii-viii.

Fischer, Volker (ed.): *Design Heute* (Munich: Prestel, 1988).

Fischer-Lichte, Erika: *Ästhetik des Performativen* (Frankfurt am Main: Suhrkamp, 2004).

Fischer-Lichte, Erika: "Grenzgänge und Tauschhandel. Auf dem Wege zu einer performativen Kultur", in Wirth, Uwe: *Performanz. Zwischen Sprachphilosophie und Kulturwissenschaften* (Frankfurt am Main: Suhrkamp, 2002).

Flusser, Vilém: *Dinge und Undinge. Phänomenologische Skizzen* (Munich/Vienna: Hanser, 1993).

Flusser, Vilém: *Gesten. Versuch einer Phänomenologie* (Frankfurt am Main: Fischer, 1994).

Flusser, Vilém: *The Shape of Things. A Philosophy of Design* (London: Reaktion Books, 1999).

Foster, Hal: "The Artist as Ethnographer", in Marcus, George E./ Myers, Fred R. (eds.): *The Traffic in Culture. Refiguring Art and Anthropology* (Berkeley/Los Angeles/London: University of California Press, 1995), pp. 302-309.

Foucault, Michel: "Texts/Contexts: Of Other Spaces", in Preziosi, Donald/Farago, Claire: *Grasping the World. The Idea of the Museum* (Aldershot/Hants: Ashgate Publishing Limited, 2004), pp. 371-379.

Foucault, Michel: *Discipline and Punish. The birth of the Prison*, trans. Alan Sheridan (New York: Vintage Books, 1995).

Frazer, James George: *The Golden Bough. A Study of Magic and Religion* (Hertfordshire: Wordworth, 1993).

Freedberg, David: *The Power of Images. Studies in the History and Theory of Response* (Chicago/London: University of Chicago Press, 1991).

Freud, Sigmund: "Totem and Taboo", in *The Basic Writings of Sigmund Freud*, trans. and ed. A. A. Brill (New York: The Modern Library, 1995), pp. 775-852.

Friedmann, Ernst: "Über Schaufensterkunst", in *Das Schaufenster. Illustrierte Zeitschrift für geschäftlichen Fortschritt*, no. 1 (Prague: 1903), p. 1.

Frutiger, Adrian: *Signs and Symbols. Their Design and Meaning* (London: Studio Editions, 1989).

Gay, Paul du: *Production of Culture/Culture of Production* (London/Thousand Oaks/New Delhi: Sage, 1997).

Geertz, Clifford: *The Interpretation of Cultures* (New York: Basic Books, 1973).

Gennep, Arnold van: *The Rites of Passage* (Chicago: University of Chicago Press, 1960).

Girard, René: *Violence and the Sacred* (London: Continuum, 1995).

Givhan, Robin: *Runway Madness* (San Francisco: Chronicle Books, 1998).

Goffman, Erving: *Gender Advertisements* (New York/San Francisco/London: Harper & Row, 1979).

Goffman, Erving: *Frame Analysis: An Essay on the Organisation of Experience* (Boston: Northeastern University Press, 1986).

Goldberg, RoseLee: *Performance. Live Art 1909 to the Present* (London: Thames and Hudson, 1979).

Graf, Fritz: *Greek Mythology. An Introduction* (Baltimore/London: John Hopkins University Press, 1993).

Graves, Michael: "Ritual Themes in Architecture", in Bourke, Julia (ed.): *The Princeton Journal: Thematic Studies in Architecture*, vol. 1 (Princeton: Princeton Architectural Press, 1983).

Grimes, Ronald L. (ed.): *Readings in Ritual Studies* (Upper Saddle River: Prentice-Hall, 1996).

Grimes, Ronald L.: *Beginnings in Ritual Studies* (Columbia, S.C.: University of South Carolina Press, 1995).

Gross, Michael quoted in: Givhan, Robin: *Runway Madness* (San Francisco: Chronicle Books, 1998).

Gross, Michael: *Model. The Ugly Business of Beautiful Women* (New York: Morrow, 1995).

Groys, Boris: "The Artist as Consumer", in Grunenberg, Christoph/Hollein, Max (eds.): *Shopping – A Century of Art and Consumer Culture* (Ostfildern- Ruit: Hatje Cantz Publishers 2002), pp.55-60.

Groys, Boris: *Über das Neue. Versuch einer Kulturökonomie* (Munich/Vienna: Hanser, 1992).

Gruendl, Harald: "Ritual Design. An Introduction", in Jonas, Wolfgang/Chow, Rosan/ Verhaag, Niels (ed.): *Design System Evolution- The Application of Systemic and Evolutionary Approaches to Design Theory, Design Practice, Design Research and Design Education* (Bremen: University of the Arts Bremen, 2005), Chapter 31, pp. 1-14.

Grunenberg, Christoph/Hollein, Max (eds.): *Shopping – A Century of Art and Consumer Culture* (Ostfildern- Ruit: Hatje Cantz Publishers, 2002).

Halbhuber, Lothar: *Schaufenstergestaltung* (Munich: Bruckmann, 1994).

Hamburger Kunsthalle/The Andy Warhol Museum (eds.): *Andy Warhol – Photography* (Thalwil/Zurich/New York: Edition Stemmle, 1999).

Handke, Peter: "They are Dying Out", in Handke, Peter, *Plays: 1. Peter Handke*, (Methuen world dramatists series) trans. Michael Roloff (London: Random House, 1997), pp 235-304.

Haug, Wolfgang Fritz: *Critique of Commodity Aesthetics: Appearance, Sexuality and Advertising in Capitalist Society* (Cambridge: Polity Press, 1986).

Hofmann, Werner (ed.): *Luther und die Folgen für die Kunst* (Munich: Prestel, 1983).

Hollein, Hans: "Das Abendmahl", in Burkhardt, Francois (ed.): *Essen und Ritual* (Berlin/ Crusinallo: Alessi, 1981), pp. 32-43.

Hollein, Hans: *MAN transFORMS. Concepts of an Exhibition* (New York: Cooper-Hewitt Museum, 1989).

Hollein, Max: "The Glamour of Things", in Grunenberg, Christoph/Hollein, Max (eds.): *Shopping – A Century of Art and Consumer Culture* (Ostfildern- Ruit: Hatje Cantz Publishers, 2002), pp.203-207.

Honeycombe, Gordon: *Selfridges. Seventy-Five Years. The Story of the Store* (London: Park Lane Press, 1984).

Hörisch, Jochen: *Theorie Apotheke. Eine Handreichung zu den humanwissenschaftlichen Theorien der letzten fünfzig Jahre, einschließlich ihrer Risken und Nebenwirkungen* (Frankfurt am Main: Eichborn, 2005).

Horkheimer, Max/Adorno, Theodor W.: *Dialectic of Enlightenment: Philosophical Fragments* (Stanford: Stanford University Press, 2002).

Hubert, Henri/Mauss, Marcel: *Sacrifice: Its Nature and Function* (Chicago: University of Chicago Press, 1981).

Hughes-Freeland, Felicia (ed.): *Ritual, Performance, Media* (London/New York: Routledge, 1998).

Humphrey, Caroline/Laidlaw, James: *The Archetypical Actions of Ritual. A Theory of Ritual Illustrated by the Jain Rite of Worship* (Oxford/New York: Oxford University Press, 1994).

Humphrey, Caroline/Vitebsky, Piers: *Sacred Architecture* (Boston/London: Little, Brown & Co., 1997).

Imdahl, Max: Giotto *Arenafresken. Ikonographie-Ikonologie-Ikonik* (Munich: Fink, 1996).

Jennings, Theodore W. Jr.: "On Ritual Knowledge", in Grimes, Ronald. (ed.): *Readings in Ritual Studies* (Upper Saddle River: Prentice Hall, 1996).

Jetter, Werner: *Symbol und Ritual* (Göttingen: Vandenhoek & Ruprecht, 1978).

Jogo (Pseudonym): "Einkaufsschlachten", in *Das Schaufenster*, vol. 2 (Passau: Passavia, 1974).

Jormakka, Kari: *Heimlich Manoevres. Ritual in Architectural Form* (Weimar: Hochschule für Architektur und Bauwesen, 1995).

Jung, Carl Gustav: *Four Archetypes: Mother, Rebirth, Spirit, Trickster*, 11th edn. (Princeton: Princeton University Press, 1992).

Kahn, Nathalie: "Catwalk Politics", in Bruzzi, Stella/Church Gibson, Pamela (eds.): *Fashion Cultures. Theories, Explorations and Analysis* (London/New York: Routledge, 2000), pp. 114-126.

Karmasin, Helene/Karmasin, Matthias: *Cultural Theory. Ein neuer Ansatz für Kommunikation, Marketing und Management* (Vienna: Linde, 1997).

Karmasin, Helene: *Produkte als Botschaften /Individuelles Produktmarketing. Konsumorientiertes Marketing Bedürfnisdynamik. Produkt-und Werbekonzeptionen. Markenführung in veränderten Umwelten* (Vienna: Ueberreuter, 1998).

Keenan, William: "From Friars to Fornicators: The Eroticization of Sacred Dress", in Steele, Valerie: *Fashion Theory. The Journal of Dress, Body & Culture*, vol. 3, Issue 4 (New York: Berg, 1999), pp. 389-410.

Kiesler, Frederic: *Contemporary Art Applied to the Store and its Display* (New York, 1929).

Kliment, Stephen A. (ed.): *Building Type Basics for Retail and Mixed Use Facilities. The Jerde Partnership* (Hoboken: Wiley, 2004).

Kolesch, Doris/Lehmann, Annette Jael: "Zwischen Szene und Schauraum: Bildinszenierungen als Orte performativer Wirklichkeitskonstruktion", in Wirth, Uwe (ed.): *Performanz. Zwischen Sprachphilosophie und Kulturwissenschaften* (Frankfurt am Main: Suhrkamp, 2002), pp. 347-365.

Koller, Gabriele: *Die Radikalisierung der Phantasie. Design aus Österreich* (Salzburg/Vienna: Residenz, 1987).

Langer, Susanne: *Philosophy in a New Key*, 4th ed. (Cambridge: Massachusetts, 1960), p. 287.

Lasn, Kalle: Culture Jam, *The Uncooling of America* (New York: Eagle Brook, 1999).

Latour, Bruno: *Iconoclash. Gibt es eine Welt jenseits des Bilderkrieges?* (Berlin: Merve, 2002a).

Latour, Bruno: *We Have Never Been Modern* (Cambridge: Harvard University Press, 2002b).

Lefebvre, Henri: *Critique of Everyday Life*, vol. 1 (London: Verso, 1991).

Lévi-Strauss, Claude: *Structural Anthropology*, vol. 1 (New York: Penguin Group, 1977).

Lévi-Strauss, Claude: *Structural Anthropology*, vol. 2 (New York: Penguin Group, 1978).

Lévi-Strauss, Claude: *The Raw and the Cooked: Mythologiques*, vol. 1 (Chicago: University of Chicago Press, 1996).

Lévi-Strauss: *The Savage Mind* (Chicago: University of Chicago Press, 1966).

Lieberson, Stanley: *A Matter of Taste: How Names, Fashions, and Culture Change* (New Haven/London: Yale University Press, 2000).

Liessmann, Konrad Paul: *Philosophie der modernen Kunst* (Vienna: WUV Universitäts Verlag, 1999).

Liessmann, Konrad Paul: *Philosophie des verbotenen Wissens. Friedrich Nietzsche und die schwarzen Seiten des Denkens* (Vienna: Zsolnay, 2000).

Lindinger, Herbert (ed.): *Hochschule für Gestaltung Ulm. Die Moral der Gegenstände* (Berlin: Ernst, 1987).

Luckmann, Thomas: "Phänomenologische Überlegungen zu Ritual und Symbol", in Uhl, Florian/Boelderl, Arthur. R. (ed.): *Rituale. Zugänge zu einem Phänomen* (Düsseldorf/Bonn: Parerga, 1999), pp. 11-28.

Macho, Thomas: *Das Zeremonielle Tier. Rituale-Feste-Zeiten zwischen den Zeiten* (Graz: Styria, 2004).

Malinowski, Bronislaw: *Magic, Science and Religion and Other Essays* (New York: Doubleday & Company, 1954).

Marx, Karl: *Das Kapital. Kritik der politischen Ökonomie* (Stuttgart: Kröner, 1957).

Mauss, Marcel: *The Gift: The Form and Reason to Exchange in Archaic Societies* (London/New York: Routledge, 2002).

Mauss, Marcel: "Theorie der Magie", in Mauss, Marcel, *Soziologie und Anthropologie 1* (Frankfurt am Main: Fischer, 1999), pp. 43-182.

McCracken, Grant: *Culture & Consumption* (Bloomington/Indianapolis: Indiana University Press, 1988).

Menchari, Leïla: *Les Vitrines Hermès. Contes nomandes* (Paris: Imprimerie Nationale, 1999).

Mendini, Alessandro: "The Alchimia Manifesto", in Sato, Kasuko: *Alchemia. Contemporary Italian Design* (Berlin: Taco, 1988), p.7.

Metzger, Rainer: "Models and Bubenreuthers. On the World, Big and Small, the Spectacular and the Incidental, Prominence and Anonymity of Juergen Teller", in Matt, Gerald et.al (eds.): *Juergen Teller. Ich bin vierzig* (Vienna: Kunsthalle Wien, 2004), pp. 56-68.

Michaels, Axel: "Le rituel pour le rituel", in *unimagazin* (Zurich: Universität Zürich, 1998).

Michaels, Axel: "Le rituel pour le rituel-oder wie sinnlos sind Rituale?", in Caduff, Corina/Pfaff-Czarnecka (eds.): *Rituale heute. Theorien-Kontorversen-Entwürfe* (Berlin, 2001).

Miklautz, Elfie: *Kristallisierter Sinn. Ein Beitrag zur soziologischen Theorie des Artefakts* (Munich/Vienna: Profil Verlag, 1996).

Mikunda, Christian: *Der verbotene Ort. Die inszenierte Verführung* (Frankfurt/Vienna: Redline, 2002).

Mikunda, Christian: *Brand Lands, Hot Spots & Cool Spaces: Welcome to the Third Place and the Total Marketing Experience* (Kogan Page: London, 2004).

Miller, Daniel: *A Theory of Shopping* (New York: Polity Press, 1998a).

Miller, Daniel (ed.): *Material Cultures. Why Things Matter* (London: UCL Press, 1998b).

Mills, Kenneth H.: *Applied Visual Merchandising* (New Jersey: Prentice Hall, 1982).

Mirzoeff, Nicholas: *An Introduction to Visual Culture* (London/New York: Routledge, 1999).

Mitchell, Thomas W.J.: *Iconology. Image, Text, Ideology* (London/Chicago: University of Chicago Press, 1987).

Mitchell, Thomas W.J.: *What Do Pictures Want? The Lives and Loves of Images* (Chicago/London: University of Chicago Press, 2005).

Moeran, Brian/Skov, Lise: "Cinderella Christmas: Kitsch, Consumerism, and Youth in Japan", in Miller, Daniel (ed.): *Unwrapping Christmas* (New York: Clarendon Press, 2001).

Molotch, Harvey: *Where Stuff Comes From. How Toasters, Toilets, Cars, Computers, and Many Other Things Come to Be as They Are* (New York/London: Routlege, 2003).

Moreno, Shonquis: "The Three-Second Rule", in *Frame*, no. 38, June 2004 (Amsterdam: BIS Publisher, 2004), pp. 92-103.

Muniz, Albert M./O'Guinn, Thomas C.: "Brand Community", in *Journal of Consumer Research*, vol. 27, March 2001 (Chicago: University of Chicago Press, 2001), pp. 412-432.

Nietzsche, Friedrich: *The Birth of Tragedy* (Oxford/New York: Oxford University Press, 2000).

Nitsch, Hermann: "Ritual als Ausdrucksform der Kunst", in Uhl, Florian/Boelderl, Arthur R. (eds.): *Rituale. Zugänge zu einem Phänomen* (Düsseldorf/Bonn: Parerga, 1999), pp. 103-113.

Nooteboom, Cees: *Rituale* (Frankfurt am Main: Suhrkamp, 1995).

Okakura, Kakuzo: *The Book of Tea* (Tokyo/New York: Kodansha International, 1989).

Osterwold, Tilman: *Schaufenster. Die Kulturgeschichte eines Massenmediums* (Stuttgart: Kunstverein, 1974).

Packard, Vance: *The Hidden Persuaders* (Harmondsworth: Penguin Books, 1968).

Panovsky, Erwin: *Meaning in the Visual Arts* (New York: Doubleday Anchor Books, 1955).

Panovsky, Erwin: *Studies in Iconology. Humanistic Themes in the Art of the Renaissance* (New York: Harper&Row Publishers, 1962).

Parrot, Nicole: *Mannequins* (Paris: Edition Olms, 1982).

Pavitt, Jane (ed.): *Brand New. Starke Marken* (Munich: Knesebeck, 2001).

Peters, Tom: *Design Mindfulness: Wellspring of "Corporate Soul" & No.1 Basis for Competitive Advantage?* (New York: Tom Peters Company Press, 2001).

Pevsner, Nikolaus: *Architektur und Design. Von der Romantik zur Sachlichkeit* (Munich: Prestel, 1971).

Pevsner, Nikolaus: *Wegbereiter moderner Formgebung* (Cologne: DuMont, 2002).

Pfabigan, Alfred: *Nimm 3 zahl 2. Wie geil ist Geiz?* (Vienna: Sonderzahl, 2004).

Pink, Sarah/da Silva, Olivia: "In the Net. Anthropology and Photography", in Pink, Sarah et.al. (eds.): *Working Images. Visual Research and Representation in Ethnography* (London/New York: Routledge, 2004).

Portas, Mary: *Windows. The Art of Retail Display* (New York: Thames & Hudson, 1999).

Postrel, Virginia: *The Substance of Style. How the Rise of Aesthetic Value is Remaking Comerce, Culture and Consciousness* (New York: Harper/Collins, 2004).

Priessnitz, Reinhard: "Ritus und Design", in Gsöllpointner, Helmuth/Hareiter, Angela/Ortner, Laurids (eds.): *Design ist unsichtbar* (Linz: Löcker, 1981), pp. 21-28.

Quick, Harriet: "What worked in 2003", in *Vogue* (UK), no. 2466, vol. 170, January 2004 (London: Condé Nast, 2004), pp. 94-99.

Reck, Hans Ulrich: "Exkurs: Alle Werbung ist schön oder der Triumph des Obszönen", in Brock, Bazon/Reck, Hans Ulrich (eds.): *Stilwandel als Kulturtechnik, Kampfprinzip, Lebensform oder Systemstrategie in Werbung, Design, Architektur, Mode* (Cologne: DuMont, 1986).

Richardson, Jane/Kroeber A. L.: "Three Centuries of Women's Dress Fashions/A Quantitative Analysis", in Kroeber, A. L./Gifford, R. H./Olson, R. L. (eds.): *Anthropological Records*, vol. 5, no. 2 (Berkeley: University of California Press, 1940), pp. 111-154.

Riewoldt, Otto (ed.): *Brandscaping. Worlds of Experience in Retail Design* (Basle/Boston/Berlin: Birkhäuser, 2002).

Ritson, Marc/Elliott, Richard: "The Social Uses of Advertising: An Ethnographic Study of Adolescent Advertising Audiences", in *Journal of Consumer Research*, vol. 26, December 1999 (Chicago: University of Chicago Press, 1999), pp. 260-277..

Rogers, Everett M: "New Product Adoption and Diffusion", in *Journal of Consumer Research*, no. 2, March 1976 (Chicago: University of Chicago Press, 1976), pp. 290-301.

Rook, Dennis W.: "The Ritual Dimension of Consumer Behaviour", in *Journal of Consumer Research*, vol. 12, December 1985 (Chicago: University of Chicago Press, 1985).

Rychlik, Otmar (ed.): *Herman Nitsch. Das Sechstagespiel des Orgien Mysterien Theaters* (Ostfildern: Hatje Cantz, 2003).

Sahagun, Bernadino de: "Historie de las casas de Nueva España", in Bataille, Georges, *The Accursed Share. An Essay on General Economy* (New York: Zone Books, 1991).

Sahlins, Marshall: *Culture and Practical Reason* (Chicago: The University of Chicago Press, 1976).

Sato, Kasuko: *Alchemia. Contemporary Italian Design* (Berlin: Taco, 1988).

Sato, Kasuko: "Ritualdesign", in Gsöllpointner, Helmuth/Hareiter, Angela/Ortner, Laurids (eds.): *Design ist unsichtbar* (Linz: Löcker, 1981), pp. 634-635.

Schechner, Richard: *Performance Studies. An introduction* (London/New York: Routledge, 2003).

Schechner, Richard: *The Future of Ritual. Writings on Culture and Performance* (London/New York: Routledge, 1995).

Schirrmacher, Joachim: "Retail Therapy", in *Style in Progress*, Issue 1, (UCM Verlag, 2004).

Schleif, Nina: *Schaufenster Kunst. Berlin und New York* (Cologne/Weimar/Vienna: Böhlau, 2004).

Schmidt, Leigh Eric: *Consumer Rites. The Buying and Selling of American Holidays* (Princeton: Princeton University Press, 1995).

Schneider, Sara K.: *Vital Mummies. Performance Design for the Show-Window Mannequin* (New Haven/London: Yale University Press, 1995).

Schönberger, M.: *Wie schreibe ich Schaufensterschilder und Plakate?* (Vienna: Schwarz, no year).

Schuh, Katrin: *Architektur als Kultur. Die Bedeutung der Bauten zwischen Fest, Feier und Alltag – über kulturelle Grundeinstellungen der Baukunst* (Frankfurt am Main: Anabas, 2003).

The
Death
of
Fashion

Schwanzer, Berthold Ch.: *Die Erlebniswelt von Geschäften und Schaufenstern* (Vienna: Modulverlag, 1988).

Schwarz, Friedhelm: *Nestlé. Macht durch Nahrung* (Stuttgart/Munich: Bastei Lübbe, 2000).

Selle, Gert: *Geschichte des Design in Deutschland* (Frankfurt/New York: DuMont, 1994).

Selle, Gert: *Ideologie und Utopie des Design. Zur gesellschaftlichen Theorie der industriellen Formgebung* (Vienna: Montage, 1997).

Selle, Gert: "Produktkultur als gelebtes Ereignis/(Versuch zur Wahrnehmung von Aneignungsgeschichte)", in Eisendle, Reinhard/ Miklautz, Elfie (eds.): *Produktkulturen. Dynamik und Bedeutungswandel des Konsums* (Frankfurt am Main/New York: Campus, 1992), pp. 159-175.

Sen, Soshitsu: *Chado. The Japanese Way of Tea* (New York/Tokyo/Kyoto: Waterhill/Tankosha, 1998).

Sennett, Richard: *Flesh and Stone. The body and the City in Western Civilization* (New York/ London: Norton & Company, 1996).

Sennett, Richard: *Respect in the World of Inequality* (New York/London: Norton & Company, 2003).

Simmel, Georg: *On Individuality and Social Forms. Selected Writings* (Chicago: University of Chicago Press, 1971).

Slater, Don: *Consumer Culture and Modernity* (Cambridge: Polity Press, 2003).

Sloterdijk, Peter: "Bilder der Gewalt – Gewalt der Bilder. Von der antiken Mythologie zur postmodernen Bilderindustrie", in Maar, Christa/Burda, Hubert (eds.): *Iconic Turn. Die neue Macht der Bilder* (Cologne: DuMont, 2005), pp. 333-348.

Sloterdijk, Peter: *Sphären III. Schäume* (Frankfurt am Main: Suhrkamp, 2004).

Soto, Pablo: *Shop window Design* (Ludwigsburg: AV Edition, 2002).

Specht, Edith: "LANAM FECIT/War die Wollarbeit von Frauen OTIUM oder NEGOTIUM?", in Sigot, Ernst (ed.): *Otium – Negotium. Beiträge des interdisziplinären Symposiums der Sodalitas zum Thema Zeit* (Vienna: Edition Praesens, 2000).

Spectator: "Frühling", in *Das Schaufenster. Offizielles Organ des Bundes österreichischer Schaufensterdekorateure*, vol. 3, March 1929 (Vienna: Spitz, 1929), p. 3.

Spies, Werner: "Die surrealistische Revolution", in Spies, Werner (ed.): *Surrealismus 1919-1944. Dali, Max Ernst, Magritte, Miró, Picasso...* (Ostfildern: Hatje Cantz, 2002).

Stafford, Barbara Maria: "Neuronale Ästhetik. Auf dem Weg zu einer kognitiven Bildgeschichte", in Maar, Christa/Burda, Hubert (eds.): *Iconic Turn. Die neue Macht der Bilder* (Cologne: DuMont, 2005), pp. 103-125.

Sturken, Marita/Cartwright, Lisa: *Practices of Looking. An Introduction to Visual Culture* (New York: Oxford University Press, 2001).

Sykora, Katharina: "Merchandise Temptress. The Surrealistic Enticements of the Display Window Dummy", in Grunenberg, Christoph/ Hollein, Max (eds.): *Shopping – A Century of Art and Consumer Culture* (Ostfildern- Ruit: Hatje Cantz Publishers, 2002), pp.130-142.

Tambiah, Stanley J.: "A Performative Approach to Ritual", in *Proceedings of the British Academy*, vol. 65, 1979, pp.113-169.

Timmins, G. L.: *Window Dressing. The Principles of "Display"* (London: Sir Isaac Pitman & Sons, 1922).

Tongeren, Michel van: *Retail Branding* (Amsterdam: BIS Publisher, 2003).

Turner, Victor: *The Ritual Process. Structure and Antistructure* (New York: Aldine de Gruyter, 1997).

Turner, Victor: *From Ritual to Theatre. The human Seriousness of Play* (New York: Performing Arts Journal Publications, 1982).

Underhill, Paco: *Why We Buy: The Science of Shopping* (New York: Simon & Schuster, 1999).

Vaizey, Marina: *Christo* (Recklinghausen: Bongers, 1990).

Veblen, Thorstein: *The Theory of the Leisure Class. An Economic Study of Institutions* (New York: Modern Library, 1934).

Vidler, Anthony: *The Architectural Uncanny. Essays in the Modern Unhomely* (Cambridge: MIT Press, 1992).

Warhol, Andy: *America* (New York/Toronto: Harper & Row, 1985).

Warnke, Martin: *Aby Warburg. Der Bilderatlas MNEMOSYNE* (Berlin: Akademischer Verlag, 2003).

Warnke, Martin: "Der Leidschatz der Menschheit wird humaner Besitz", in Hofmann, Werner (ed.): *Die Menschenrechte des Auges. Über Aby Warburg* (Frankfurt am Main: Europäische Verlagsanstalt, 1980).

Weber, Max: *Economy and Society: An Outline of Interpretative Sociology* (Berkeley/London: University of California Press, 1978).

Weibel, Peter/ Latour, Bruno (eds.): *Iconoclash. Beyond the Image Wars in Science, Religion and Art* (Cambridge/Karlsruhe: MIT Press/ ZKM, 2002).

Weibel, Peter: "Schaufenster-Botschaften/
Ein Piktorial zur Ikonographie des Urbanismus",
in Weibel, Peter/Pakesch, Peter:
Künstlerschaufenster (Graz: Steirischer Herbst,
1980), pp. 5-39.

Wiedenmann, Rainer E.: *Ritual und
Sinntransformation. Ein Beitrag zur Semiotik
soziokultureller Interpenetrationsprozesse*
(Berlin: Duncker & Humbolt, 1991).

Wilson, Elizabeth W.: *Adorned in Dreams.
Fashion and Modernity* (London/New York:
Tauris, 2003).

Wilson, Elizabeth W.: "Magic Fashion", in:
*Fashion Theory. The Journal of Dress, Body &
Culture*, vol. 8, Issue 4 (New York: Berg, 2004),
pp. 375-386.

Wirth, Uwe: "Der Performanzbegriff im
Spannungsfeld von Illokulation, Iteration
und Indexikalität", in idem (ed.): *Performanz.
Zwischen Sprachphilosophie und
Kulturwissenschaften* (Frankfurt am Main:
Suhrkamp, 2002), pp. 9-62.

Wissova, Georg (ed.): *Paulys Realencyclopädie
der classischen Altertumswissenschaft*
(Munich: Druckenmüller, 1894).

Wittgenstein, Ludwig: *Remarks on Frazer's
Golden Bough* (Atlantic Highlands/New Jersey:
Humanities Press, 1979).

Wittgenstein, Ludwig: *Traktatus logico-
philosophicus. Logisch-philosophische
Abhandlung* (Frankfurt a. Main: Suhrkamp,
1963).

Wood, Denis/ Beck, Robert J.: Home Rules
(Baltimore&London: The Johns Hopkins
University Press, 1994).

Zizek, Slavoj: *The Plague of Fantasies* (London/
New York: Verso, 1997).

Remarks

| Quotation

◁ Seen in the Show Window

Typographic References

PARIS, CHANEL

VIENNA, HELMUT LANG

London, Vivienne Westwood

NEW YORK, RALPH LAUREN

HAMBURG, JIL SANDER

Acknowledgements

Thanks to:

Martin Bergmann
Gernot Bohmann
Roman Breier
Christo and Jeanne-Claude
Alison Clarke
Fortunato Depero
Simon Doonan
Günter Eder
Angela Fössl
Gert Hasenhütl
HAT Archive
Carol Johnssen
Renate Kromp
Bianca Lingg
Thomas W.J. Mitchell
Marcel Neundörfer
Lucian Perkins
Ulrike Rieger
Alexander Schweiger
Thomas Slunecko
Edith Specht
Nita Tandon
Mario Terzic
Mélanie van der Horn
Chloe Veale
Peter Weibel

And all those who helped in making this book possible.